HOLLYWOOD NORTH

Mike Gasher

HOLLYWOOD

The Feature Film Industry in British Columbia

NORTH

UBCPress · Vancouver · Toronto

09 08 07 06 05 04 03 02 5 4 3 2 1

Printed in Canada on acid-free paper ∞

National Library of Canada Cataloguing in Publication Data

Gasher, Mike, 1954-
 Hollywood North

 Includes bibliographical references and index.
 ISBN 0-7748-0967-1 (bound); ISBN 0-7748-0968-x (pbk.)

 1. Motion picture industry – British Columbia – History. I. Title.
PN1993.5.C32B7 2002 384′.8′09711 C2002-910737-7

Canadä

UBC Press gratefully acknowledges the financial support for our publishing program of the Government of Canada through the Book Publishing Industry Development Program (BPIDP), and of the Canada Council for the Arts, and the British Columbia Arts Council.

This book has been published with the help of a grant from the Humanities and Social Sciences Federation of Canada, using funds provided by the Social Sciences and Humanities Research Council of Canada.

Printed and bound in Canada by Friesens
Set in Minion, Meta, and Machine
Design: Neil and Brenda West, BN Typographics West
Copy editor: Sarah Wight
Proofreader: Gail Copeland

UBC Press
The University of British Columbia
2029 West Mall
Vancouver, BC V6T 1Z2
604-822-5959 / Fax: 604-822-6083
www.ubcpress.ca

This book is dedicated to my parents, Millie and Tony Gasher of Coquitlam, British Columbia, who have supported me in every way possible.

Contents

Acknowledgments

No one writes a book like this alone, and for that reason I would like to thank sincerely all those who helped me to see this project through. The following people deserve special mention: my wife and best friend, Dianne Arbuckle, for *always* being there; my children, Adam and Danielle, for helping me to keep everything in perspective; my doctoral supervisor, Bill Buxton, for keeping me focused and for encouraging me to think of my dissertation as a book; my friend Larry Pynn, for indulging my taste in movies; Emily Andrew of UBC Press, for believing in this book and guiding me through the publishing process; Sarah Wight, for her careful and respectful editing of the manuscript, and Camilla Jenkins of UBC Press, for seeing it through to publication; the three anonymous reviewers of the manuscript for their comments and corrections.

I would also like to thank the following people, who helped me at the research stage: Brian Young and Ann ten Cate of the BC Archives and Records Service; Romi Casper and Lindsay Allen of the BC government's Cultural Services Branch; former BC film commissioner Peter Mitchell; and Grace McCarthy.

HOLLYWOOD NORTH

1

Cinema in the Age of Globalization

My first recollection of the film industry in British Columbia dates from 1979, when my friend Gord Darby invited me to attend the Vancouver premier of a film in which he claimed to have played a central role. Gord is 6-foot-10 and played college basketball. As he tells it, he received a phone call at home one evening from a film producer, whose first words were, "I hear you're tall." Gord was thus recruited to wear the large and cumbersome costume of the monster in the John Frankenheimer horror movie *Prophecy*, which was shooting some scenes in North Vancouver. We laughed all the way through this ridiculous film – until the end, that is, when Gord's name was excluded from the credits, leading us to believe that none of his scenes had made the final cut.

I had a similar experience in 1986 when another friend, Larry Pynn, a reporter with the *Vancouver Sun*, signed on as an extra for the Michael Chapman fantasy *Clan of the Cave Bear*, then filming on Bowen Island. At the film's Vancouver debut, it seemed that most of the audience consisted of extras like Larry. To this day, Larry still searches for himself on the screen – midway through the film, at the edge of the frame of a busy scene in which hundreds of extras adorned in animal skins arrive for a gathering of the clans. I found him as hard to recognize as Gord had been in his monster costume. The credits, at least, verified Larry's participation.

The BC film industry was in those days, to me and my friends at least, a lark, nothing we were prepared to take seriously. Even when, as a student at Simon Fraser University, I began to study the Canadian film industry during the free-trade debates of the late 1980s, I had little regard for what was happening all around me. Filmmaking in British Columbia was not *real* cinema, because the province was little more than a Hollywood back lot, and because the films shot in British Columbia were almost always set somewhere else. The province's role seemed no more integral to these films than Gord and Larry had been to theirs. To my mind, the products of what had come to be called Hollywood North lacked the integrity of those rare home-grown films like Phillip Borsos's *The Grey Fox* or Sandy Wilson's *My American Cousin,* films that were conceived, shot, *and* set in British Columbia. I was convinced that, for the most part, real cinema took place elsewhere.

But the film industry in British Columbia has become harder and harder to ignore. It has grown steadily, producing more films and television programs, and spending more money in the province each year. Some years have been leaner than others, certainly, but Hollywood's anticipated desertion of British Columbia has never materialized. In fact, during the busy summer months, often enough film crews and studio space aren't available to satisfy Hollywood's demands. If anything, Hollywood's presence in British Columbia has become further entrenched in recent years as major Hollywood studios establish local production facilities. At the same time, a small indigenous industry has emerged, gaining notice and occasionally awards at film festivals throughout Canada and internationally.

British Columbia has become in the span of twenty-five years one of the largest centres of film and television production in North America. Compared to just 4 productions and $12 million in direct spending in 1978, the film and television industries spent $1.18 billion on 192 productions – including fifty-six feature films – in British Columbia in 2000 (BC Film Commission 2001b). These numbers are significant not only to British Columbia. They attest to the growing importance of regional and foreign location production within the Canadian film industry. Every province in Canada has at least one government office promoting film production, and within the provinces there are regional and municipal film commissions seeking to attract location activity to their areas.

At the same time, these numbers underscore the increasing internationalization of commercial film production by the major studios, a development

California film workers have found threatening. Two Hollywood labour organizations – the Directors Guild of America and the Screen Actors Guild – commissioned a study that singled out British Columbia as a chief culprit in luring film and television production away from southern California (Monitor Company 1999). During the spring and summer of 1999, California film and television workers staged rallies in Burbank, Sacramento, and Hollywood, calling for action from the state legislature to stem so-called runaway production (Movie, TV workers 1999).

A report commissioned by the International Trade Administration (2001, 27) of the US Department of Commerce estimated US$2.8 billion in direct expenditures were lost to runaway production in 1998, although the Directors Guild of Canada claimed the figure was closer to a still-substantial US$1.74 billion. The Film and Television Action Committee (2001) said that of the 37 percent of all US-developed film and television productions in 1998 made in foreign locations, 81 percent were made at least partly in Canada; it accused Canada of trying to steal the film industry from the United States (see also Magder and Burston 2001, 208). By October 2001, a bill had been introduced in Congress asking the US government to provide wage-based tax credits for small to mid-size projects filmed in the United States (Garvey 2001a). In December 2001, the Film and Television Action Committee and the Screen Actors Guild filed a petition with the US Department of Commerce, asking Washington to impose penalties on film and television productions shot in Canada (Garvey 2001b).

Canadian film and television production has become a $4.4 billion industry, creating the equivalent of 46,000 full-time jobs annually. The industry produces about forty Canadian feature-length films each year (Yaffe 2001). British Columbia occupies a distinct place within this industry, given its relatively recent emergence as a production centre, its heavy reliance on foreign service production, and its consequent modest contribution to Canada's stock of indigenous films and television programs. From 1990 to 2000, for example, spending by foreign film and television producers accounted for more than two-thirds of the industry's economic activity (BCFC 2001b). As recently as 1995, BC production represented just 7 percent of Canadian production budgets, compared to Ontario's 59 percent and Quebec's 30 percent (CFTPA 1997, 1-10).

British Columbia's heavy reliance on foreign location production raises an obvious question: What does it mean, in an age of global image flows

and transnational audiovisual production, to speak of the *British Columbia* film industry, an industry with clearer links to Hollywood than to Canada? Besides being the geographical site of production, what relevance does this place have to the dramatic cinema that is produced within its boundaries? Such questions have been the source of some angst, as the opening paragraphs of a front-page article in the *Vancouver Sun* attest: "It's the old familiar story. In the movie business, BC residents are the hewers of wood and drawers of water for a seductive foreign culture – and Beautiful British Columbia itself stands in for less beautiful foreign parts, usually in the United States. The movie invasion of British Columbia by US producers may be good for Canada's economy, but what is it doing for our soul as a nation? In the circumstances, the nickname 'Hollywood North' takes on an ominously ironic ring" (Canadian culture? 1995). Where does British Columbia fit within this cinema? Is it merely a convenient yet expendable site of production? Or can it make a more integral claim to the cinema made within its boundaries?

These questions arise from unstated assumptions about the nature of cinema and the proper relationship between a cinema and its site of production. These assumptions, which cast the BC film industry as some kind of misfit, thwart serious evaluation of what kind of cinema it is and how we might understand its relationship to place. The idea that British Columbia's feature film industry is a dis-placed cinema is written into the nicknaming of Vancouver, the province's centre of film production, as "Hollywood North" or "Brollywood." The *New York Times* has called Vancouver "The City That Can Sub for All of America" (Elias 1996).

CINEMA AS NATIONAL CINEMA

If cinema is one of the media through which we imagine place, it must also be acknowledged that place is one of the templates with which we imagine cinema. Cinema, in other words, has commonly been analyzed as a medium of expression specific to a geographically situated culture. And within cinema's taxonomy, privilege has been granted to *national* cultures. Even those studies that foreground genre or auteur analyses frequently appeal to national cultural contexts to explain specific characteristics of film texts. Thus, we read about German expressionism, Soviet socialist realism, Italian neo-realism, French impressionism and surrealism, and the American western (see Cook 1985; Bordwell and Thompson 1986; Turner 1990).

Certainly it can be argued that context remains pertinent to the analysis of both film industries and film texts. But what is less clear is how context itself should be demarcated. Classifying cinema as national cinema can no longer be assumed to be the most appropriate category of analysis for a body of films produced within a given nation-state, nor can it be taken for granted that all film industries are national industries. The nation is not the only scale on which place can be imagined. The framing of cultural production as national cultural production is called into question by transnational enterprise, by local or regional cultural workers, and by cultural producers whose identity is not tied to geographic proximity. Thus, we can point to women's cinema, black cinema, and queer cinema as examples of filmmaking traditions emanating from communities that do not necessarily share a geographical locale.

Classification is an important issue because how we categorize cinema informs how we talk about films, or whether we talk about them at all. Critical categories, such as national cinemas, help to define cinema by assigning the medium a particular social role, by establishing parameters of discussion, by including certain film texts, and by excluding others. Dissonant elements, however, are then either suppressed or overlooked: "The problem is that categories have a mythologizing and homogenizing function: they perpetuate a logic of identity, a logic which dictates that the critic emphasize elements (textual or extra-textual) of coherence, unity and wholeness" (Stukator 1993, 118).

Andrew Higson (1989) argues that there is no single, accepted discourse of national cinema. National cinema can be defined in economic terms, whereby the term "national cinema" embraces an entire domestic film industry. National cinema discourse can also take a text-based, consumption-based, or criticism-led approach, reducing national cinema to "quality art cinema": "In other words, very often the concept of national cinema is used prescriptively rather than descriptively, citing what *ought* to be the national cinema, rather than describing the actual cinematic experience of popular audiences" (36-7). The process of identifying a national cinema, Higson maintains, is an attempt to contain that cinema, to limit what it can mean and, ultimately, produce (37).

Peter Morris (1994) offers a specific example of this problem in his analysis of canon formation in Canadian film studies during the 1960s and 1970s. A prevailing assumption of criticism in that period, Morris remarks,

was that films in Canada should be discussed as products of a national culture. Morris invokes two Claude Jutra films: *Mon Oncle Antoine* (1971), which has been thoroughly analyzed and is a staple of film studies courses; and *À tout prendre* (1963), which remains marginal to Canadian cinema study. While both are generally acknowledged to be excellent films, they are distinguished by their treatment of identity. *Mon Oncle Antoine* deals with French-English relations, and therefore fits comfortably within the "two solitudes" discourse of Canadian film scholarship. *À tout prendre* is a very personal and autobiographical film, and thus falls beyond the thematic boundaries of Canadian national cinema. Morris argues that the nationalist orientation of 1970s criticism "effectively negated any meaningful debate about how a 'national' cinema might be defined" (30-3).[1]

For Bart Testa (1994), Canadian film scholarship has been constrained by a "social-reflection thesis," a legacy he traces to John Grierson, who institutionalized this thesis in the National Film Board of Canada: "Canadian critics (and governments too) have repeatedly declared that there should be 'distinctly' Canadian movies. The distinction would be that these movies would 'reflect' Canadian social realities, and so they would somehow have to be 'realistic.' This social-reflecting activity, in turn, would constitute Canadian identity. It is this social-reflection prescription that provides unity to critical debates and to Canadian cinema" (9). Testa remarks a "consensual preoccupation" among Canadian film scholars that "movies should serve a high moral purpose" – nation-building, the articulation of a national culture – as opposed to being, for instance, sources of entertainment.

Organizers of an extensive Canadian cinema retrospective at the Centre Georges Pompidou in Paris in 1993 struggled over how to categorize the disparate assortment of 145 films they chose to screen. The cumbersome title of the exhibition – *Les Cinémas du Canada: Québec, Ontario, Prairies, côte Ouest, Atlantique* – acknowledged plurality at the same as it embedded Canada's national cinema in the country's diverse regions.[2] The catalogue that accompanied the retrospective devoted chapters to Quebec and "les autres provinces" as well as to documentary, feminist, experimental, and IMAX films (Garel and Pâquet 1992). In his introduction to the catalogue, Sylvain Garel (1992, 9) acknowledges that "ces cinématographies abordent des thèmes et développent des styles très différents, à tel point qu'il aurait été plus logique d'intituler cette rétrospective et cet ouvrage «Les cinémas du Québec et du Canada»." However, "ce titre a dû être abandonné à cause de

problèmes économico-politiques résultant de l'interminable et complexe débat constitutionnel canadien."[3]

Michael Dorland (1998, 3) proposes that the challenge to scholars of filmmaking in Canada is "the utter heterogeneity of its cinema." Besides its various genres – documentary, experimental, animation, features, shorts – Canada offers distinct production traditions emanating from an array of institutional sites. "Given the complex heterogeneity of Canadian cinema, where was the analyst to actually 'locate' it?" he asks (5). Canadian film scholarship has typically treated Canadian cinema's heterogeneity "as problems to be disposed of," Dorland argues, rather than as "starting points for a problematic of historiographical method." The concept of national cinema has conveniently allowed scholars to provide a unified frame for a fragmented Canadian cinema (5-6). By reducing cinema in Canada to national cinema, and thereby glossing over the difficulties of sharing the North American continent with the United States, English-Canadian film critics, in Dorland's view, have tried to play a role in forging a national culture (11).

Conventional analyses of cinema as national cinema also ignore or suppress what has become an increasingly prominent feature of contemporary film. The transnationalization of Hollywood's film production sector, which resulted from the Hollywood majors abandoning the factory-like studio system of production in the postwar period, further complicates the relationship between cinema and place. What Toby Miller (1996, 77) refers to as "the new international division of cultural labor" means that local film industries around the world include both indigenous filmmaking and runaway production conceived and financed by, typically, American film companies. In places like British Columbia, the hybrid motion picture industry is devoted *primarily* to foreign location production. Over time, local film workers have increasingly implicated themselves in the production of Hollywood films and television programs by assuming creative roles as performers, directors of photography, assistant directors, and occasionally as directors. When Steven Spielberg shot portions of *Schindler's List* (1993) in Poland, for example, Polish nationals Janusz Kamiński (director of photography), Allan Starski (set designer), and Ewa Braun (costumes) occupied key creative positions (Wertenstein 1995).

John Hill (1994b) suggests that if *specific* cinemas are contested categories, so is the category of cinema itself. In other words, when we talk about "cinema," what exactly are we talking about? A cinema comprises three main

components: the structures of film production, the textual characteristics of film, and the distribution and exhibition of films. These three components have permitted film scholars to make analytical distinctions between, for example, cinema in Europe and European cinema, a distinction that may hide as much as it reveals about cinema's sense of place. Given Hollywood's dominance of European cinema screens and the major studios' investment in runaway production, Hill suggests that "it could be possible for there to be a successful European film industry which is nonetheless neither making nor showing European films" (54-5).

Ireland is one such example: "Since the 1930s, the state's support for film production has usually been limited to addressing problems of unemployment through encouraging foreign capital to invest in films in Ireland" (Rockett 1994, 128). Kevin Rockett points out that well-known "Irish" films like *My Left Foot* (1989), *The Field* (1990), *The Commitments* (1991), *The Playboys* (1992), and *Far and Away* (1992) were produced largely with British and American money. The Irish government established a film office in Los Angeles in 1995 for the purpose of promoting Ireland as a location for runaway production (Dwyer 1995).

Hill (1994a, 5) argues that Hollywood is not simply a parallel "other" that can be ignored in the analysis of indigenous cinemas. He suggests that it may be useful to think of Hollywood less as a national industry than as a global cinema, which Europeans – and Canadians – have both helped to create and have integrated into their own popular culture.[4] For example, when Irish filmmakers began to construct their own "cinematic Ireland" in the wake of numerous Hollywood images of their country, they were compelled to develop a film form better suited to the films' thematic preoccupations, constituting "an attempt to re-imagine Ireland" (McLoone 1994, 168).

Stephen Crofts (1993, 61) lists seven varieties of national cinema in an attempt to acknowledge that there is a wider range of cinemas than is typically signified by that term: "Not only do regional and diasporic cinema production challenge notions of national cinemas as would-be autonomous national businesses. So, too, Hollywood's domination of world film markets renders most national cinemas profoundly unstable market entities, marginalized in most domestic and all export markets, and thus readily susceptible, *inter alia*, to projected appropriations of their indigenous cultural meanings." One of the seven varieties Crofts identifies is regional/ethnic cinema, a category that includes, for example, Catalan, Québécois, Welsh, Aboriginal,

Cinema in the Age of Globalization

Maori, native American, Chicano, and Afro-American filmmaking. Unfortunately, Crofts does not elaborate on the particular sense of "national" these cinemas evoke.

In a similar vein, Tom O'Regan opens up the category of national cinema analysis about as far as it will go without rendering it altogether meaningless. For O'Regan (1996, 4), a national cinema is "a film milieu made up of antagonistic, complementary and simply adjacent elements, which are to be made sense of in their own terms." This accounts not only for the varied motivations of local filmmakers, but also for the presence in the same milieu of the transnational commercial film industry.

If Crofts and O'Regan call into question the way national cinemas are conceived and analyzed, they stop short of rejecting the frame altogether. They maintain the hegemony of the national, a classification that cannot account for the possibility that certain sub-national jurisdictions may constitute cinemas obeying alternative spatio-temporal dynamics, with distinct histories, laws, institutions, traditions, and funding mechanisms, cinemas integrated within industrial networks operating both intra- and internationally. What such criticism points to, instead, is a category crisis. Too many cinemas today defy the national category, because the production community is not a national community in any sense of the term, or because nations have too many cinemas for the term to have meaning, or because filmmaking in any one nation is increasingly intertwined with transnational networks of finance, production, distribution, and exhibition.

The film industry in British Columbia certainly cannot be understood within the national cinema frame. It doesn't fit. If the idea, proposed by Tom O'Regan, is to make sense of particular cinemas "in their own terms," then it is necessary to set aside prefabricated conceptual frameworks, such as "national cinema," and allow the characteristics of these cinemas to establish their own terms of understanding. That is what this book sets out to do.

CINEMA AND GLOBALIZATION

This category crisis also calls into question conventional understandings of "place," the physical and social environment in which film and television production occurs, and the relationship between filmmaking and its site of production. The framing of cinema as national cinema is particularly vulnerable in an era of globalization.

Scholars who have engaged with the phenomenon of globalization from

a number of disciplinary perspectives maintain that globalization has reconfigured our senses of space and place. They underline, further, the significant role the mass media play in the complex process of how we imagine and construct ideas of place, as well as the related notions of community, culture, society, nation, and identity. Far from rendering place irrelevant or inconsequential, however, such scholarship encourages a radical reconceptualization of place in the context of intensified global social relations. This reconceptualization implicates culture as well as place: "Globalization pulls cultures in different, contradictory, and often conflictual ways. It is about the 'deterritorialization' of culture, but it also involves cultural 're-territorialization.' It is about the increasing mobility of culture, but also about new cultural fixities" (Robins 1997, 33).

The contemporary world is characterized by the compression of time and space. Social relations extend further than ever before, with greater frequency, immediacy, and facility. The term "globalization" refers to the increased mobility of people, capital, commodities, information, and images associated with the postindustrial stage of capitalism, the development of increasingly rapid and far-ranging communication and transportation technologies, and people's improved access to these technologies. Globalization has increased and facilitated intercultural contact across an array of social sites, from the workplace to the supermarket, from the bus stop to the living room.[5]

The term "globalization" is unfortunate because it suggests that *all* significant social relations now occur on a global scale. What the term more properly refers to, however, is an intensified *interrelation* of social activity on local and global scales, rather than their opposition (Massey and Jess 1995, 226). Rob Wilson (1996, 318) applies the more useful term "global/local interface." Doreen Massey (1992, 6) describes this interface as follows: "Each geographical 'place' in the world is being realigned in relation to the new global realities, their roles within the wider whole are being reassigned, their boundaries dissolve as they are increasingly crossed by everything from investment flows, to cultural influences, to satellite TV networks." She adds that the social relations that constitute a given locality increasingly extend beyond that locality's borders, no longer contained within any given place (7).

Of course, international migration is not new, nor is the mobility of capital or the global circulation of cultural products. What is new about

Cinema in the Age of Globalization

globalization is its intensity: the expanded reach and the immediacy of contemporary social relations. Migration, whether regional, intranational, or international, voluntary or forced, has become a more common experience. Russell King (1995, 7) notes that few people in the Western world today live their entire lives in the same place. King remarks a trend to an increasing diversity of migrant source countries and a change in the push and pull factors of migration. Push pressures in developing countries are increasing, as poverty, overcrowding, political instability, and environmental degradation reach intolerable levels, and people have acquired at least some knowledge of living conditions in the industrialized world. As a consequence, migrants from the margins have moved to the centres of economic and political power. At the same time, pull pressures have changed. The decline in manufacturing has reduced the need for traditional migrant labourers, while the growth of the service sector has increased the demand for highly skilled workers, resulting in what King calls "a new breed of executive nomads who, whilst quantitatively much less important than the mass labour migrations of the past, nevertheless wield enormous influence over the functioning of the global economy" (22-4).

The increased mobility of capital, of course, is not unrelated to the issue of migration. Corporations are becoming transnational. They are less rooted to their "home" territories than ever before, seeking greater productivity and improved access to international markets wherever these advantages can be found. In the economic realm, David Morley and Kevin Robins (1995, 109) insist that globalization organizes production and markets on a world scale. Nowhere has capital been more successful at penetrating world markets than in the cultural sphere. Morley and Robins argue that two key aspects of the new spatial dynamics of globalization are, first, technological and market shifts leading to the emergence of "global image industries," and, second, the development of local audiovisual production and distribution networks (1-2). The authors refer to a "new media order" in which the overriding logic of corporations is to get their product to the largest possible number of consumers (11).

But if, as Stuart Hall (1995, 27) notes, satellite television is the epitome of transnational forms of mass communication, "the most profound cultural revolution has come about as a consequence of the margins coming into representation." He argues that within the global mediascape, story tellers and image makers have won the space to assert their own particularity: "The

emergence of new subjects, new genders, new ethnicities, new regions, new communities, hitherto excluded from the major forms of cultural representation, unable to locate themselves except as decentered or subaltern, have acquired through struggle, sometimes in very marginalized ways, the means to speak for themselves for the first time" (34).

Media images also serve as a reminder of how far our social relations stretch, and the extent to which those relations are technologically mediated. Morley and Robins (1995, 141) observe: "The screen is a powerful metaphor for our times: it symbolizes how we exist in the world, our contradictory condition of engagement and disengagement." The perpetual flows of people, capital, goods, services, and images that characterize globalization carry significant implications for how we experience and imagine place, how we define community, and how we constitute identity. Globalization renders actual borders more porous and metaphorical boundaries passé. But with all this movement and intermixing, how can we retain a sense of local particularity (Massey 1991, 24)?

Globalization has not caused place to lose meaning so much as it has intensified struggles over the meaning of place and thereby *exposed* the extent to which "place" is a social construction. Places are vulnerable to reification, the perception that they are something other than products of human activity. However, places have no natural boundaries, nor are they in any way naturally confined in scale. If places have boundaries at all, these boundaries have been drawn by social actors: "Geographers have long been exercised by the problem of defining regions, and this question of 'definition' has almost always been reduced to the issue of drawing lines around a place" (Massey 1991, 28).

As noted above, the various flows we associate with globalization are not new. Globalization has, however, both increased the traffic – human, material, electronic – across some borders, and reconfigured others. For example, the free-trade agreement between Canada and the United States was an attempt to facilitate trade across the border that divides the two countries. Although the legal boundary remains, the meaning of the border has changed, at least as far as trade relations are concerned. Satellite television, on the other hand, ignores terrestrial boundaries altogether, and is confined instead only by the satellite "footprints" that mark the limits of a satellite's transmission.

The heightened permeability of borders has been met, among some, by

the desire for a more rooted sense of place. Scholars are in some disagreement over whether relatively isolated, cohesive, and homogeneous communities ever existed, or if they did, how far back in history we need to go to find them. Massey (1992, 8) rejects inherited notions of a "singular, fixed and static" identity of place by arguing that "'places' have for centuries been more complex locations where numerous different, and frequently conflicting, communities intersected." She maintains that "it has for long been the exception rather than the rule that place could be simply equated with community and by that means provide a stable basis for identity." The identity of a place "does not derive from some internalized history. It derives, in large part, precisely from the specificity of its interactions with 'the outside'" (13).

Although there is disagreement as to the genesis of the relationship between space and place, there is consensus that place can no longer be thought of as a simple "enclosure" for community, identity, or culture. Gillian Rose (1995, 88) notes that place has been a privileged component of identity formation: "Identity is how we make sense of ourselves, and geographers, anthropologists and sociologists, among others, have argued that the meanings given to a place may be so strong that they become a central part of the identity of people experiencing them." Places, and the experiences we associate with places, both as individuals and as members of a group, inform memory and our sense of belonging. This sense of belonging is critical to understanding the relationship between identity and a particular locale. "One way in which identity is connected to a particular place is by a feeling that you belong to that place," as Rose points out (89). We might, therefore, detect different senses of belonging between native residents of a place and migrants. Such migrants as refugees and exiles, who have not moved of their own free will, may feel little sense of *appartenance* in their new place of residence (96). Rose argues, "Increasing flows of ideas, commodities, information and people are constantly challenging senses of place and identity which perceive themselves as stable and fixed. The increasing interdependence between places means that, for many academics at least, places must be seen as having permeable boundaries across which things are always moving. Identities, too, more and more often involve experiences of migration and cultural changing and mixing" (116).

Culture is another means by which identities of place are constructed and sustained. Stuart Hall (1995) argues that we tend to imagine cultures as "placed" in two ways. First, we associate place with a specific location where

social relationships have developed over time. Second, place offers cultures "symbolic boundaries," which separate those who belong from those who don't. At the same time, "there is a strong tendency to 'landscape' cultural identities, to give them an imagined place or 'home,' whose characteristics echo or mirror the characteristics of the identity in question" (182). However, Hall adds, "the ways in which culture, place and identity are imagined and conceptualized are increasingly untenable in light of the historical and contemporary evidence" (186).

While one impact of globalization has been the diminution of "place" as the basis for identity or culture, postmodern thinking and improved networks of transportation and communication facilitate the imagination of communities based on gender, race, ethnicity, sexual orientation, or class. Proximity, in other words, is not a necessary element of identity formation. If culture and identity are not confined to a particular place, it follows that any one place is not confined to a single culture or identity. This has precipitated localized struggles over immigration, language, urban development, architecture, and foreign investment. Mike Featherstone (1996, 66) remarks that "cultural differences once maintained between places now exist within them." For example, "The unwillingness of migrants to passively inculcate the dominant cultural mythology of the nation or locality raises issues of multiculturalism and the fragmentation of identity." Massey (1995, 48) argues that the way places are defined – by media reports, by local government policies, by development proposals – "can be important in issues varying from battles over development and construction to questions of which social groups have rights to live where."

Identities of place are always the subject of dispute. Often they are achieved through the construction of "Others," which creates a sense of community insiders and outsiders (Rose 1995, 104-5). Or claims to a specific identity may be based on a particular reading of history: "In this sense, what is being named or interpreted, is not just a space or place, but a place as it has existed through time: what one might think of as an *envelope of space-time*" (Jess and Massey 1995, 134). Such contestation occurs, not as an occasional battle, but as a continual process on a range of geographical scales (172).

The conventional container of identity and culture that has come under greatest challenge from the reimagining of community has been the nation-state. Questions of citizenship have been increasingly dissociated from questions of identity (Morley and Robins 1995, 19). The emergence of trading

blocs in Europe, Asia, and North America, and the prevalence of both international and sub-national cultural networks, have undermined the primacy of the nation-state in contemporary conceptions of community, identity, and culture: "The nation-state, in effect, having been shaped into an 'imagined community' of coherent, modern identity through warfare, religion, blood, patriotic symbology, and language, is being undone by this fast imploding heteroglossic interface of the global with the local: what we would here diversely theorize as the *global/local* nexus" (Wilson and Dissanayake 1996, 3).

THE PLACE OF THE MEDIA IN SOCIETY

The communications media have their own role to play in "dis-placing" and "re-placing" community, identity, and culture, given that the media have historically been important tools in constructing accepted notions of community on both symbolic and material levels. To be more precise, five specific roles can be ascribed to the media in how we imagine community: first, they are the media of *encounter,* putting us in touch with one another via mail, telephone, e-mail, or fax; second, they are the media of *governance,* enabling the central administration of vast spaces and dispersed places; third, the media *represent* community by depicting actuality and by creating fictionalized "sociological landscapes"; fourth, the media *construct* communities of audiences, based on diverse criteria ranging from physical proximity to shared tastes in popular music; and fifth, they create *rituals* through which readers and spectators imagine themselves as part of a communal audience.

While face-to-face interaction – on the street, in the park, at work, at school, at public meetings, at the corner store – remains central to social relations in even the most globalized of environments, proximity no longer binds us to community. Communications technologies like the cellular telephone, fax machine, and personal computer bind social spaces and enable people to maintain regular and frequent contact. This is particularly so as these technologies have become more accessible in terms of cost, ease of use, and availability, and as these media have entered the private sphere of the home. The instantaneousness with which technologically mediated conversations can be held approximates face-to-face communication. As the boosters of the digital age delight in telling us (e.g., Negroponte 1995), such media enable us to maintain social relations over great distances, and their increasing sophistication minimizes the obstacles implied by physical separation.

Similarly, as Harold Innis argued, communications media enable the

centralized governance of a political community on the scale of the modern nation-state, and the centralized administration of a transnational corporation of intercontinental range. Both national governance and global capitalism require efficient means of communication to establish a coherent agenda, disseminate instructions and information, monitor the activities of remote departments, and receive reports from local managers in the field. This is a relationship of power in which an authoritative body exercises control over social space and the social order (see Drache 1995, xlv-xlvi).

The third role the media play in how we imagine community is through representation. They create what Benedict Anderson (1989, 35-6) calls a "sociological landscape" or "socioscape" in which their narratives are set. As Anderson's terminology indicates, these settings are both peopled and bounded. If, historically, the eighteenth-century novel and newspaper taught people to imagine community on the scale of the nation, contemporary socioscapes present us with communities that are imagined in any number of ways. The population of these settings and the location of their boundaries either reinforce conventional notions of community or propose new social horizons.

In addition to representing communities, the media also construct them out of audiences and markets. The newspaper provides a particularly good example, in that newspapers are designed to address various kinds of community. They may serve a community of geographical proximity, such as the *Vancouver Sun* on a metropolitan scale and the *East Ender* on a neighbourhood scale. They may serve a particular community contained within a locale, such as *Le Soleil* for Vancouver's francophone community, or *Sing Tao* for Vancouver's Chinese community. Or they might serve a community bound by a common interest in computers *(Vancouver Computes)*, cinema *(Reel West),* environmental issues *(B.C. Environmental Report)*, business *(Equity)*, or alternative music *(Loop)*. All of these communities are plural and can therefore be further distinguished; most subscribers to Vancouver's two daily newspapers will be Vancouver residents, but they can probably be differentiated on the basis of various demographic criteria. This, of course, is how newspapers operate as commercial enterprises: they assemble audiences to sell to advertisers (Smythe 1982, 25-8). Federal funding mechanisms for broadcasting and film are good examples of how the Canadian state has attempted to use media to construct an imagined community on a national scale.

Finally, the media produce widely shared rituals of readership and spectatorship. When we sit down to watch the six o'clock news, we can imagine millions of others doing the same thing at the same time, even if the news they are watching is on another channel. Similarly, when we sit down to read the newspaper over morning coffee, we can imagine ourselves as a community of newspaper readers, even if, again, we are not all reading the same paper. These rituals take their most obvious form in cinema spectatorship, in which a group of people gather to watch a film, and thus literally form an audience as community, if only for a couple of hours (Shohat and Stam 1996, 153-5).

As a medium of representation, cinema, specifically, offers us pictures of our physical and social world, showing us where we live, with whom we share community, and from whom we are different. Cinema offers us depictions of history, stories that explain to us how we got here and why our community is the way it is. When we participate in its production, cinema brings us together as cultural workers, people who participate in the representation of their social world, people who determine their own social horizons. If this cultural work is devoted to depicting a given place, it also defines that place by becoming one of the things cultural workers there do. Place, then, is not simply rendered symbolically, but is embodied by a film's characters and the film workers themselves (see Relph 1986).

In light of the above, this book seeks to transcend "the national" as the determining category in its analysis of the film industry in British Columbia. It asserts that any given cinema is a social construction whose particular definition is contingent upon a nexus of historical, economic, political, and cultural forces. What the term "cinema" signifies in any specific context is the result of choice, struggle, negotiation, and compromise, processes that are often overlooked. These processes of definition privilege one particular film form – such as animation, documentary, experimental, or feature – over others, favour one form of governance – such as private enterprise or public service – over others, and identify specific social roles for cinema – such as entertainment, education, cultural enlightenment, or nation-building.

As a socially constructed institution, a given cinema is defined across a number of sites. I have identified four that have shaped in fundamental ways the feature film industry in British Columbia: provincial film history, the economic structure of the commercial cinema, federal and provincial film policy, and film practice. Each of these is a site of the production of

meaning, creating particular understandings of cinema and place, and I approach each differently.

It is important to clarify one matter from the outset. While, in popular discourse, the term "film industry" typically refers to all forms of audiovisual production, and while the convergence of the film and television industries prompts some reflection on conventional analytical borders between these media, I want to maintain a distinction between film and television in this book. Film and television remain distinct industries in Canada from the perspective of their histories, their regulatory environments, and their funding mechanisms. These three areas are especially pertinent to this study. The fact, for example, that television exhibition is regulated through Canadian-content quotas renders television a far more inclusive medium than cinema. This theme of inclusion/exclusion from the film industry is a key element of both the film industry in British Columbia and this book. Similarly, the fact that the television industry in Canada is governed by national broadcasters (such as CBC, CTV, and Global) distinguishes it structurally from the regional orientation of feature film production. Again, the regional aspect of film production is central to this study.

Chapter 2 describes the history of filmmaking in British Columbia from the late 1890s to the early 1970s. Drawing on both primary and secondary sources, this history reveals that the defining characteristics of British Columbia's feature film industry today have been in place for over 100 years. These characteristics – an emphasis on foreign location production, provincial government intervention, an industrial conception of cinema – only became decisive advantages to British Columbia when the commercial film industry based in Hollywood began to externalize production in the postwar period. Besides documenting the early history of film production in the province, this chapter sketches the context out of which British Columbia's feature film industry emerged in the 1970s, and establishes a sense of continuity between the history of filmmaking in the province and British Columbia's contemporary cinema. I argue that British Columbia's historical inheritance is a perception of cinema as a medium, not of cultural expression, but of regional industrial development.

Chapter 3 builds on this theme by applying a political-economic analysis to the feature film industry. All film production is governed to some extent by economic factors. Film is both a capital-intensive and labour-intensive medium, and thus even the most modest film project demands some form of

Cinema in the Age of Globalization

funding, whether in the form of investment, loan, subsidy, or barter. Feature film, as cinema's predominant commercial form, is especially implicated by the transnational industry that organizes cinema as a form of commodity production. Hollywood's dominance of this industry has had a profound influence on normalizing particular forms of cinema and thus on the circulation and projection of individual movies. As Albert Moran (1996, 6-7) writes, "With the increasing transnationalization of film production, of motion picture financing, the articulation of a long chain of distribution outlets and their domination by the [Hollywood] majors, and the growth of independent producers who themselves frequently act as brokers between filmmakers and the principal distributors, the system now exists whereby national film making is, through a series of commercial linkages, also a part of Hollywood." When it opted to develop a feature film industry in the 1970s, British Columbia mobilized a distinctly industrial strategy in which, to support Moran's contention, British Columbia's cinema became part of Hollywood. Chapter 3 argues that the opportunity to develop a feature cinema in British Columbia was a product of both national and international factors: British Columbia's exclusion from Canada's national cinema, concentrated in Ontario and Quebec; and British Columbia's inclusion in Hollywood's transnational audiovisual production.

Chapter 4 employs political history and social discourse analysis to assess the policy initiatives undertaken by the BC government since the 1970s to develop a feature film industry. The policy process establishes guidelines, regulatory instruments, funding vehicles, and institutions that become integral to film production by directing resources in certain directions with identifiable aims. More specifically, policy also stakes out the degree of state intervention a government chooses to exercise in the regulation of a cultural practice. Policy discourse constructs a privileged notion of what cinema is, and delineates film production in particular ways. Discourse can be defined as "an area in which knowledge is produced and operates, both openly and in a less than overt way. It fixes norms, elaborates criteria, and hence makes it possible to speak of and treat a given problem at a particular time" (Miller 1993, xiv). Social discourse analysis situates discourse within the broad framework of society and culture, emphasizing "the relationships between discourse and social structures" (Van Dijk 1997, 22). The chapter demonstrates that the economic opportunity represented by foreign location production was well suited to Victoria's industrial perception of cinema and its

long-term objective of expanding and diversifying the province's recession-prone, resource-based economy.

Any attempt to conceptualize the relationship between cinema and place in the context of an analysis of British Columbia's feature film industry would be incomplete without reference to the films themselves. Chapter 5 considers a sampling of feature films produced in British Columbia since the late 1970s. The method of textual analysis employed here is governed by the question of how the films depict British Columbia, and how these depictions speak to the province's sense of place. While foreign service productions almost always appropriate British Columbia within "America," denying the province its sociohistorical particularity, a number of British Columbia's indigenous films reassert the region's distinctiveness.

To my knowledge, very little analysis in film studies has been devoted to the implications of location filming for the rapport between story and setting, and what little there is foregrounds aesthetic rather than political or cultural concerns. If locations are mentioned at all, they are most commonly treated within larger discussions of *mise en scène* (e.g., Giannetti 1993). Charles Affron and Mirella Joan Affron (1995) have gone some distance in rescuing the study of set design from a general neglect within film studies, and they include examples of locations within their larger analysis of the degrees of intensity with which film sets establish time, place, and mood. Yet even they treat locations as simply another type of film set. In a too-brief article, Bernard Nietschmann (1993) argues that geography should matter in film production, but too often does not. In films shot on location, Nietschmann insists, setting is reduced to background, contributing nothing to the content of the film – "all is context, not content" – and suppressing the meaning and power of place (5). Locations are thereby rendered irrelevant: "When a place is shown or seen as just a location for a story or as but pretty scenery, there is a dislocation between people and nature, between image and experience, between the screen and geography, and between the director and the audience" (7).

Chapter 6, finally, concludes that British Columbia is particularly well suited to what Doreen Massey (1991) has termed a "global sense of place," which conceives of place as a meeting ground or intersection – for international flows of people, capital, commodities, and images – rather than as a clearly bounded cultural enclosure. Such a sense of place is critical to understanding the BC film industry, which is itself built upon a complex interface

between transnational and regional/local regimes of production. In this way, the film industry in British Columbia can be seen as very much a cinema of its time and place.

Together, these chapters tell the story of the rapid rise of the film industry in British Columbia, and they position this industry as both a model for commercial film production in the twenty-first century and as an industry whose basic characteristics have deep roots in a province that has always perceived cinema as, first and foremost, a medium of regional industrial development. If this book treats British Columbia as a unique case in many respects, I aim nonetheless to demonstrate that the film industry in British Columbia is part of a growing and widespread phenomenon in which cinemas around the world – and outside Quebec and Ontario within Canada – are based predominantly on location service production. In so doing, I seek to contribute to film studies debates over the category of national cinema, the framing of cinema as industry, and the relationship between cinema and place, regardless of where in the world these debates occur.

2

Cinema As a Medium of Regional Industrial Development: A History of BC Film Production

While the film production industry that has emerged in Vancouver over the past twenty-five years is new to British Columbia, the central characteristics that define this industry are not. Foreign producers have been visiting British Columbia to shoot films since the end of the nineteenth century, attracted by the province's natural beauty and the diversity of its landscapes. If, in the earliest days of cinema, British Columbia's scenery occupied the foreground – tracking shots along the railway lines of the Fraser Canyon became a visual cliché – today British Columbia forms the backdrop to fictional narratives set all over the continent. Nor is provincial government involvement in film-making new. Victoria has assumed a central role as promoter, patron, and producer in BC cinema since at least 1908.

This chapter seeks to establish a sense of continuity between British Columbia's billion-dollar feature film industry and earlier state-sponsored initiatives that employed cinema as a medium of regional industrial development. Historically, that is, the BC government has perceived cinema as a way to attract immigrants, capital investment, and tourists; encourage tourism by British Columbians within their own province; advertise its industrial products around the world; and promote education pertaining to health, safety, and conservation issues. The chapter asserts that the provincial government's sudden interest in *feature* film in the 1970s, which would seem

to signal a change in its thinking about cinema, can in fact best be understood as an opportunistic revision of Victoria's long-term regional industrial development strategy. Once looked upon as a promotional appendage to its traditional resource industries, today cinema in British Columbia is an industry in and of itself.

Specifically, this chapter traces the historical roots of three themes that characterize the feature film industry in British Columbia today: first, the predominance of foreign location production in the province's film history; second, the central role played by the provincial government as a film producer throughout the twentieth century; and third, the privilege Victoria's role as producer, and as regulator of the exhibition sector, has afforded the provincial government in defining what "cinema" has meant historically in British Columbia. These themes distinguish British Columbia's tradition within the larger history of film production in Canada and serve to distance west coast filmmaking from the notion of cinema as the product of a national culture.

INVENTING HOLLYWOOD NORTH

Location film production in British Columbia has a rich genealogy. Colin Browne (1979, 3) notes that, in the first quarter of this century, "whenever motion pictures were actually made in British Columbia they were almost always filmed by outsiders and produced elsewhere, returning as finished products that interpreted the province through either eastern Canadian or American or British eyes." Of course, British Columbia's population at the time consisted primarily of migrants; according to the 1921 census, 95 percent of the province's 525,000 residents were not native born (Browne 1992, 174). The films these newcomers made in British Columbia were based on their own preconceptions of the province (Brown 1979, 3).

Location production dates from the earliest days of cinema. Films of the period were subject-driven, and when subject matter demanded, film production companies travelled with their cameras to shoot "found events." As early as 1897, Niagara Falls attracted filmmakers from France and the United States. In 1899, filmmakers representing the Edison Company and the American Mutoscope and Biograph Company of New York filmed Canadian troops training and departing for the Boer War (Morris 1978, 244-5). Edison licensed the Klondike Exposition Company in 1899, sending Thomas Crahan and Robert Kates Bonine into the Yukon gold fields to shoot three movies

(Musser 1991, 144-5). In 1901, James White, head of Edison's Kinetograph department, shot two films for the Canadian Pacific Railway in British Columbia (191-2).

The first filmmakers to photograph British Columbia came from the United States and Great Britain. G.W. (Billy) Bitzer, who later achieved fame as the cameraman for D.W. Griffith (see Bitzer 1973), made at least six short films for the American Mutoscope and Biograph Company, beginning in 1899. Browne (1992, 174-5) points out that in being shot by an American for US audiences, these films anticipated later developments in BC cinema.

British filmmaker Charles Urban established the Bioscope Company of Canada to make films for the Canadian Pacific Railway, whose commercial viability depended upon western settlement. Urban's crew travelled from Quebec to Victoria for its *Living Canada* series. Urban released thirty-five of these films in 1903-4, which included travelling shots made along the CPR tracks in the mountains of British Columbia, salmon fishing on the Fraser River, canneries at Steveston, logging activity near Vancouver, and the departure for Japan of the Canadian Pacific steamship *Empress of China* (Morris 1978, 33-6; Browne 1992, 174-5). In 1906, several of these films were re-edited, condensed, and re-released as *Wonders of Canada* (Morris 1978, 35). A member of Urban's film crew, cameraman Joseph Rosenthal, is credited with the first film drama made in Canada: *Hiawatha: The Messiah of the Ojibway*, released by Urban in 1903. Rosenthal made a one-minute drama in British Columbia, *Indians Gambling for Furs – Is It Peace or War?* also released in 1903. Bioscope's work for the CPR led to a contract with the government of British Columbia in June 1908. Urban was hired for the purpose of "making known the advantages and resources of British Columbia to the outside world" (Morris 1978, 36).

From May to July 1914, American ethnographer Edward S. Curtis, the author of a twenty-volume work on North American Aboriginal life, made a full-length motion picture of the Kwakiutl people, shot at Fort Rupert on Vancouver Island. Entitled *In the Land of the Head-Hunters,* Curtis's film was screened later that year in Seattle and New York City (Holm and Quimby 1980).[1]

When it came to the production of dramatic films, particularly, Browne (1979, 5) maintains British Columbia could best be described as a "good set." He writes: "Predictably, stories set in British Columbia were about lumberjacks, Mounties, or the CPR (preferably all three), the interpretation of which

Cinema As a Medium of Regional Industrial Development

most Canadians felt should be treated with more reverence than British or American studios were willing to manifest." Between 1907 and 1974, US film companies made 575 films with plots set entirely or principally in Canada (Berton 1975, 16). Hollywood films shot in British Columbia included: *The Man in the Moonlight,* by Universal Pictures, in 1919; *Winds of Chance,* by First National Pictures, in 1925; *The Flaming Forest,* by Cosmopolitan Productions, in 1926; *Canadian Pacific,* by Twentieth Century-Fox, in 1949; and *The Cariboo Trail,* by Twentieth Century-Fox, in 1950 (Berton 1975, 254-68; Browne 1979, 21).[2]

One of the more interesting stories in British Columbia's film history involves the shooting of the Columbia Pictures feature *Commandos Strike at Dawn,* directed by John Farrow on Vancouver Island during the summer of 1942. The film is the fictional account of a raid by British commandos on a seaside village in Nazi-occupied Norway, and features Paul Muni and Lillian Gish in lead roles. But the lesser-known stars of the film are the Canadian soldiers training at Camp Nanaimo – the Royal Rifles of Canada, the Sault Ste. Marie and Sudbury Regiments, the Canadian Scottish Regiment, and the 114th Veterans' Guard – who played the soldiers in the film, as well as the Royal Canadian Navy vessel *Prince David,* which appeared as the raiding warship. Most of the location shooting took place at Finlayson Arm, and the cast stayed at the regal Empress Hotel. Historian J.M.S. Careless (1980, 12-13) recounts one episode in which Alexander Knox, late for the bus taking actors to the set, "stamped briskly through the lobby in Nazi officer's uniform and Iron Cross, followed by jack-booted soldiers of the *Wehrmacht* – and nearly caused heart attacks among the old ladies of the Empress in the shrubbery. No one had told them that the Germans had got *this* far."

The film was intended to be released sometime in 1943, but in the wake of the disastrous Dieppe Raid in August 1942 – a raid that resembled Columbia Pictures' commando raid in all but its outcome – the studio rushed *Commandos Strike at Dawn* into distribution in late 1942 to maximize its propaganda value on the home front. The warship *Prince David* was later converted into a heavy landing ship and participated in the Normandy invasion in June 1944. Among the Canadian troops the ship delivered to Juno Beach that day was the same Canadian Scottish Regiment from the film shoot on Vancouver Island two years earlier (Careless 1980, 9-16).

Early attempts to establish a feature film industry based in British Columbia consistently failed, usually because of a lack of capital. New York

producer John Arthur Nelson, for example, incorporated Dominion Films Corporation Ltd. in February 1917, but couldn't raise enough money to move into production. Companies with names like Canadian Historic Features Ltd., British Canadian Pictures Ltd., Lion's Gate Cinema Studios, and British-American Films Ltd. were founded in the 1920s, but just as quickly disappeared without leaving a trace of film (Browne 1979, 19-20).[3]

A.D. (Cowboy) Kean did manage to make some films, but ·became increasingly frustrated in his attempts to obtain adequate distribution and exhibition for his films. As his nickname suggests, Kean had been a working cowboy before he began making films in 1912. Throughout his correspondence, Kean complains of being obstructed by US film companies who were then in the process of establishing their dominance in the Canadian distribution and exhibition markets. Kean's initial grievance was that the "monopolistic operations" of the American Motion Picture Patents Company and its film exchange, the General Film Company, refused to sell him a movie camera. He finally managed to purchase a British camera (Duffy and Mattison 1989, 29).

Kean shot newsreels and films about rodeos, First World War recruiting efforts, and British Columbia wildlife. These films enjoyed limited release in Victoria and Vancouver theatres. In 1916, Kean made *Whaling: B.C.'s Least Known and Most Romantic Industry,* a documentary filmed at the Kyuquot station of the Victoria Whaling Company on the west coast of Vancouver Island: "In it Kean presented the grisly spectacle of a whale hunt: the chase, the harpooning, the whale's frantic struggle as it fights to escape; the ship towing the inflated carcass back to the whaling station; the flensing operation performed by Japanese labourers and a steam winch, and a hellish scene of workers tending steaming vats of blubber. The film poignantly ends with a native Indian, described as an old-time whaler, 'talking' to the camera, expressing his amazement at the white man's efficiency" (Duffy and Mattison 1989, 29-31; see also Browne 1979, 347). Kean also shot actuality films for the province's Game Conservation Board and the British Columbia Patriotic and Educational Picture Service in the early 1920s.

Kean made his first dramatic feature, *Told in the Hills,* in 1917, shooting scenes at the Penticton and Princeton rodeos in September of that year. It was shown only once (Morris 1978, 294). Kean's second feature film proved to be his most ambitious project and, sadly, his swan song. The historical epic *Policing the Plains* was based on a popular history of the North West

Cinema As a Medium of Regional Industrial Development

Mounted Police published by the Rev. R.G. MacBeth in 1922. Kean obtained the motion picture rights from MacBeth for $5,000 in January 1924, then established a syndicate of more than forty investors who agreed to finance a six-reel film, budgeted at $40,000. Before the film was completed, three years later, Kean ran short of money several times and was forced to postpone production. The finished, eight-reel film cost more than $125,000 to produce (Duffy and Mattison 1989, 31-8).[4]

Filmed on location in Vancouver and Green Lake, British Columbia, and Banff, Fort Macleod, Standoff, and Wainwright, Alberta, and completed at the Ontario Government Motion Picture Bureau's Trenton studios, *Policing the Plains* played at Toronto's Royal Alexandra Theatre for just six days, from 19 to 24 December 1927. The Toronto screening proved to be the film's only booking, and Kean blamed the American distribution chains for obstructing its further release. In 1928, Kean left the movie business for a much more successful career as a freelance writer and radio broadcaster in Toronto (Duffy and Mattison 1989, 34-9; Browne 1979, 229-30). Peter Morris (1978, 91) argues that the delayed and modest release of *Policing the Plains* "was the last testament of Canada's still-born feature film industry." The promise of producing a viable film industry in the postwar period had faded: "Investors had been burnt too often, the brief flurry of nationalism in film production died down and Canada increasingly turned to Hollywood films with Canadian plots as a substitute for the – obviously – doomed domestic production. Hollywood responded magnificently."

When the Canadian government established a federal inquiry in 1930 to examine alleged combine activity by the Hollywood film companies operating in Canada, Kean was one of those who testified. While it is difficult to weigh the merits of Kean's particular complaints, the federal inquiry under commissioner Peter White indeed concluded that a combine of exhibitors, producers, and distributors had existed in Canada since at least 1926 (Canada 1931).

The most vibrant period of filmmaking in British Columbia, before the present, occurred as a result of Britain's Cinematograph Films Act of December 1927, which reserved a percentage of screen time in British movie theatres – beginning at 5 percent, gradually climbing to 20 percent – for films made within the British Empire. As early as 1925 rumours of a British quota were circulating, and business people and municipal politicians in Victoria and Vancouver were eager to promote British Columbia as the film capital of the Empire (Browne 1979, 21, 69).[5] However, American producers turned out to

be just as eager to exploit the British quota law by shooting their films on Canadian soil.

In 1927, Nils Olaf Crisander, head of the National Cinema Studios Syndicate of Hollywood, announced plans to construct a $750,000 studio on Vancouver's North Shore to supply the British quota market. He bought some property for that purpose, but was unable to raise enough capital and his company was neither incorporated nor registered. Hollywood producer Samuel Bischoff registered British Canadian Pictures Ltd. in June 1928. Bischoff had an agreement with the Gaumont Company of England to supply them with six features starring the German shepherd dog Silverstreak, but the company never made a Silverstreak movie in Canada (Browne 1979, 19-21).

Where others failed, Kenneth James Bishop succeeded – for a time. Bishop arrived from California in 1932, leased the main show building from the BC Agricultural Association at Willows Park in Oak Bay, and converted it into a film studio. The first two companies Bishop formed went into receivership: Commonwealth Productions Ltd., which released *The Crimson Paradise* in 1933, and Northern Films Ltd., which released *Secrets of Chinatown* in 1935.[6] But in 1935, Bishop convinced Columbia Pictures to produce films in British Columbia for the British quota market. Bishop's new company, Central Films Ltd., made twelve "quota quickies" over the next two years, using Hollywood directors, stars, and technical personnel, and a few local actors. Among the Central Films productions were: *Tugboat Princess* (1935-6), *Secret Patrol* (1936), *Lucky Corrigan* (1936), *Death Goes North* (1937), and *Across the Border* (1937) (Browne 1979, 25-7).

The success of Central Films was short-lived, however, because it exposed the abuses of the British quota legislation, which allowed US-produced films to be screened as Empire products. Browne (1979) argues that the kind of films produced by Columbia in Victoria had a direct impact on the decision to revise the act in 1938 and disqualify films made outside Britain. The Central Films studios were demolished in April 1939 (28).

For Peter Morris (1978, 194), the quota quickies mark an opportunity lost for Canadian cinema: "In terms of developing a domestic film industry Central Films and its sister companies contributed absolutely nothing. Indeed ... its effect was exactly the reverse. Being totally dependent on a set of circumstances beyond domestic control and operable only at the whim of a New York or Hollywood distributor, the effort sapped the drive of those Canadians who might have been able to take advantage of the positive possibilities

Cinema As a Medium of Regional Industrial Development

the British quota law offered to Canadian production." Colin Browne (1979, 6), however, situates the quota films within the context of British Columbia's dependence on the American film industry: "Why British Columbia essentially bit the hand that Britain extended may be more understandable in view of the province's relations with the movie industry throughout its history. It is a story of foreign domination and the quota legislation ... was only one of the beckoning fingers that led to broken dreams."

Dennis Duffy (1986, 22-3) describes the period between 1940 and 1965 as a general slump for feature filmmaking in British Columbia, characterized by "brief periods of promising activity in the 1940s and a few isolated productions in the 1960s." If the Second World War was the catalyst for anti-Nazi propaganda film production in the 1940s – *Commandos Strike at Dawn* is one example – British Columbia's popularity as a film location waned in the aftermath of war. Universal shot *Johnny Stool Pigeon* and Twentieth Century-Fox shot *Canadian Pacific* in 1949, and Republic Pictures shot *Timberjack* in the province in 1954. But British Columbia had to wait another decade for the next British or American picture. Robert Altman shot – and set – *That Cold Day in the Park* in Vancouver in 1969 and returned to film *McCabe and Mrs. Miller* in 1970. Bob Rafelson shot portions of *Five Easy Pieces* on the Gulf Islands in 1969, and Mike Nichols shot *Carnal Knowledge* on location in British Columbia in 1971 (Duffy 1986, 23-4, 34).

Alberta, however, began to replace British Columbia as a Hollywood film location in the early 1970s. Prompted by the shooting of the Arthur Penn film *Little Big Man* west of Calgary in 1969, Alberta became one of the first jurisdictions in North America to establish a film commission when it opened an office in 1972 (Kupecek 1993). Alberta subsequently established the Alberta Motion Picture Industries Association in November 1973, putting in place the kind of liaison network that British Columbia could not provide, which had been a source of complaint among Hollywood producers shooting in the province (see Wasserman 1976).

VICTORIA AS PRODUCER

Governments have played a central role in shaping British Columbia's film culture since at least 1908. The provincial government in Victoria acted first as a producer of films and a regulator of the exhibition sector, but in more recent years it has turned its attention to promoting a feature film industry in the province through the efforts of the BC Film Commission and British

Columbia Film. The federal government, while not as fully committed to regional film production as many would like, has nevertheless played a part in British Columbia's film history through the regional presence of the National Film Board and the Canadian Broadcasting Corporation, and through the investment provided by Telefilm Canada (originally the Canadian Film Development Corporation).

Victoria's initial foray into film production came in the summer of 1908 when the government hired British cameraman James Ferens to record the province's industries and scenery. Ferens shot footage of the Hastings Sawmill, lumber being loaded onto ships, Vancouver street scenes, fish canning on the Fraser River, panoramic views of the Fraser Valley, and early orchard plantings in the valleys of the Interior (Browne 1979, 9). The London office of the agent-general for British Columbia instituted a lecture program illustrated with motion pictures and lantern slides in 1909. It is not known whether the films used were those shot by Ferens the year before, but according to J.H. Turner, one of the lecturers: "These animated pictures are proving to be most valuable; they so perfectly show the life and work of our Province, and, no doubt, they have been one of the causes for the increased correspondence and number of callers at the Office." The 1909 annual report of the Office of the Agent-General for British Columbia contains a request to Victoria for more films (Agent-General 1909, G41-4). By 1910, films of British Columbia were being shown at agricultural and horticultural shows throughout Britain and being loaned to itinerant lecturers by the agent-general's office in London (Agent-General 1910, H33-5). British Columbia's Bureau of Provincial Information also began to use motion pictures for publicity purposes in 1910 (BC Bureau 1911, M33-5). In September and October 1913, Arthur H.C. Sintzenich of Charles Urban's Natural Colour Kinematograph Co. in London travelled throughout the province for British Columbia's Department of Lands, shooting forests, sawmills, ranches, fruit farms, and travelogues of Victoria (Browne 1979, 9).

An amendment to the Moving Pictures Act in 1920 created the British Columbia Patriotic and Educational Picture Service under the Department of the Attorney-General and introduced a quota provision that required British Columbia movie theatres to introduce each film program with fifteen minutes of films either produced by, or approved by, the Picture Service. The amendment further stipulated the *kinds* of films the Picture Service was to provide: "films and slides of a patriotic, instructive, educative, or

Cinema As a Medium of Regional Industrial Development

entertaining nature; and in particular, without limiting the generality of the foregoing, films and slides depicting the natural, industrial, agricultural, or commercial resources, wealth, activities, development, and possibilities of the Dominion, and especially of the Province; or which may tend to inform or educate the public as to Imperial, Federal, or Provincial public events, and the men and women of note connected therewith" (*BC Statutes* 1920, 577-9). The BC Picture Service was "the first government film unit in North America with statutory authority to compel the screening of its productions" (Duffy and Mattison 1989, 32).

At one point, the Picture Service had more than 100 titles in circulation. Duffy (1986, 3) argues: "This represents the earliest substantial commitment to film production of any of the provincial governments of Canada." Little is known about specific agency productions – the only government-initiated film to have survived is a 1926 travelogue entitled *Beautiful Ocean Falls*, believed to have been shot by A.D. Kean – but what remains on the historical record is the considerable opposition the quota provision provoked. It was a topic of public debate during the 1920 provincial election, and by 1924 funding for the Picture Service had dried up and the fifteen-minute screen quota was no longer enforced (Browne 1979, 14-15; see also British Columbia 1924, 15).[7]

The introduction of 16 mm film stock in the 1920s rendered film a more accessible medium, and several provincial government departments initiated film production programs. The most enthusiastic was the Forest Branch of the Department of Lands, which used films for publicity and fire-safety education as early as 1920 (BC Lands 1921). In 1924, for example, motion pictures were used to illustrate lectures during "Save the Forest Week." The annual report of the Forest Branch for 1924 states: "Moving-picture theatres exhibited forest-protection slides and the film 'Red Enemy,' and also offered the use of their theatres for forest-protection lectures" (BC Lands 1925). In 1925, British Columbia movie theatres used trailers "embodying 'The care with fire in the woods lesson'" from May to September (BC Lands 1926).

The department, later named the Forest Service, remained active in film production through the 1970s. In 1973, for example, the library of the Forest Service made 2,470 film loans to schools in the province (BCLFW 1974, S42). In addition to general industry publicity and fire-prevention messages, by the 1970s the Forest Service was using film for propaganda purposes to combat growing criticism of its practices.[8] Its 1971 annual report notes: "Mounting

public concern over forest-land uses throughout 1971 resulted in a more concentrated effort by the Forest Service to 'tell its side of the story.'" That year, the Forest Service began production on a series of reforestation films entitled *Trees Unlimited* (BCLFW 1972, V42).

The Department of Agriculture also became active in film production in the 1920s with the encouragement of Premier Simon Fraser Tolmie (1928-33), who had a personal interest in agricultural education and improvement. By 1949, the Department of Agriculture owned five projectors and its field representative was authorized to obtain films from the National Film Board and the University of British Columbia, as well as the department's own library (British Columbia 1949, 18). The BC Bureau of Industrial and Tourist Development, the Physical Education Branch of the Department of Education, and the provincial Game Commission also instituted film programs in the 1920s and 1930s (Browne 1979, 17-18; Mattison 1986a, 95-6).

The British Columbia government established in-house production in 1937 when Clarence Ferris and Dick Colby toured the province with 16 mm cameras, making travelogues for the Bureau of Industrial and Tourist Development (Browne 1979, 18-19). In 1938, this bureau moved to the Department of Trade and Industry and became the British Columbia Government Travel Bureau. While the bureau's principal duty was to promote tourism – then estimated to be a $30 million industry – it was also required to "induce settlement and general development" in the province (BC Trade 1939, FF23). In 1939, the bureau added to its library films depicting a tour of British lumbermen, sport fishing, skiing, and "scenic features" of the province. The bureau organized film and lecture tours of the Prairie provinces and commissioned the Vancouver company Travel Films to make "several films in colour depicting attractions of various districts" (BC Trade 1939, FF20). Browne (1979, 18-19) notes that wartime prosperity further encouraged the Travel Bureau, and by 1952, thirty-one films in the Travel Bureau's catalogue were its own productions.

The Travel Bureau's film program enjoyed a boost in 1941 when a film called *Beautiful British Columbia,* produced for the bureau under contract by Leon C. Shelly, was released theatrically by Columbia Pictures and Warner Bros., and its narration was translated into Spanish for screening in Latin America. The bureau's annual report states: "The success achieved by this picture induced the Bureau to make arrangements for production of another similar picture, which will feature hunting, fishing, and other recreational

and outdoor features." The Travel Bureau had by this time developed its own production studio and projection room (BC Trade 1941, Q24). The following year, the Travel Bureau's newest theatrical feature, *Evergreen Playground,* was released by Twentieth Century-Fox (BC Trade 1942, M24).

In April 1957, the Photographic Branch of the Travel Bureau was transferred to the newly created Department of Recreation and Conservation, for whom it produced films about government campsites, sport fishing, highway construction, big-game species, and Haida totem poles. The Photographic Branch also made travelogues about the province's various tourist regions, as well as educational films about the BC ferry service, the BC International Trade Fair, firearm safety, waterfowl conservation and "the importance of the white centre line on the highway." In 1967, both the Photographic Branch and the BC Government Travel Bureau were moved to the Department of Travel Industry, "reaffirming the branch's primary commitment to tourist promotion" (Duffy 1986, 6). What had come to be called the Film and Photographic Branch remained the responsibility of the tourism ministry until 1984, when it was closed. Dennis Duffy (1986, 8) notes that the BC government accounted for a "significant portion" of all film production between 1941 and 1965. In 1984, all of the provincial government's film production units, with the exception of that of the Ministry of Agriculture and Food, were merged within Government Information Services.

Admittedly, the topics of government-produced films seem terribly mundane and unlikely to be of interest to very many people. Yet many of these films enjoyed wide circulation – greater circulation, in fact, than many of the commercial features produced in British Columbia today – and a few won awards of excellence for films of their genre. By the mid-1940s, Photographic Branch films were already being screened for audiences totalling more than 100,000, and by the mid-1960s these films were reaching total audiences of between 1.5 and 2 million, not including television audiences (BC Recreation 1967; BC Travel 1968). BC government films were regularly distributed by the Canadian Government Travel Bureau's film library, the offices of the National Film Board, the Bell Telephone Co., British Columbia Hydro, and through British Columbia House in London, San Francisco, and Los Angeles. As mentioned above, these films were also occasionally distributed theatrically by major Hollywood film companies. Both the Odeon and Famous Players theatre chains in Canada screened Forest Service films as trailers in the summers of 1956 through 1959 (BCLF 1957, 1958, 1959, 1960).

Beginning in 1948, a selection of BC government films was televised. Station WRBC in Birmingham, Alabama, for example, telecast fourteen Travel Bureau films in 1949 (BC Trade 1950, DD59). The CBC network broadcast the Forest Service film *Flying Surveyors* in 1953 (BCLF 1954, 109) and the Photographic Branch's sport-fishing film *Tight Lines* in November 1959 (BC Recreation 1960, Y55). By 1965, the Photographic Branch reported 500 screenings of its films on American television (BC Recreation 1966, Y66). The Branch had a veritable blockbuster on its hands in 1969, however, when a reported 56 million viewers saw a dubbed version of *Ski B.C.* on Japanese television (BC Travel 1970, H61).

Between 1957 and 1974, five Photographic Branch productions won awards. *The Road Home* won first prize for sociological films at the Kootenay International Film Festival in 1957 (BC Recreation 1958, II43). *Men, Mountains and the Challenge* was chosen best industrial film at the Kelowna Centennial Film Festival in 1958 and won a citation as "the most distinguished contribution to publicity for good roads across the nation" from the Canadian Good Roads Association (BC Recreation 1959, Q56). Two films, *The Silent Ones* and *Fraser Canyon,* won unspecified awards at the 1961 Vancouver International Film Festival (BC Recreation 1962, V65), and *'Ksan,* a documentary on the rebirth of Gitksan culture near Hazelton, won an award at the Annual Industrial Photography Film Awards in New York in 1974 (BC Travel 1975, H50-2). The BC Forest Service film *Axe Facts* won two awards in 1969; it was selected best training film by the Canadian Forestry Association and won an award of distinction at the International Festival of Forest Fire Control Films (BC LFW 1970, 27).

Undoubtedly, however, the most distinguished provincial government production was the ten-minute film entitled *The Theatre of the Antipodes,* which played forty-five times daily in the BC Pavilion at Expo '70 in Osaka, Japan. The film was projected on a vertical screen measuring 12.8 metres high and 4.3 metres wide. It employed both full-screen and split-screen sequences, and intermittently highlighted objects suspended both in front of, and behind, the screen (BC Development 1970, Y21-2).

PROVINCE AS REGULATOR

While the provincial government grasped early the power of cinema and was keen to exploit the medium to promote immigration, industrial development, and tourism, it was also wary of that same power when it came to

the commercial cinema. British Columbia was the first province to invoke film censorship (Morris 1978, 149). Malcolm Dean (1981, 6) notes that "film arrived in Canada in a climate where freedom of the press and freedom of expression were not clearly established, and where the new visual media were viewed not as serious arts, but as vehicles for sensationalism." As early as 1911 there was pressure on the BC government to regulate the commercial cinema, given that all of the films came from the United States. Colin Browne (1979, 10-11) writes: "Consequently, reformers, legislators, and countless clergymen expressed concern about the purely American vision being stuffed down eager Canadian gullets."

The British Columbia Moving Pictures Act, adopted in June 1913, established a provincial censor, who "created what quickly came to be known as the most rigid motion picture censorship on the continent ... By October, 1913, regular complaints were being received from the United States regarding rejection of films displaying the Stars and Stripes" (Browne 1979, 11). In 1914, the BC censor banned fifty film reels for their display of US flags; only infidelity and seduction were more frequently cited by the censors (Morris 1978, 55). British Columbia passed a new Theatres Act in 1914 that added restrictions and penalties, and gave the censor greater power over the seizure of films. The government began licensing theatres, which were not allowed to open on Sundays (Dean 1981, 116).

Even though motion picture exhibition was beyond Ottawa's jurisdiction, the federal government also expressed interest in film censorship. In 1924, W.J. Egan, deputy minister of the federal Department of Immigration and Colonization, wrote to BC Minister of Finance John Hart seeking his cooperation in a scheme to ban films that gave an "unfavourable impression" of Canada. In a letter dated 12 January, Egan explained that Ottawa, the CPR, and the Crown corporation Canadian National Railways were working together to promote the immigration of "desirable classes of settlers into Canada," but that their efforts were being thwarted by motion pictures that were creating "wrong impressions concerning Canadian life and conditions." Egan explained: "Many of the representations of Canada which are made on the screen are grotesque and damaging in the extreme, while as a matter of fact a portrayal of actual conditions would be of greater value to the picture house itself." Egan proposed that provincial censors be asked to "lay down as a principle that any motion picture film which given an unfavourable representation of Canadian life or conditions in Canada, or a representation

likely to mislead the audience as to the attractiveness of Canada as a field for settlement and investment, should be denied the privilege of exhibition in this country" (BCARS, GR 1323, file M-283, microfilm B2210). There is no record of British Columbia taking any such action.

As times changed, so did the activities of the provincial censor: "When economic conditions in the 1930s shook traditional beliefs in the free-market economy, the censors kept a beady eye out for newsreels or features which might put forth a sympathetic view of the trade union movement, or of other 'seditious political philosophies'" (Dean 1981, 119). Two films deemed seditious and banned by the BC censor in 1929 were Sergei Eisenstein's *Battleship Potemkin* and *October*.

It was not until 1970 that a new Motion Pictures Act replaced the term "censorship" with "classification." Speaking to the amendment in the BC Legislative Assembly, Attorney-General and Minister of Labour Leslie R. Peterson explained: "The main thrust of the Bill is moving from the concept of censorship to the idea of classification of films, but still giving to this office the responsibility of rejecting films for showing to the public. That has not been removed in its entirety" (British Columbia 1970, 626). The amendment, however, did nothing to prevent the nearby American border town of Blaine, Washington, from making its reputation in the 1970s as the place to see such uncensored hard-core features as *Deep Throat* and *The Devil in Miss Jones* (Dean 1981, 119-20).

The issue of the American presence on Canadian cinema screens was raised again in 1930. During the 1920s, the Canadian affiliates of the major American studios created an association that came to be called the Motion Picture Distributors and Exhibitors of Canada. This consortium, which included the vertically integrated distributor Paramount Pictures and exhibitor Famous Players, awarded exclusive exhibition rights to its members' films to Famous Players, squeezing out the rival Allen theatre chain. By 1929, having bought the Allen chain and nine others, Famous Players controlled 207 of the 299 theatres belonging to chains (Canada 1931).

In 1930, federal Minister of Labour G.D. Robertson ordered an inquiry under the Combines Investigation Act. Commissioner Peter White concluded that a combine had existed since at least 1926, comprising Famous Players and the distributors Paramount, Universal, Fox, Columbia, RKO, and First National (Canada 1985, 42-3). The case was prosecuted in Ontario in 1932, where it was thought to have the best chance of success, but Ontario Supreme

Cinema As a Medium of Regional Industrial Development

Court Justice Garrow cleared the accused of all charges. Famous Players and the distributors "were acquitted on the basis that the prosecution could not establish that the alleged combine was detrimental to the public interest" (Pendakur 1990, 90-1). The acquittal was attributed to the limited scope of the Combines Investigation Act itself (Canada 1985, 43; Morris 1978, 311).

The combines investigation and subsequent court proceeding prompted considerable public debate over the kinds of films shown in commercial movie houses in British Columbia. A memo dated 16 October 1930, addressed to Premier Tolmie from the Imperial Order, Daughters of the Empire in British Columbia, requested the revival of the provincial screen quota "so that at least 15 minutes at every show will be given to Canadian Patriotic and Educational subjects, illustrating the products, resources, and scenery of the Province, and that the expense of these as a *matter* of *right* be paid for by the Exhibitors as part of their regular programme" (BCARS, GR 1323, file M-178, microfilm B2326). H.B. Page of Oak Bay advised MLA J.H. Beatty on 17 April 1931 of the formation of a local film group, "an informal association of Canadian citizens who are dissatisfied with the present conditions of foreign monopoly and commercial exploitation of Canadian screens, and who desire to see the art of the motion picture used constructively to raise the standards of our national life." One of the five specific objectives of the group was: "To encourage genuine Canadian film production, free from foreign influence" (ibid.).

Other participants in the debate had a material interest in local film production. A newsletter from British Picture Producers Ltd. of Victoria, published in July-August 1930, contained an implicit endorsement from an unidentified author for the development of a local industry: "There are some who consider that a studio on this coast ... would be in a position to make great film spectacles of historical and foreign subjects, in an attempt to 'out-Hollywood' Hollywood. I do not agree with this attitude. It is a principle of business management to use one's resources to best advantage. Why should we in Victoria, for instance, create elaborate settings of the Australian bush or the Pacific Islands, when an Australian company could use the genuine locations? – or build ruined castles such as lie within easy reach of Elstree?" (BCARS, GR 1323, file M-178, microfilm B2326). In a letter dated 22 July 1931, the manager of a Victoria theatre endorsed the conclusions of the White Report and urged BC Attorney-General Robert H. Pooley to proceed with legal action against the American film monopoly: "They have ruined scores of small theatre owners, including myself" (ibid.).

But opinion was divided. An editorial in the *Victoria Times* on 8 July 1931 endorsed the principle of laissez-faire capitalism: "As far as the quality of the motion picture product in Canada is concerned, whether we have a combine or not makes no difference. This is determined absolutely by the public, subject to provincial censorships which are supposed to protect the public morals by banning indecent or otherwise undesirable films. A motion picture is a commodity which survives or falls on its merits. It will not succeed because it is British, Canadian, American, German or Zanzibarian ... The idea that government regulation can determine the taste of the public in respect of picture films is stupid beyond childishness" (BCARS, GR 1323, file M-178, microfilm B2326).

In the aftermath of the combine investigation and court proceeding, Pooley announced he would look into the imposition of film exhibition quotas. As early as 4 December 1929, Pooley had written to BC censor Joseph Walters, stating: "In spite of what Col. Cooper [John A. Cooper, president of the Motion Picture Distributors and Exhibitors of Canada] would suggest, we in British Columbia want clean pictures and as many British pictures as possible" (BCARS, GR 1323, file M-178, microfilm B2326). An April 1932 amendment to the BC Moving Pictures Act granted the lieutenant governor in Council special authority to regulate a quota for films "of British manufacture and origin," an authority that remained on the statutes until 1971, but was never implemented (Browne 1979, 23-4).

By 1937, the province's concern with the exhibition of motion pictures had more to do with how theatres were operated than with what kind of films they showed. In January 1937, J.M. Coady was appointed head of a provincial royal commission under the Public Inquiries Act to examine regulations governing motion picture projectors and projectionists. In essence, the commission was concerned with fire safety regulations and the working conditions of film projectionists (see British Columbia 1937).

DEFINING THE MEDIUM

Through its interventions as a film producer and industry regulator, the government of British Columbia played a central role in establishing particular film practices and in defining what cinema in the province was to be. As a result of Victoria's early sponsorship of film production, "various provincial governments have recognized the promotional and educational possibilities of film both for attracting settlers, manufacturers, and visitors to the

Cinema As a Medium of Regional Industrial Development

province and for instilling in the population a strong moral character, pride in country, and respect for environment, especially the dense forests that were vulnerable to fire" (Mattison 1986a, 79-80). Dennis Duffy (1986, 30) argues that because of Victoria's intervention, "The filmed image of the province has always been mediated primarily by the twin concerns of industry and tourism."

The British Columbia Government Travel Bureau was foremost among provincial production units in realizing the promotional and educational possibilities of film. It achieved the longest period of continuous production of any provincial government film unit, over forty years (Mattison 1986a, 80). The creation of the Travel Bureau can be traced to a Depression-era movement by business leaders, community service groups, and municipal politicians to promote tourism as a "Back to Prosperity" ticket in British Columbia. Norman W. Whittaker, the MLA representing Saanich in T. Dufferin Pattullo's Liberal government, submitted a brief on the tourism industry to the government in January 1935. The following year, the Pattullo government responded to the initiative by proposing a new Department of Trade and Industry "to attract visitors through advertising and general publicity." The 1937 statute creating the new department included three separate bureaus. One of them was the Bureau of Industrial and Tourist Development, which incorporated the former Bureau of Provincial Information. In 1938, an amendment to the Department of Trade and Industry Act renamed the Bureau of Industrial and Tourist Development the BC Government Travel Bureau and assigned the bureau "to assemble, classify, and distribute information and conduct general publicity and advertising" (Mattison 1986a, 80-1). Travel Bureau productions included *Beautiful British Columbia* and *Evergreen Playground,* already discussed above, as well as the travelogue *North of the Border* (1938); *All-Sooke Day* (1940), about Sooke's community festival; *Dollars and Sense* (1941), which describes manufacturing in British Columbia; and the travelogue *Vancouver Island: British Columbia's Island Playground* (1942) (Mattison 1986a, 85-6; Browne 1979, 217).

The Travel Bureau also assumed the task of promoting British Columbia as a location for foreign films in 1942, when Columbia Pictures arrived in Victoria to shoot *Commandos Strike at Dawn.* While not directly involved in the production, the Travel Bureau produced an illustrated folder containing congratulatory messages for the film's principals from Commodore W.J.R. Beech, commanding officer of the Royal Canadian Navy's Pacific Coast

fleet; Major-General G.R. Pearkes of Pacific Command; Air Vice-Marshall L.F. Stevenson of the Royal Canadian Air Force's Western Air Command; Lieutenant-Governor W.C. Woodward; and Premier John Hart (BC Travel Bureau 1942). This pamphlet was issued to moviegoers on the US west coast (Mattison 1986a, 86-7).

The private sector also played a role in producing promotional films. In fact, the Canadian Pacific Railway must be regarded as a pioneer in exploiting film to promote tourism and settlement throughout western Canada, two activities in which it had a direct, material interest. The CPR sponsored a tour of Britain by independent Manitoba filmmaker James Freer in 1898-9 to promote Canadian immigration (Morris 1978, 30-2, 128). In 1910, the CPR hired a dramatic troupe from the Edison Manufacturing Co., asking them to travel across Canada "developing fictional shorts which would glorify the new land and the opportunities for love and success it promised." Browne (1979, 9) writes: "Certainly no other company in Canada, or perhaps the world, realized the potential of film in selling its product as quickly and surely as the CPR."

Elsewhere, Browne (1989, 29) argues that the CPR publicity machine turned Canada – and, by extension, British Columbia – into a commodity to be purchased, and that the CPR-sponsored films addressed those viewers who saw their films as potential customers: "There is enough evidence to suggest that the pre-Great War commodity called Canada was almost single-handedly invented by the maps, pamphlets, posters, photographs, paintings, motion pictures, and other image-rich promotional paraphernalia of the CPR – with the grateful blessing of the Dominion government. In this way, the CPR provided a young, untried nation with an accessible image." The subject of the films produced by the CPR in British Columbia "is not the realist construction of BC mountain landscape through photographic representation, but rather the construction of the viewing subject, a potential tourist and money spender" (Browne 1989, 30).

The institutional film production of the provincial government and the Canadian Pacific Railway established patterns of film practice that would persist. Even later films made by British Columbians themselves continued to serve promotional ends, even if the filmmakers tried to frame them as educational (Browne 1992, 175). The shortcomings apparent in many of these early films can be explained by "a degree of creative restraint" imposed by industrial or government sponsorship (Duffy 1986, 32-3).

Cinema As a Medium of Regional Industrial Development

These films also contributed to the early development of a particular film practice in British Columbia: "The early Mutoscope, Edison, and other phantom ride reels are of interest to us because they more or less define film practice as it has developed in British Columbia since the turn of the century. We have not, in general, been a feature filmmaking society, or a culture of question-askers, muckrakers, or myth-makers. With the exception of a hardy and significant few, the film industry in BC has for all intents and purposes been government- and/or corporate-sponsored" (Browne 1989, 31). A key dimension of the image of British Columbia established in these films is its malleability. Mattison (1986b, 20) cites the example of Travel Bureau films: "The provincial government over the years refined through travelogues the image of British Columbia to fit the perceptions of tourists seeking both relaxation and self-fulfillment. As one advertising agency writer put it, 'We can be whatever anyone wants us to be.'" As will be discussed in Chapter 5, this credo has been adopted almost word-for-word by the BC Film Commission to promote the use of British Columbia as a location for Hollywood films.

CINEMA AS INDUSTRY

From the outset, then, the history of film production in the province has been informed by the frequent presence of foreign producers using British Columbia locations and by an active provincial government interested in employing film to promote immigration, industrial development, tourism, and public education. Specifically, the British Columbia film industry today shares three characteristics with the province's pre-1970s cinema. First, it is driven by foreign location production, which accounts for between two-thirds and three-quarters of its annual direct spending. Second, it is an industry largely created and sustained by the promotional efforts of the provincial government through Crown institutions, namely the BC Film Commission and British Columbia Film. Third, the provincial government's purpose in promoting film production in British Columbia remains industrial rather than cultural: Victoria promotes foreign-location production for the capital it attracts and for the employment and publicity it generates.

Although cinema in British Columbia has historically been regarded as a promotional appendage for its traditional resource industries of forestry, fishing, mining, and agriculture, cinema has become over the past twenty-five years an industry in and of itself. Further, it shares many of the attributes

of the province's other resource industries. The film industry in British Columbia is highly dependent on foreign investment, and it is responsible primarily for the supply of raw materials – in this case, labour and scenery – to out-of-province producers who subsequently manufacture the finished product elsewhere – in this case, feature films. These films are, of course, imported back into Canada where they are consumed with considerable enthusiasm.

3

The Terms of Inclusion: British Columbia within the Political Economy of North American Film Production

The opportunity for British Columbia to become a major feature film production centre in the 1970s arose because Hollywood began to transform its method of film production in the postwar period. The 1948 Paramount Decision, which forced the major Hollywood studios to divest their theatre holdings in the United States, and the emergence of television as a rival medium in the entertainment business, prompted the major studios to abandon the Fordist production methods of the studio system. They came to embrace a production system based on contractual relationships with independent producers who favoured the flexibility and economy of location shooting.[1] Whereas the continental integration of the film industry's distribution and exhibition networks had since the 1920s relegated film producers in Canada to the margins of the commercial cinema, the postwar restructuring of the Hollywood film industry – and particularly the externalization of production – created an opportunity for Canadians to make feature films, provided they were Hollywood films.

Yet if Hollywood's vertical integration has been one of the central explanations for the exclusive structure of the commercial film industry, a second factor that has contributed to the particular formation of the BC film industry is agglomeration. A multifaceted enterprise, film production tends to cluster in urban centres that can provide a pool of skilled labour,

cinema-specific services, and sources of investment. Vancouver's relative proximity to Los Angeles was a structural advantage when Hollywood began to decentralize production – particularly in the 1970s when the exchange rate began to favour Canadian locations – but Vancouver's distance from Montreal and Toronto was a clear disadvantage when an indigenous feature cinema began to develop in the 1960s and 1970s. Montreal and Toronto are Canada's principal financial centres, Montreal is the home of the National Film Board, and the two central Canadian cities are the respective headquarters of the French- and English-language television industries. It was in Montreal and Toronto that Canada's principal film production and distribution companies established their head offices, and where most of the Canadian "studios" that emerged in the 1990s remain.

This chapter positions British Columbia within the political economy of feature film production in North America. It contends that British Columbia's inclusion within transnational Hollywood audiovisual production provided west coast filmmakers with the opportunity to establish a commercial cinema, an opportunity that had been denied British Columbia by the concentration of the Canadian film industry in Ontario and Quebec.

THE STUDIO SYSTEM OF PRODUCTION

From the late 1920s, when the major Hollywood studios were established in southern California, until the late 1940s, the motion picture industry was dominated by large, vertically integrated firms that produced films "via a routinized, factory-like production process." Industrialized production methods were widely accepted by the 1920s, and the studios patterned the film production process "in the image of the assembly line, as in the auto and machinery industries" (Christopherson and Storper 1986, 305-6). Los Angeles was initially a shooting location for independent producers taking advantage of its clement weather, its diverse settings, and California's open-shop labour legislation, which meant labour costs were 25 to 50 percent lower than in New York (Stanley 1978, 43-4; Sklar 1978, 67-8).[2] Permanent studio sets only became necessary with the introduction of sound technology in 1927. As the volume of film production grew, "studios were transformed into large vertically integrated motion picture factories" (Stanley 1978, 43-4). By the late 1920s, Hollywood had become a major employer, with an estimated 12,000 full-time workers and another 150,000 extras on call (Christopherson and Storper 1986, 314).

There were eight "major" Hollywood production companies in the period of the studio system, between (roughly) 1930 and 1948. Warner Bros., RKO Radio Pictures, Twentieth Century-Fox, Paramount, and Loew's (MGM) were the "big five" studios, vertically integrated with distribution and exhibition networks. United Artists, Universal, and Columbia Pictures were the "little three" studios, or "mini-majors." Universal and Columbia owned studios and distribution facilities and supplied the big five with low-cost films. United Artists operated exclusively as a distributor for a select group of independent producers (Balio 1990, 4).[3]

This was a period of movie mass production, characterized by the breaking down of the production process into small components through the division of labour, the direct employment of film workers (including actors), and the standardization of films into two general categories: what came to be known as "classic" Hollywood films, which consisted of a "highly specific type of narrative structure combined with a circumscribed range of cinematic expressions of narrative"; and genre films, such as musicals, westerns, and gangster movies (Cook 1985, 10-11).

Independent producer-director Thomas Ince is credited with being the first to adapt Fordist production techniques to movie making, instituting in 1913 at his five-stage Hollywood studio the factory methods he had seen Henry Ford apply to automobile production earlier that year (Schatz 1983, 40). Films were no longer viewed as products that had to be treated as organic wholes, but could be assembled from component parts: "Ince developed a management-oriented model that strictly separated conception from execution. The vehicle for this production process was the 'continuity script,' which fragmented the story of a motion picture and reordered it so that each bloc of scenes in a set or location could be filmed at the same time or, alternatively, so that a set of actors could film all the scenes in which they were to be involved in a continuous work session" (Storper 1989, 278). Preproduction, production and postproduction were all organized on mass-production principles: "For example, the major studios had permanent staffs of writers and production planners who were assigned to produce formula scripts in volume and push them through the production system. Production crews and stars were assembled in teams charged with making as many as thirty films per year. Studios had large departments to make sets, operate sound stages and film labs, and carry out marketing and distribution. A product would move from department to department in assembly-line fashion"

(278). Warner Bros., for instance, introduced assembly-line production techniques in the early 1930s as a method of maintaining strict control over budgets and production schedules during the Depression, and was able to produce up to sixty films annually (Cook 1985, 11-12).

Each of the studios, of course, put its own stamp on these general production techniques. MGM was reputed to be the most dictatorial in insisting that film workers faithfully follow a blueprint for each film, while Paramount offered filmmakers more leeway (Mast 1986, 232). RKO, on the other hand, deviated from the norm by adopting "unit production" in 1931, "a system whereby independent producers were contracted to make a specific number of films for RKO entirely free from studio supervision, with costs shared by the studio and the producer, and distribution guaranteed by RKO" (Cook 1985, 20). *King Kong* (1933) and *Citizen Kane* (1941) were two films produced in this fashion (Cook 1985, 20-2).

The vertical integration of the big five with distribution and exhibition networks ensured the circulation of their films and raised the barriers to entry for would-be competitors. In 1944, for example, these studios earned 73 percent of domestic theatre rentals and owned or had an interest in 4,424 movie theatres, a quarter of the US total. The "big five" theatres included 70 percent of all first-run theatres in the ninety-two US cities with populations over 100,000 (Christopherson and Storper 1986, 305-7). In almost half of all US markets, one distributor owned all of the theatres.

The movie industry was radically restructured in the aftermath of the Second World War, and antitrust action put an end to the studio system of production. The US Justice Department first filed an antitrust suit against the eight major studios in 1938, "charging them with combination and conspiracy to restrain trade and monopolize interstate trade and commerce in violation of the Sherman Act." In 1940, the government settled for a "consent decree" against Paramount, Loew's (MGM), RKO, Warner Bros., and Twentieth Century-Fox, by which the studios agreed to alter four specific trade practices. They promised to limit "block booking," by which exhibitors were forced to book films in groups, to a maximum of five films; end "blind bidding" by offering at least one trade showing of every film; stop forcing theatres to accept short films as a condition of renting a feature film; and cease acquiring new theatres. However, the government retained the option to reopen the suit if it found the consent decree ineffective, which it did in 1944 (Sklar 1978, 170).

The case of *United States* v. *Paramount Pictures, Inc., et al.* was initially tried in Federal District Court in New York in October 1944. The court ruled that the movie industry's distribution system violated the Sherman Act, but instead of requiring the studios to divest some of their holdings, the court directed the studios to institute a competitive bidding system for all films. The Justice Department appealed the ruling to the US Supreme Court, which in 1948 upheld the lower court's findings, but disagreed with its solution. It asked the lower court to consider breaking up the vertically integrated industry. In July 1949, Circuit Judge Augustus N. Hand ordered the separation of the studios from their exhibition networks, and the big five controlled no theatres by 1954 (Sklar 1978, 272-4). Christopherson and Storper (1986, 308) insist: "This decision eliminated an assured market for films and increased the risks associated with production."

A second, concurrent blow to the studio system was a sudden shift in entertainment from the public to the private sphere, prompted by the arrival of television and the trend to suburbanization. Between 1946 and 1956, cinema audiences declined by 50 percent and more than 4,000 US movie houses closed (Sklar 1978, 274). Christopherson and Storper (1986, 308) explain: "What had been a market dominated by one medium became a segmented market in which different products competed for the consumer's entertainment expenditures." The Hollywood studios responded to this crisis first by reducing the number of films they made, and second by differentiating their products through such innovations as colour, three-dimensional film, and wide-screen formats like Cinerama and CinemaScope (Storper 1989, 279-80; see also Balio 1990; Wasko 1995). Increased attention to individual film "spectaculars" meant increased budgets for talent, marketing, and advertising (Christopherson and Storper 1986, 309). The trend also signalled the end of assembly-line production within the studios: "This strategy of product differentiation increased the need for specialised inputs. The studios began to turn to independent producers to develop these differentiated film products" (Storper 1989, 281).

During the 1950s there was a gradual externalization of both production and preproduction. Term contracts, by which above-the-line personnel signed exclusive deals with a studio for a set period of time (often up to seven years), were replaced by more flexible project contracts. Below-the-line personnel were placed on seniority rosters, and the unions became hiring halls for the studios (Storper 1989, 282).[4] The major studios continued to

dominate film finance and distribution – from 1960 to 1972, for example, the eight major studios accounted for 83 percent of distributors' gross revenues in the United States and Canada – but during the 1960s and 1970s, more and more of their production was assigned to independent producers (Christopherson and Storper 1986, 310).

In 1970, all of the major studios suffered large financial losses, and it became clear that their holdings in studio facilities and property had become liabilities. The studios began to divest themselves of their production facilities – for example, Twentieth Century-Fox sold the land that is now Century City in Los Angeles – and those properties they held became "profit centers" that were "required to support themselves through rentals to independent producers making films with studio financing." The studios also changed their relationship to the nascent television industry by renting their film libraries to the networks and by financing the production of made-for-television movies. By the mid-1970s, the major Hollywood studios were specializing in high-budget theatrical features, leaving television movies and low-budget features to independent production companies (Christopherson and Storper 1986, 310-11).

One result of the studios' transformation since the 1950s was an increase in location shooting: "Initially, vertical disintegration encouraged location shooting as a cost-cutting move on the part of independent production companies, and as a product differentiation strategy in the case of some spectaculars. Location shooting, which is a type of change in production technique, began as a direct consequence of vertical disintegration; like many such practices, it seems to have reinforced itself in circular and cumulative fashion with the result that the studios can no longer control its use" (Storper 1989, 285).

While the breakdown of the studio system was a "push" factor stimulating location production, the postwar debt crisis in Europe was a "pull" factor. In the aftermath of war, European nations could no longer afford to import luxury items like motion pictures – and export their earnings – when the need for more vital commodities was pressing. A common remedy to these states' balance-of-payments problems was to freeze funds; films were allowed entry, but only a portion of their earnings could be withdrawn. In 1948, Great Britain became the first European territory to freeze funds. Britain lifted its 75 percent import duty on motion pictures, but restricted US film companies to withdrawing US$17 million annually over the next two years. France, Italy, and Germany followed suit (Balio 1985, 407). American

production companies concocted elaborate schemes to retrieve their blocked funds in the form of goods they could subsequently liquidate, including motion pictures. Initially they invested in shipbuilding, and bought wood pulp, whiskey, and furniture abroad to sell for US dollars (Guback 1985, 477-8). But ultimately, "the availability of unremittable funds drove companies to shooting abroad, and films were made, partially or entirely, in Europe." Runaway production in Britain, Italy, France, and Spain was "a direct result of blocked earnings and company desires to spend them" (Guback 1969, 164-5).

The major studios continued the process of production externalization throughout the 1960s. Between 1950 and 1973, only 60 percent of total production starts by American film companies were located in the United States (Christopherson and Storper 1986, 310). The trend continued through the 1980s: "Location shooting is now a genuine alternative to the studio in most situations, offering a more realistic 'look' and lower overhead costs. Locations, too, have begun to promote themselves by offering better services and, sometimes, considerable subsidies to production companies" (Storper 1989, 285). The Hollywood of the 1980s had a "split locational pattern" with preproduction and postproduction work concentrated in the greater Los Angeles area and production activity dispersed globally. The movie business has become a "transactions-intensive industry" with the major studios acting as institutional investors who control the "afterlife" of a film in ancillary markets, spreading the initial risk of film production to the independents (Christopherson and Storper 1986, 313-16).[5]

CANADIAN FEATURE FILM PRODUCTION

Canada renewed its efforts in the postwar period to establish a Canadian feature film industry. Thanks to its vertically integrated structure, the Hollywood industry had dominated the Canadian market since the 1920s, deterring Canadians from developing a market for their movies and providing Canadian audiences with little access to indigenous films. Canada's own attempt in the 1930s to break up the Hollywood movie cartel through the courts had failed, and the 1948 Paramount Decision did not apply outside the United States. In Canada, it was business as usual for the Hollywood studios (see Pendakur 1990). This state of affairs was summed up by the Massey Commission's 1951 report on the state of national cultural production when it referred to cinema as "not only the most potent but the most alien of the influences shaping our Canadian life" (Canada 1951, 50).

There was pressure on the Canadian government, however, to recapture its own market, and a postwar balance-of-payments crisis with the United States forced the federal government to consider protectionist measures for the Canadian film industry. Motion pictures were, however, exempted from the 1947 Emergency Foreign Exchange Conservation Act, which imposed restrictions on a number of imported goods from the United States, even though $17 million of the $20 million taken out of Canada by the movie industry went to the United States. A lobby from the Motion Picture Export Association of America (MPEAA) and Famous Players Canada Corp. instead convinced Minister of Trade and Commerce C.D. Howe that Hollywood could help resolve the problem it had largely created, without resorting to restrictive trade legislation (Pendakur 1990, 136).

Rather than impose screen quotas, import restrictions, or excise taxes, Ottawa negotiated the Canadian Cooperation Project with Washington and the resourceful MPEAA. The deal, signed in 1948, required Hollywood to produce a film on Canada's trade-dollar problem, provide more complete newsreel coverage of Canada, produce short films about Canada, release National Film Board films in the United States, include Canadian sequences in its feature films, make radio recordings by Hollywood stars extolling Canada, make more careful selections of films to be shown in Canada, and work with a Canadian government officer in Hollywood to coordinate the project (Cox 1980, 34). Manjunath Pendakur (1990, 137-41) dismisses the Canadian Cooperation Project as "public relations gimmicks to stop the Canadian government from legislating any quotas ... The smoke screen created by the MPEAA lobby through the CCP began to thin out in less than a year." The Canadian Cooperation Project expired in 1951 when Canada's currency reserves crisis eased.

The first serious attempt by the Canadian government to stimulate indigenous feature film production was the establishment of the Canadian Film Development Corporation (CFDC) in 1967, Canada's centennial year. With an initial budget of $10 million, the CFDC was instructed to "foster and promote the development of a feature film industry in Canada" through investment in Canadian feature films, loans to Canadian feature film producers, awards for outstanding production accomplishments, professional development grants to film-industry workers, and advice and assistance with regard to film distribution and the administration of production (CFDC 1969, 9). Ted Magder (1996, 165) points out that the CFDC was an industrial

The Terms of Inclusion

policy instrument: "From its inception, the CFDC was conceived as a commercial agency, interested as much (if not more) in the profitability of the films it supported as in their contribution to Canada's cultural life." By 1971, the CFDC had invested $6.7 million in sixty-four film projects.

In 1974, the federal government revised its capital cost allowance program to stimulate private-sector investment in the film industry. The tax shelter, which had since 1954 permitted film producers to claim 60 percent of their capital costs against their taxable income (from all sources) in the year the film was made, was restructured to allow producers to claim 100 percent of costs in the first year for film projects that met minimum Canadian-content criteria. This change, which coincided with a devaluation of the Canadian dollar (against US currency) and the abolition of a similar tax-shelter program in the United States in 1976, sparked a production boom that lasted until 1982. Investors with no previous experience in film production were suddenly attracted to a high-profile industry that held out the potential, at least, of significant returns (Pendakur 1990, 169-71). In concert with the revised tax shelter, the CFDC in 1978 shifted its emphasis from providing equity financing to offering bridge financing to film projects, designed to take advantage of the tax shelter (CFDC 1979).

This was a period of considerable – albeit short-lived – optimism in the Canadian film industry. While in 1966 Canada produced only three feature-length theatrical releases, the Canadian Film Development Corporation in its first decade invested almost $26 million in 220 films. In 1978-9, for example, the CFDC invested in 27 films with budgets totalling $50 million (CFDC 1979). The previous year, the CFDC for the first time recovered more than $1 million from its investments in a single year, thanks in large part to the commercial and critical success of three indigenous features – *Outrageous!*, *Who Has Seen the Wind*, and *Why Shoot the Teacher?* – and increased television sales (CFDC 1978). The boom reached its peak in 1979 when seventy features were produced in Canada – thirty-six without CFDC financing – with budgets exceeding $150 million (CFDC 1980). This is a fantastic number of films when compared to Hollywood's output of ninety-five features the same year, but as Martin Knelman (1987, 24) reminds us, more than half of the Canadian films produced that year were never released.

The boom went bust by the early 1980s, as a nationwide economic recession underscored the growing recognition that returns on film investment were exceedingly rare. If Canada still managed to produce fifty features with

total budgets of $165 million in 1980 and thirty-seven features with budgets of $85 million in 1981, by 1982 the CFDC invested in a total of just twenty-four projects – features, documentaries, television series, *and* shorts – with budgets totalling $28.3 million (CFDC 1981, 1982, 1983). Production, moreover, is not the whole story: "Measured in terms of employment and total dollars spent, the tax-shelter boom was a success. But many of the films produced during this period were never distributed; many of those that did receive distribution were second-rate efforts that were ... practically indistinguishable from American ones (notable examples include *Meatballs* and *Running*)" (Magder 1996, 166-7). Investment in films also proved highly speculative: "Investors flocked to movies, glad to have their money sheltered, but also hoping for a future profit. Too often the future profit failed to materialize, and so, even though they had the advantage of tax relief in the short term, the investors lost money in the long term" (Knelman 1987, 24). In 1983, the capital cost allowance was adjusted to allow producers to claim 50 percent in each of two years, and in 1988 the benefit was reduced again to 30 percent per year (Magder 1996, 166-7).

THE TAX SHELTER RECONSIDERED

The tax-shelter years are typically regarded with scorn by scholars who have catalogued the squandered investment and the films' dubious claims to Canadian content (e.g., Knelman 1987; Pendakur 1990; Magder 1993, 1996). But while the period may not have earned Canadian cinema much respect, it merits reconsideration in light of a number of subsequent developments in the industry. The 1970s not only led to the industrialization of Canadian cinema but also revealed a number of characteristics of the commercial cinema that led to the restructuring of the nascent Canadian industry.

First of all, the tax-shelter experience exposed in stark terms the futility of government policies that address only the production sector of the industry and neglect the distribution sector so vital to theatrical release. Public investment and tax relief proved to be a boon to production, but did nothing to challenge Hollywood's domination of Canadian cinema screens, and therefore had little impact on what movies Canadians saw in their theatres. Through the 1980s and 1990s, Canadian films' share of screen time in Canadian movie theatres hovered around 3 percent, although this average is skewed by their concentration in select downtown theatres of the larger urban centres, where such films might run for a week or two (Magder 1996, 150).

The Terms of Inclusion

Canada's two principal theatre chains, Famous Players and Cineplex Odeon, remain vertically integrated with major Hollywood studios, ensuring and privileging access to Canadian movie screens for the products of those studios. Together Famous Players and Cineplex Odeon control an estimated 82 percent of the Canadian film exhibition market (S. McCarthy 1997). Famous Players, with 884 screens in 102 locations across Canada, is a wholly owned subsidiary of Viacom Inc. of New York, a diversified entertainment and communications conglomerate that owns the major Hollywood studio Paramount Pictures (Famous Players 2001).[6] Cineplex Odeon operates 850 screens in 125 theatres across Canada (Olijnyk 2000). The company merged with Sony Corp.'s Loews Theaters in September 1997 to form Loews Cineplex Entertainment (LCE), the second-largest film exhibitor in the world with 2,900 movie screens in more than 400 locations in Canada, the United States, and Europe (LCE 2001). The exhibitor's two principal shareholders are the Hollywood major studios Sony Pictures and Universal Studios (Craig 2001).[7]

The monopolization of Canada's theatre screens by Hollywood led to a second revelation during the tax-shelter years: television is a much more reliable distribution vehicle for the Canadian film industry, thanks to Canadian-ownership and Canadian-content regulations, and thanks to the licensing in the 1980s of pay-television and specialty channels devoted to broadcasting movies. As of 1980, television was by far the largest source of revenue for private Canadian film and video companies; TV commercials accounted for 41 percent of revenues, and the sale and rental of TV pro-gramming represented another 30 percent. Theatrical exhibition accounted for just 3 percent of the industry's total revenues (Canada 1982, 257). The Canadian Radio-television and Telecommunications Commission (CRTC) expanded the market to Canadian film producers by licensing its first national pay-TV networks – First Choice and Lively Arts Market Builders (C-Channel) – in March 1982 (Magder 1993, 202). A year later, the CRTC licensed three cable services specializing in feature-length movies: Super-Channel (in western Canada), The Movie Network (in eastern Canada), and the French-language Super Écran (CCTA 1995).

Producers committed to film production on a full-time basis began to explore a variety of funding sources, such as co-production between the private and public sectors, and hybrid film-television production. The 1981 film *Les Plouffe,* for example, received one-fifth of its budget from the CBC, and was released in three versions: as a six-hour television miniseries, as a

French-language feature film, and as an English-language feature. The principal backers of the 1982 feature film *The Terry Fox Story* were broadcasters Home Box Office and CTV. It was distributed theatrically by Astral Films in Canada and by Twentieth Century-Fox internationally. The convergence of television and film had strategic advantages: "Feature film producers were now more eager than ever to obtain major funding from broadcasters, who had become an important source of film capital. Always narrow, the space between the two industries was growing narrower still" (Magder 1993, 200-1).

In recognition of the promise television held, the federal government in 1983 altered the mandate of the Canadian Film Development Corporation. The federal Department of Communications introduced the $35 million Canadian Broadcast Program Development Fund, to be administered by the CFDC, which later that year changed its name to Telefilm Canada to reflect its new emphasis on television. While the sum of money in the Broadcast Fund may not appear significant, it considerably increased the leveraging power of production companies in their quest for other sources of investment. It also encouraged Canadian film producers to look more and more to television production: "In no uncertain terms, the Broadcast Fund made Telefilm a major player in the production industry. Obviously, it also meant that there was an enormous incentive for Canadian feature film producers to shift their activities to the production of television features and other forms of television programming in the drama, children's, and variety categories ... In a very real sense the Canadian government had solved the problem of distribution and exhibition by gearing production activities to the regulated market of Canadian television" (Magder 1993, 209, 211).

Because a number of investors had been burned by Canada's tax-shelter cinema, a third effect of the experience was what economists refer to as a "rationalization" of the film industry. Players who were in it for short-term profit rather than long-term industrial development were eliminated: "Among those who had used the tax-shelter boom as a way of moving Canada's film industry closer to the form and substance of a Hollywood North, the neophytes – those fly-by-night producers with little or no long-term experience in the film industry – bid a hasty retreat, while the more successful producers bravely depicted the production downturn as a necessary, and useful, consequence of market adjustment" (Magder 1993, 196).

It was in the tax-shelter period that a number of today's industry leaders established production houses. For example, the corporate roots of Alliance

Communications, Canada's largest audiovisual entertainment company until its merger with Atlantis Communications in July 1998, date from 1972 when Robert Lantos and Victor Loewy formed the distribution company Vivafilm (Rice-Barker 1996). The Lantos and Steven Roth company RSL Productions produced *In Praise of Older Women* (1978) and *Agency* (1978).[8] Companies such as Behaviour Communications (formerly Malofilm), Astral Communications, Paragon Entertainment, Atlantis Films, Productions La Fête, Cinar Films, and Nelvana were all founded in this period. In April 1981, nine of the ten largest feature film production companies in Canada – Astral Film Productions, Dal Productions, Filmplan International, International Cinema Corp., Paragon Motion Pictures, Robert Cooper Productions, RSL Films, Ronald I. Cohen Productions, and Tiberius Productions – formed the Association of Canadian Movie Production Companies (ACMPC) to strengthen the relationship between Canada's established production houses and American distributors. In 1980, these companies had produced more than $75 million worth of feature films (Big nine 1981; Magder 1993, 196, 286).

If the tax-shelter boom led to a rationalization of the industry, it also concentrated Canadian feature film production in Ontario and Quebec. A 1977 study commissioned by the secretary of state noted that 75 percent of Canada's 150 production companies were located in the Montreal-Ottawa-Toronto triangle, and accounted for at least 90 percent of the country's production (Canada 1977, 154). The report noted that, given the small Canadian market, the Canadian film-production industry depended for its economic survival on producing commercials, commercial documentaries, and sponsored films; 80 percent of these companies were involved in at least two nontheatrical sectors (71-2, 152). "The picture emerges of a production industry comprising a large number of producing firms, few if any big enough to sustain all the facilities and resources needed for large-scale production, and an infrastructure of more solidly established firms or individuals providing the necessary services and physical resources as and when they are required" (153). The report explained the industry's agglomeration this way: "As has been shown, the majority of film-production units are dependent on the availability of specialized services and facilities. This sector of the film industry operates on the principle of high turnover and low profit margins, and therefore tends to be concentrated in areas where demand is high ... These concentrations facilitate the continuous relationships that must exist between producers and the service sector on the one hand, and between

producers and customers on the other, while reducing the costs of transporting people and materials. Producers located further afield are thus at a disadvantage in many respects" (154-5).

Montreal was, and remains, the centre for French-language film and television production in Canada, and as the home of the National Film Board (since 1956), it was where a number of NFB-trained filmmakers made their first forays into feature film in the 1960s. An earlier wave of Quebec cinema had produced fifteen French-language and four English-language features between 1944 and 1953, the best-known of which are *Le Père Chopin* (1944), *La Petite Aurore, l'enfant martyre* (1951) and *Tit-Coq* (1953). But the arrival of Canadian television in 1952 killed off this emergent cinema and drove the main Montreal production houses, Renaissance and Quebec Productions, out of business (Clandfield 1987, 59-61).

By the early 1960s, however, interest among Quebec filmmakers in producing a *cinéma d'auteur* was stimulated by the example of the *Nouvelle Vague* in France. As Marcel Jean (1991) recounts, the passage from documentary filmmaking to feature production was signalled in 1962 when NFB filmmakers Denis Héroux, Denys Arcand, and Stéphane Venne made *Seul ou avec d'autres* at the University of Montreal. Crew members included Michel Brault (camera), Marcel Carrière (sound), Bernard Gosselin (editing), and Gilles Groulx (editing) (56-57), all of whom became well-known Quebec filmmakers. Between 1963 and 1967, Claude Jutra *(À tout prendre)*, Gilles Groulx *(Le Chat dans le sac)*, Gilles Carle *(La Vie heureuse de Léopold Z)*, and Michel Brault *(Entre la mer et l'eau douce)* made their first features at the NFB (58-59). Jean writes, "Alors que, durant les années 50, le cinéma québécois produisait tout au plus deux longs métrages par année, alors que, en 1962, *Seul ou avec d'autres* était le seul long métrage réalisé, huit longs métrages verront le jour en 1964 et treize en 1965. Une industrie commence à développer: pour le meilleur (l'acroissement de la production) et pour le pire (la soumission de la création au commerce)" (59).[9]

The NFB made its first English-language feature, *Drylanders*, directed by Don Haldane, in 1963, followed by Don Owen's acclaimed *Nobody Waved Good-bye* in 1964 (Clandfield 1987, 87). A number of independent Montreal producers also began to make feature films in the 1960s. Roger Blais, Pierre Patry, and Jean-Claude Lord formed Co-opératio in 1963 and produced seven features over the next five years (73). The prolific Jean Pierre Lefebvre made his first feature, *Le Révolutionnaire*, in 1965 (see Harcourt 1981). Quebec was

also one of the first provinces to establish an investment program for indigenous film, creating l'Institut québécois du cinéma in 1975 to support local film production, distribution, and exhibition (Lever 1988, 271-4).

David Clandfield (1992) describes the period from 1963 to 1984 as the emergence of Ontario, and especially Toronto, as the principal centre of English Canadian film production, when an estimated 150 to 200 feature films were made. This was also the period when Toronto became Canada's largest city and the country's financial and communications centre. Toronto has been home base of the CBC's English-language television services since 1952, and the Ontario government established the Ontario Arts Council (which included funding for film arts) in 1963, the Ontario Film Institute in 1968, and the educational broadcaster TV Ontario (which programmed both classic Hollywood and international films) in 1970. The Toronto film festival was founded in 1976 and the NFB established a regional production centre in Toronto that year. Clandfield writes that everything favoured the consolidation of Toronto as the centre of the nascent English-language film industry and of movie going (133).[10]

MEANWHILE, IN BRITISH COLUMBIA

Even at the height of the tax-shelter boom, very few indigenous features were made on the west coast. British Columbia remained a remote outpost of the Canadian film industry in the 1970s, physically removed from the key sources of both public and private investment, from the principal Canadian distribution companies, and from the head offices of both the public and private television networks. While geographical distance does not prevent the generation of film ideas and scripts, it does inhibit the kinds of social interaction that fosters industry contacts and creative collaborations, and that leads to the kind of financing and distribution agreements that enable films to get made. West coast filmmakers talk about "the $5,000 cup of coffee" in reference to the prohibitive costs of a business trip from Vancouver to Toronto, where most distribution and television presales agreements must be negotiated (see Caddell 1998a, 1998b).

What is regrettable about the postwar history of British Columbia cinema is that the vibrant film community that emerged in Vancouver in the 1950s and 1960s was not encouraged to develop further. The CBC established its fourth television station, CBUT, in Vancouver in December 1953, and CBUT's Vancouver Film Unit – founded by Stan Fox, Jack Long, and Arla

Saare – produced more than 150 films over the next twelve years (Browne 1992, 177-8; Reimer 1986, v). Dennis Duffy (1986, 17) notes that the CBC's Vancouver presence "brought about a renaissance of regional filmmaking at new levels of artistic and technical competence." Notable early films included the documentaries *A Profile of Ethel Wilson* (Ron Kelly, 1955) and *Skidrow* (Allan King, 1958). CBUT subsequently generated a number of regional series including *Cariboo Country,* its first major filmed drama series, which ran in 1958-60 and 1963-6. Produced and directed by Philip Keatley and based on scripts by noted BC journalist Paul St. Pierre, *Cariboo Country* was unmistakably rooted in the plateau country of 1960s British Columbia (see Miller 1987, 68-90). It was originally shot in CBUT's Vancouver studios, but in its second run was filmed on location in the Cariboo and Chilcotin regions, and in the cities of Vancouver and Williams Lake (Duffy 1986, 17-19, 80-1).

The CBC, however, suffered from what Mary Jane Miller (1987, 333) has termed "periodic swings toward centralizing production," and by the mid-1960s the Toronto headquarters of the English-language television network was reasserting its control over dramatic programming. By the mid-1970s, CBUT was limited to producing the long-running half-hour drama series *The Beachcombers* (1972-90) and occasional specials (Duffy 1986, 21). With the loss of production went the loss of some of its best talent. Daryl Duke, who began producing public affairs programs at CBUT in 1954, "graduated to corporate headquarters" in 1958, where he produced the hour-long weekly series *Sunday* (Knelman 1978, 42-3, 140). Allan King, who joined the Vancouver Film Unit as a director in 1954, went to England to form his own film company in the 1960s, later moving to Toronto where he made the acclaimed documentaries *Warrendale* (1966) and *A Married Couple* (1969), and the feature film *Who Has Seen the Wind* (1977), based on the W.O. Mitchell novel (Bastien and Handling 1980, 207-8).

The CBC's commitment to regional television production had been called into question as early as the report of the Royal Commission on Broadcasting (the Fowler Commission) of 1957 (Canada 1957, 75-6), and in her study of the first three decades of CBC television drama, Mary Jane Miller (1987, 327) was unable to discern any coherent CBC policy on the role of regional dramatic programming. Defending the CBC's centralization in the corporation's 1959-60 annual report (CBC 1960, 7), president Alphonse Ouimet argued: "The natural pressures of television, which are present in every country, have resulted in Toronto and Montreal becoming the focal

The Terms of Inclusion

points of program production for Canada. This centralization has taken place in every country." Nevertheless, Ouimet allowed that "the further development of regional contributions to the national television network" was expected to be one of the CBC's most important future developments. The corporation's 1960-1 annual report (CBC 1961, 29) made a point of noting a "substantial increase" in regional contributions to the English network, rising from 30.3 percent to 34.7 percent of programming. But by 1965, even the public broadcaster acknowledged that it did not yet "adequately reflect the diversified pattern of life, ideas and opinions from the various regions of Canada" (CBC 1965, 32).

A decade later, the issue was raised again. During the CRTC's public hearings on the renewal of CBC licences in February 1974, the British Columbia Committee on the CBC pressed the CRTC "to require the CBC to respect its mandate concerning local and regional programming as well as ... national unity" (Raboy 1990, 229-30). The BC Committee for CBC Reform published a manifesto in the *Vancouver Sun* on 11 March 1976, urging the CBC to "abandon its Toronto-oriented policy of progressive centralization and restore programming and financial AUTONOMY to regional broadcasting centres." The more than a hundred prominent British Columbians who signed the statement noted that the only region of Canada "not subject to the dictates of Toronto and Ottawa" was Quebec. "In B.C., we have a prime example of how regional programming, once original, alive and interesting to listen to and watch, has become increasingly subservient, in the name of efficiency and economy, to the centralizing authority of CBC Toronto" (BC Committee 1976). In a speech in November 1976, CBC president Al Johnson vowed "that the CBC, over a five-year period, would increase significantly the regional production for drama, music and variety – whichever programmes are most appropriate and indigenous in the several regions of Canada." But because this promise required substantial funding, the increase in regional programming was never realized (Miller 1987, 329-30).

As a result of the CBC's centralization in Toronto, Vancouver filmmakers were denied both the training opportunity of television production and a dependable market for their films. The only non-CBC drama series made in British Columbia in the 1960s was *The Littlest Hobo,* produced in Vancouver by Canamac Pictures. *The Littlest Hobo* was made with the American television market foremost in mind, but was broadcast in Canada by the CTV network (Duffy 1986, 22). This problem became particularly acute once

the Canadian film and television industries converged in the 1980s, and television became Canadian cinema's principal delivery system. From a national standpoint, Mary Jane Miller (1987, 327) remarks, what was squandered was Vancouver's voice as "the true counterweight in quality and quantity to a Toronto-based vision of this country and its concerns."

If CBC television's commitment to production in British Columbia was inadequate, the National Film Board's contribution to west coast film-making was little better. Founded in 1939, the NFB did not establish its first regional production centre until 1965, when veteran producer Peter Jones was assigned to be the board's eyes and ears in Vancouver. Vancouver, however, fared better than the regional production offices in Halifax, Toronto, and Winnipeg, which were closed in 1969 as an austerity measure. The NFB did not have a production presence in all regions of Canada until 1976 (Jones 1981, 177-8; Dick 1986, 118-21). Historian Ronald Dick (1986, 120) credits Jones himself with making the NFB's initial commitment to regional production work for Vancouver: "More perhaps than anyone else, Peter Jones may be considered responsible through his tireless missionary work for the eventual acceptance of the regional idea at the NFB."

Until 1968, Jones's role at the Vancouver office was to offer advice to local filmmakers, conduct research for film projects submitted to the NFB's head office in Montreal, file reports to Montreal on local film talent and "other resources," produce the few films that were cleared by the production committee in Montreal, and perform public-relations activities on behalf of the NFB. Jones wanted the Vancouver office to be a regional producer of NFB films with its own guaranteed annual production budget, and he asked a reluctant head office for $2,000 to $2,500 annually for equipment rental, film stock, and processing "for developing film makers to show what they could do" (NAC, MG 31, D210, vol. 4, file 1). In an 11 July 1968 letter to Frank Spiller, the NFB's director of English production, Jones noted that "practically all" NFB films were still produced in Montreal, and he advocated that "the NFB apportion part of its production funds to Regional Film Production." Jones proposed that each regional production centre be given an initial film production budget of $100,000, excluding sponsored films and special projects like Challenge for Change (NAC, MG 31, D210, vol. 7, file 3).[11]

Jones received some production money after 1968, and was able to support films by Sandy Wilson, Sylvia Spring, Al Razutis, and David Rimmer. These funds were increased in fiscal 1971-2, and by 1972-3, Vancouver was

allotted its own production budget (NAC, MG 31, D210, vol. 4, file 1). Between 1972 and 1977, the Vancouver office was allotted the following amounts for production:

1972-3	$475,000
1973-4	$500,000
1974-5	$500,000
1975-6	$492,000
1976-7	$535,000

In its first four years of regional production, the Vancouver office made twenty-eight films, ranging from one-minute clips to fifty-seven-minute documentaries. One of the first of these films was *He's Not the Walking Kind* (1972) by Sandy Wilson of Penticton, who would play a key role in the emergence of an indigenous feature film industry in British Columbia a decade later (NAC, MG 31, D210, vol. 7, file 6).[12]

NFB decentralization became government policy in 1972 (see Magder 1993, 145-6) and in its 1976-7 annual report, the NFB committed 20 percent of its English production budget to the regional production centres in Vancouver, Halifax, Toronto, and Winnipeg, and 15 percent of its French budget to its Moncton, Toronto, and Winnipeg offices. English regional production was to increase to 42 percent by fiscal 1980-1, and "then rise more moderately until it reaches the maximum 50% mark." The policy was an attempt to make the NFB a truly national institution: "The objective of this policy, in keeping with the role of the Film Board, is to provide each region the opportunity to interpret a regional subject to a national audience or a national subject from a regional point of view. Regional production provides the NFB with access to the best creative and technical resources at the local level and in turn provides Canadian filmmaking talent from across the country with access to the national public film agency." The purpose of the regionalization plan, the report went on, was twofold: "to provide more diversified programming to reflect regional concerns and the relevance of the regions to the rest of the country; [and] to encourage the development and employment of independent film-makers locally." Regionalization, however, would not occur at the expense of the Montreal production facility; the volume of activity at the NFB's headquarters would be maintained (NFB 1977, 5-11; see also Shepherd 1979).

A native of Ontario who had worked for the NFB in Ottawa and Montreal for twenty years prior to his Vancouver assignment, Peter Jones got a taste of Western alienation first-hand. Quickly recognizing both the paternalism and the impracticality of having regional film proposals approved by a production committee based in Montreal, Jones reflected on his own conversion to decentralization in a letter to government film commissioner Sydney Newman:

> My concept of Canada as a federal nation used to be based on a strong central authority which would listen to representative-advisers from the regions but would not allow them any significant participation in government policy-making or administration. I now believe (after witnessing the alienation of Western Canada) that the strongest kind of federalism would be the system which guaranteed basic benefits and rights to all Canadians, but would permit the execution of federal policies to be carried out by regional *federal* offices – on the spot and in the midst of the citizenry they are serving. Because we are *not* all identical from coast to coast and the government that understands this will be a strong government with widespread support in this country.
>
> This is particularly true of a cultural agency such as the N.F.B. Why should we insist that a film-maker leave the environment he knows and loves in order to make films for the federal government? (27 September 1972; NAC, MG 31, D210, vol. 7, file 5).[13]

In a December 1982 letter responding to the conclusions of the Applebaum-Hébert report, Jones noted: "Since its inception as a production centre, the Pacific Regional Studio has proved its value by the production of an impressive collection of films, most of which would not have been made if the Studio had not existed" (NAC, MG 31, D210, vol. 4, file 7).

The federal institution that was intended to have the most direct impact on the feature film industry was the Canadian Film Development Corporation, but little CFDC investment came British Columbia's way, especially after the fiscal year 1972-3. As Table 3.1 indicates, the CFDC/Telefilm Canada participated in the production of twenty-five BC films in its first sixteen years, an average of fewer than two films per year. It also offered grants of $50,000 to nine west coast filmmakers in 1971-2 and $49,575 to seven BC filmmakers in 1972-3 (CFDC 1972, 1973).

In sum, the federal institutions that had both the mandate and the

Table 3.1

BC films produced with CFDC/Telefilm Canada assistance

Fiscal year	Film title	Director
1968-9	–	–
1969-70	*The Plastic Mile*	Morrie Ruvinsky
	The Brotherhood	Al Sens
	Madeleine Is ...	Sylvia Spring
1970-1	*Another Smith for Paradise*	Tom Shandel
	The Life and Times of Chester-Angus Ramsgood	David Curnick
	The Finishing Touch	Morrie Ruvinsky
1971-2	*Proxy Hawks*	Jack Darcus
	The Mask	Judith Eglington
1972-3	*The Beast*	Al Razutis
	A Game of Bowls	Douglas White
	The House That Jack Built	David Curnick
	The Late Man	Andreas Schroeer
	Return of Cowboy	J. Andrew de Lilio Rymsza
	Straight People	Phil Surguy
1973-4	*Wolf Pen Principle*	Jack Darcus
	The Inbreaker	George McCowan
1974-5	*Sally Fieldgood & Co.*	Boon Collins
	The Supreme Kid	Peter Bryant
1975-6	*Keeper*	Tom Drake
1976-7	*Skip Tracer*	Zale Dalen
1977-8	–	–
1978-9	*Yesterday*	Larry Kent
1979-80	*Going for Broke*	George McCowan
1980-1	*The Grey Fox*	Phillip Borsos
1981-2	–	–
1982-3	*Deserters*	Jack Darcus
1983-4	*Walls*	Tom Shandel

Source: Compiled from CDFC/Telefilm Canada annual reports, 1968-9 to 1983-4.

resources to provide British Columbia with a base for developing its own cinema merely reinforced the concentration of Canada's feature film industry in Montreal and Toronto. Certainly, some persistent independent filmmakers made features in British Columbia during the 1960s and 1970s, among them Morrie Ruvinsky, Tom Shandel, Jack Darcus, and Zale Dalen. But as Colin Browne (1992) argues, the most vibrant filmmaking activity

came from such experimental directors as Byron Black, Ellie Epp, Chris Gallagher, Gordon Kidd, Peter Lipskis, Sam Perry, Al Razutis, David Rimmer, and Bill Roxborough, and such documentary filmmakers as Jan Marie Martell, Jim Monro, Rick Patton, Moira Simpson, Dennis Wheeler, and Sandy Wilson. Browne writes: "Entre 1960 et 1970 ils ont créé à Vancouver les prémices d'un cinéma politiquement engagé et ont tracé la voie pour les générations futures" (177; see also Duffy 1986, 27-35; Douglas 1996; Testa 1992).[14]

In a December 1982 response to the Applebaum-Hébert report, Raymond J. Hall, president of the British Columbia Film Industry Association, argued: "B.C. receives a disproportionately small share of the nations [sic] film production and distribution opportunities despite having the country's 3rd largest metropolis and the 2nd largest English language film community." Hall advocated decentralization of the CBC to allow "greater access to both regional audiences and independent filmmakers," and he sought local program and budget authority for the CFDC office in Vancouver "in order to reflect the potential of the Regional feature interests." He branded the NFB's regionalization strategy a failure: "The NFB has not lived up to its earlier promise to expand its regionalization program. It remains a highly centralized organization with program authority and production activity concentrated at its Montreal Headquarters." Hall concluded his pointed critique of the federal film institutions with an anecdote that summarized British Columbia's marginality within Canadian cinema: "A Montreal producer once proposed entitling a television series interpreting British Columbia to the rest of Canada 'The Outsiders.' As long as Toronto and Montreal are the interpreters of Canada, filmmakers and audiences in the regions will continue to be – outsiders" (NAC, MG 31, D210, vol. 4, file 7).

FOUNDATION LAID

This chapter has traced the developments leading up to Hollywood's externalization of audiovisual production in the wake of the 1948 Paramount Decision and the arrival of television and suburbanization in the 1950s. This created the opportunity for rival jurisdictions throughout the United States and around the world to become participants in the production of Hollywood films. In short: "The dismantling of the integrated Hollywood 'studio system' of motion picture production and the ensuing search for new locales laid the foundation for the emergence of new centres of production. Vancouver was able to capitalize on this restructuring" (Murphy 1997, 534).

While Hollywood was perceived to be the principal impediment to the development of a Canadian cinema, the indigenous feature film industry that began to emerge in the 1960s was concentrated in Ontario and Quebec, and thus did little to nurture filmmaking in regions outside central Canada. At the same time that it became evident the federal film institutions were failing the film community on Canada's west coast, the provincial government in Victoria was looking for ways to promote British Columbia as a film location. If British Columbia could not be a full participant in the Canadian cinema, then the province would look to Hollywood for a way into the commercial cinema, and the BC government would assume the leadership role in building a regional feature film industry.

Promote It and They Will Come:
Provincial Film Policy in British Columbia

Grace McCarthy traces the beginnings of British Columbia's feature film industry back to 1976, during a casual conversation she had with *Vancouver Sun* newspaper columnist Jack Wasserman at an arts community awards dinner at Vancouver's Bayshore Inn hotel. At the time, McCarthy was "Madame Socred" – the former party president and current deputy premier, house leader, provincial secretary, and minister of recreation and travel industry – in William Bennett's newly elected Social Credit government. Wasserman was the *Sun*'s eyes and ears on the entertainment beat. "There was a lot of talk about [the film industry] in advance," McCarthy recalls. "It really just congealed that night at the Bayside Room in the Bayshore Inn when Jack Wasserman said, 'Why don't we have a film industry?' and I said, 'Okay Jack, tell me, why don't we?'" (G. McCarthy 1997).

Wasserman explained to McCarthy that British Columbia was losing Hollywood film business to Alberta and Ontario because visiting filmmakers were frustrated at the complications involved in shooting in British Columbia. Wasserman maintained that all it would take to make the province industry-friendly would be a film office to "pave the way" – to serve as a liaison with the various levels of government, to facilitate the importation of film equipment and personnel, and to secure the necessary permits for shooting in public locations. McCarthy liked the idea and presented it to

Bob McClelland, the minister of economic development. When McClelland's ministry proved too busy to deal with such a small matter, McCarthy investigated the idea herself. In August 1977, she established British Columbia's first film development office at Vancouver's Robson Square under the auspices of the Ministry of Tourism.

"Frankly, when I started it, I looked at it strictly as an economic development, with a little spin-off for tourism, so it justified putting it in my department," McCarthy (1997) explains. "I thought, first of all, it was a job creator. Secondly, we could use it as a tool for tourism. It was justifiable. So to this day, it is still in the travel industry portfolio of the provincial government, which may make people wonder, because it actually is an economic development initiative first and foremost" (see also British Columbia 1986).[1]

This anecdote underscores two points. First, in taking the initiative to encourage feature filmmaking in British Columbia, the provincial government perceived cinema strictly in industrial terms, with no thought at all for its cultural dimension. The promotion of a BC film industry was meant to be exclusively an economic development initiative designed to attract foreign capital and create local jobs. Second, Victoria's initial promotional efforts were directed at Hollywood, with no regard for encouraging local, indigenous production, even at a time when BC filmmakers were largely excluded from the indigenous production industry based in central Canada. Local producers had to wait another decade for provincial government assistance in making indigenous films, but even then, the industrial perception of cinema in British Columbia prevailed.

Unlike the federal government (see Dorland 1998; Gasher 1997) and provincial governments in Alberta, Saskatchewan, Manitoba, Ontario, and Quebec, the BC government was reluctant to include culture in its field of jurisdiction, and treated filmmaking as an opportunity to expand and diversify the provincial economy. If at first Victoria refused to use public funds for either investment or subsidy, both forms of incentive were introduced after 1986 to protect the gains the industry had made against both inter- and intranational competition.

This chapter describes three phases of provincial film policy. During the first phase, from 1976 to 1986, Victoria heard opportunity knocking and established the BC Film Commission to promote foreign location production within the province. The second phase, from 1986 to 1993, was characterized by industry restructuring and diversification. On the one hand,

increasing amounts of runaway production and increasing competition for Hollywood location shoots compelled Victoria to address a shortage of studio space in Vancouver. On the other hand, the BC film industry's overdependence on Hollywood prompted Victoria to set up the public funding agency British Columbia Film to encourage more indigenous production. The third phase, from 1993 to 2001, was characterized by *intra*national competition, as British Columbia moved to remain competitive with the rival Canadian jurisdictions of Ontario and Quebec by introducing the tax-credit program Film Incentive BC as an inducement to both foreign and indigenous producers.

INVITATIONS ARE SENT

McCarthy's gesture to foreign filmmakers was by no means the BC government's first. Provincial highways minister Phil Gaglardi loaned British director Sidney Hayers a plane and pilot to help him scout locations for *The Trap*, part of which was shot at Birkenhead Lake near Pemberton in 1965 (U.K. filming 1965). In 1968, the Department of Travel Industry in the W.A.C. Bennett government placed a full-colour advertisement in the Hollywood trade papers entitled "Invitation to Film in British Columbia." The ad reportedly prompted forty-one inquiries (BC Travel 1969, 57). In 1971, the provincial government again placed a four-page, full-colour brochure in the Hollywood trade papers. A message from W.A.C. Bennett informed filmmakers that "our province offers an endless selection of unspoiled scenic locations suitable for films of every type" and he invited filmmakers "to visit a few of our choice 'locations' in the near future" (Associated Press 1971). Travel minister Ken Kiernan promised that his department's film and photographic branch "is prepared to provide interested film producers with a complete package of information on any location in British Columbia. This can include details of highway, rail and air communications, accommodation, rental equipment, production facilities, technical staffs and talent" (in Wedman 1971). In concert with its advertising campaign, the provincial government hired Ivan Stauffer to act as British Columbia's representative in Los Angeles. "We don't want to take away any production that can be done in Hollywood," Stauffer said at the time. "But we can offer unparalleled scenery, as well as production costs that are considerably less than here" (Thomas 1971).

The BC government was encouraged in this direction by the modest, yet regular, number of Hollywood features that were shot in the province

between 1969 and 1971, including *That Cold Day in the Park, McCabe and Mrs. Miller, Five Easy Pieces,* and *Carnal Knowledge.* Vancouver director Daryl Duke nonetheless cautioned: "This is never going to be another Hollywood. But you can figure that Vancouver is a good location for three, four, five films a year" (Studer 1971).

David G. Murphy (1997, 534-6) argues that organized labour prepared much of the groundwork for Victoria's efforts. Local freelance technicians had chartered a branch of the American film technicians' union (International Alliance of Theatrical Stage Employees and Moving Picture Machine Operators [IATSE] Local 891) in 1962 to service runaway productions, and a group of local technicians, producers, and service providers founded the British Columbia Film Industry Association as a lobby group in 1964. As early as 1975, IATSE Local 891 sent its business agent to Hollywood to drum up film business for British Columbia.

The New Democratic Party government of Dave Barrett, which came to power in September 1972, tried over the next two years to find a more comprehensive role for Victoria in the development of a BC feature film industry, but it was largely unsuccessful. As early as October 1972, Premier Barrett, education minister Eileen Dailly and minister of industrial development, trade and commerce Alex Macdonald held a meeting with Peter Jones, executive producer of the National Film Board's regional production office in Vancouver. They discussed the possibility of the BC government co-financing feature films with the NFB (NAC, MG 31, D210, vol. 3, file 3.14). In a 25 October 1974 letter to Gary Lauk, who had succeeded Macdonald in his portfolio, Jones makes further reference to the BC government's plans to develop a film policy (NAC, MG 31, D210, vol. 3, file 3.18). By November 1974, however, Lauk was dispelling hopes that the BC government could participate in the launch of a local film industry. Money had become tight and the BC government had higher priorities. While Lauk remained in favour of the development of an indigenous film industry in Canada, he was opposed both to screen quotas – "because it offends my sense of freedom" – and government grants to filmmakers – "because management becomes less effective, doesn't have to meet payments and it all becomes Vanity Productions" (Wedman 1974).[2]

In June 1975, the BC Film Industry Association perceived a crisis in the fledgling provincial film industry and requested a meeting with the Barrett government. In a six-page brief to the premier, Bob Linnell of the BCFIA outlined four principal problems: there was a decline in the number of

features being shot in British Columbia; this decline was prompted in large part by the lack of access to distribution and exhibition networks; the provincial government had no department dedicated to film industry concerns; and the BC government had made no attempt to communicate with the film industry. Linnell proposed that the provincial government establish a film office to act as a liaison with the local industry and to promote filmmaking in the province (Walsh 1975).

Linnell's comments echoed similar concerns expressed by film producers throughout Canada, who were beginning to remark the failure of Canadian Film Development Corporation investment to gain better access for Canadian films to Canadian cinema screens. Sandra Gathercole, head of the Council of Canadian Filmmakers, went so far as to describe the Canadian film industry as a "national disgrace," owing to the federal government's "timidity" in the face of Hollywood's dominance (UPI 1976). Among the proposals being aired by Canadian producers were box-office levies and exhibition quotas (see Walsh 1972; Shields 1973). In February 1974, a group of twenty filmmakers, among them Denys Arcand, Don Shebib, and Peter Pearson, signed the Winnipeg Manifesto following a Canadian film symposium at the University of Manitoba. Arguing that the "present system of film production/distribution/exhibition works to the extreme disadvantage of the Canadian film-maker and film audience," the manifesto called for three immediate measures: public financing of feature films through a federal government production company; a national film marketing board; and a system of exhibition quotas (Walsh 1974). The crisis in the Canadian film industry was particularly severe for English-language production; although thirteen English-language features were made in 1972, only six were produced in 1973, and four in 1974 (Farrer 1975).

EVERYTHING SHORT OF INVESTMENT

While the federal government responded to the crisis in Canadian cinema with its 1974 capital cost allowance program in an attempt to increase private investment in what it saw as an important national cultural industry, the BC government took a very different tack. Victoria maintained its perception of film production as regional industrial development and opted for a strategy of promoting foreign location production when the Social Credit party returned to power in December 1975. After all, Hollywood had continued to use the province as a film location – the films *The Groundstar Conspiracy*,

Master of Images, Harry in Your Pocket, The Rainbow Gang, and *Russian Roulette* were among those made in British Columbia between 1972 and 1975 – and there was good reason to believe that, with the right kind of promotional effort, more film and television shoots could be attracted to the province (MacIntyre 1996).

Social Credit was a private-enterprise party that viewed the state's proper role in society as fostering an economic environment in which the private sector could flourish. The party had governed the province from 1952-72, and did not relinquish power to the NDP again until 1991. In his March 1981 budget speech, finance minister Hugh Curtis summarized the Socred position this way: "Our priorities flow from our economic philosophy, which is to encourage and coordinate growth in the private sector. Let me put it quite bluntly. We want to help without meddling" (British Columbia 1981).

This philosophy applied to cultural activity as well.[3] Throughout the late 1970s, the Social Credit government responded to New Democratic Party opposition demands for a comprehensive provincial cultural policy by repeating its laissez-faire stance. Replying to a 26 July 1979 complaint by NDP MLA Charles Barber that the province lacked a cultural policy, Curtis, then the provincial secretary and minister of government services, informed the Legislative Assembly: "I'm not sure that government should attempt to develop a cultural policy ... If you have a provincial government cultural policy, that suggests that it's going to be imposed from above; it's going to be laid on the arts community" (British Columbia 1979, 1036-7). The extent of the provincial government's commitment to cultural practice at the time was a $10 million endowment. Victoria established the $5 million Centennial Cultural Fund in March 1967, "for the purpose of stimulating the cultural development of the people of the Province" (*BC Statutes* 1967, c. 7, 23), adding another $5 million in March 1972 when it changed the fund's name to the BC Cultural Fund (*BC Statutes* 1972, c. 10, 25).

British Columbia was well behind the times when it came to provincial government support for the arts. Alberta established its Cultural Development Branch in 1946 "to promote, encourage and coordinate cultural development in Alberta." Part of Alberta's Department of Culture, Youth and Recreation as of 1971, the Cultural Development Branch promoted tours and exhibitions throughout the province to stimulate both public interest and performance opportunities, held workshops, provided consultative services to government agencies, school boards, and individuals, and offered financial

assistance to amateur and professional arts groups and to students for training. Saskatchewan created the Saskatchewan Arts Board in 1948 to promote the enjoyment, production, and study of the arts; Quebec established its ministère des Affaires culturelles in 1961; Ontario founded the Ontario Council for the Arts in 1963; and Manitoba created the Manitoba Arts Council in 1965 (Pasquill and Horsman 1973, app. A).

In 1986, in the context of a discussion of British Columbia's program of matching grants for local and regional cultural initiatives, Grace McCarthy, then provincial secretary and minister of government services, described both the BC Festival of the Arts and the 100th anniversary of the provincial museum as boosts to tourism and the economy, with no mention of their heritage value. Cultural events, McCarthy told the Legislative Assembly, have become "an important part of the provincial economy and are significant factors in the tourism industry. It's clearly time for communities throughout the province to enter into partnerships and increase funding levels to reflect the importance of the arts in British Columbia. Cultural industries form one of our largest business sectors. They are the country's fourth largest employer" (British Columbia 1986b).

This attitude toward cultural activity would also inform provincial film policy. As it became clear in 1976 that the Socred government was investigating the establishment of a film office, the BC Film Industry Association was pushing McCarthy to adopt a two-pronged strategy. In a letter to McCarthy dated 22 August 1976, BCFIA treasurer Kirk Tougas maintained that the objectives of the film office should be "to attract foreign feature film productions to the province" *and* "to encourage feature films produced by B.C. filmmakers" (BCARS, GR 1672, box 6242). This insistence upon an indigenous element to the provincial film strategy was consistent with the BCFIA's push to increase British Columbia's share of Canadian film production. In a brief dated April 1977 and addressed to federal secretary of state John Roberts, the BCFIA's Feature Film Committee argued that Canada needed a cinema representative of all regions of the country, and that British Columbia needed a film industry that was not dependent on foreign production. "We want to see more films made that are relative [sic] to Canadian lives – we want to see them made in all regions of Canada, so that above all, Canadians may have an opportunity to see how the other half, or quarter lives" (BCARS, GR 1672, box 6242).

McCarthy was all in favour of encouraging local film production,

provided that encouragement did not take the form of provincial government subsidy. This position was evident in her response to a request by Mr. R. Tarplett of West Kootenay Film Productions in Trail that film production be eligible for grants from the BC Cultural Fund. In an 8 November 1976 letter denying Tarplett's request, McCarthy explained: "It would seem to us that the future of the industry lies in self-sufficiency. If the industry is to grow and prosper it must be as a healthy competitive industry with the support of the Government of British Columbia, but not subsidized by the Government of British Columbia" (BCARS, GR 1672, box 6242). Asked in an interview with the author why her government did not address local, indigenous production as the BCFIA advocated, McCarthy (1997) said the federal government had assumed that responsibility through the Canadian Film Development Corporation and the Canada Council: "In effect the national government was really addressing that. I was more interested in getting the business end of it here – to support our artists here, but to support it in a stand-alone, they-earn-their-way, not-to-be-subsidized way. To me, that was the key. And yes, it was totally a commercial venture on behalf of those who paid out the money, the private sector. We simply just made it easy for them; that was our motivation."

McCarthy was supported in this position by her deputy minister, Wayne R. Currie. In a 5 May 1977 memo to McCarthy, Currie noted that of 300 productions funded by the Canadian Film Development Corporation through 1976, only 7 had recouped their production costs and only 3 had made "a modest profit." Currie wrote: "I would suggest the funding of motion picture production by Government is not an attractive investment opportunity, and would constitute an extremely expensive 'incentive' to attract production to the Province. I believe our policy should be one of utmost co-operation, cutting red tape, facilitating production, finding locations, etc. – in short – everything short of investing in the production itself" (BCARS, GR 1672, box 6245).

McCarthy felt that film *promotion* was one area in which government enjoyed an advantage over the private sector. To illustrate this point, she recalled once receiving a frantic phone call from a film location on Vancouver Island. The crew needed federal government permission to shoot a scene in which a plane bearing US markings was to fly over the set. While the crew stood waiting, McCarthy called BC senator Ray Perrault in Ottawa, who in turn called Transport Canada. Within hours permission was granted. "The

big thing about a film development office," McCarthy (1997) explained, "is they can open doors and pave the way as a private-sector person couldn't."

SPECTACULAR VIEW, REASONABLE PRICES

McCarthy hired Wolfgang Richter as BC film officer in August 1977. A North Vancouver teacher who had worked in distribution at the National Film Board, Richter was one of 120 applicants for the job. His principal functions would be to promote British Columbia as a film location, facilitate film shoots, and serve filmmakers in a public relations capacity. While the primary target for his efforts would be Hollywood, Richter also hoped to attract filmmakers from elsewhere in Canada (Wedman 1977). By April 1978, however, Richter had been dismissed for unspecified reasons, and he was replaced on a temporary basis by veteran production manager Bob Gray. Gray was in turn replaced by producer Justis Greene in August of that year (Wedman 1978; B.C. really 1978).

While British Columbia attracted just four film projects in each of 1977 and 1978 – fewer films, in fact, than the province had attracted in each of the previous four years (BCMPA 1992) – 1979 proved to be a breakthrough year. Sixteen productions responsible for $50 million in direct spending were filmed in the province. The suspense film *Bear Island,* starring Donald Sutherland, Vanessa Redgrave, and Richard Widmark, was responsible for $13.5 million alone. Noting that Canadians comprised between 75 and 85 percent of the production crews, Greene said: "We don't claim to be the best place in the world to shoot pictures. We just find that we shoot more pictures for less money with the same visual appeal" (Shepherd 1980; BC Small Business 1980).

Besides the spending the province attracted, the nascent BC feature film industry enjoyed a certain amount of critical acclaim by association when two of the features shot in the province in 1979 were nominated for best Canadian picture at the 1980 Genie Awards. Starring Hollywood actor George C. Scott, Peter Medak's *The Changeling* – the eventual Genie winner – was shot on location in Vancouver and at Hatley Park in Victoria, and Peter Carter's *Klondike Fever,* starring Rod Steiger, Angie Dickinson, and Lorne Greene, was shot at Barkerville. Both films were part of the $185 million boom in Canadian production in 1979 that was sparked by the federal government's liberalization of the tax-shelter rules (Walsh 1980a; MacIntyre 1996; Locherty 1979; Canadian Press 1979; Warren 1980).

British Columbia followed up on its 1979 success with another record year in 1980. Of the fifteen projects – twelve feature films, two television series, and one made-for-television movie – responsible for $65.8 million in direct spending, two were Canadian features (BC Tourism 1981). Celebrated Quebec director Claude Jutra shot the $3.3 million *By Design* in Vancouver (Walsh 1980b) and the promising local director Phillip Borsos shot his first feature, the $3.48 million *The Grey Fox*, in the BC interior. Borsos earned an Academy Award nomination that year for his documentary short *Nails*, which had been produced with the assistance of the NFB's Vancouver office in 1979. *The Grey Fox*, which recounted the story of Bill Miner, reputed to be Canada's first train robber, was to become one of the most highly regarded Canadian features ever produced (Wedman 1980).[4]

Although a Hollywood labour dispute slowed production in 1981, and the tax-shelter boom in Canadian production subsided, British Columbia was being proclaimed "Hollywood North" by 1982. The province attracted an unprecedented sixteen major film productions that year, including *First Blood* (with Sylvester Stallone and Brian Dennehy), *The Terry Fox Story* (Robert Duvall and Chris Makepeace), and *Star 80* (Mariel Hemingway and Cliff Robertson), based on the real-life story of murdered *Playboy* playmate Dorothy Stratten of Vancouver (Mulgrew 1982).

Dianne Neufeld succeeded Justis Greene as director of what was now called the BC Film Commission in November 1982. While she found herself competing for location film production with more than 100 other jurisdictions throughout North America, she was confident in being able to build on Greene's success in attracting Hollywood to British Columbia with the promise of an eighty-cent dollar and a "wealth of locations" (Mulgrew 1982). Notoriously high wages for production crews in California and the desire for more realistic locations increasingly drove Hollywood filmmakers out of the state as the 1980s progressed. *The Economist* reported in March 1984 that whereas 51 percent of the feature film productions initiated in California in 1981 were subsequently shot there, that figure had dropped to 29 percent in 1982. Between 1981 and 1982, total film production in the United States dropped by 37 percent (Hollywood 1984). So-called runaway production cost the state of California an estimated US$1.6 billion between 1979 and 1982 as filmmakers moved production to New York City, Texas, Toronto, and Vancouver (Foote 1984). By 1984, an estimated 70 percent of the major studios' feature films were being made outside California, costing the state between

$1 and $1.5 billion in spending.[5] "Hollywood has priced itself out of the market," declared Steven Spielberg (Blowen 1985).

British Columbia capitalized on its ability to provide locations to suit all purposes. The province can play any number of narrative settings – mountain wilderness, sea-swept coastline, urban jungle – depending on the needs of the production, and most of these settings can be found within easy reach of Vancouver. Typically, Vancouver is transformed into such American cities as Seattle or San Francisco, or even New York, and British Columbia becomes part of the United States' Pacific Northwest region.

GROWING PAINS

If the strengths of the BC feature film industry to this point were its cost advantages and its diverse locations, its success in attracting film production soon revealed two structural weaknesses: a shortage of both studio space and postproduction capacity. In addition, there was increasing concern that the predominance of foreign location production – accounting for an estimated 85 percent of direct spending between 1979 and 1985, 90 percent of which came from the United States (Cawdery 1985, 2) – left the industry exceedingly vulnerable to fluctuations in the currency-exchange rate. The BC economy had long been dominated by the boom and bust cycles of the resource industries, and there was fear that the film industry was leaving itself similarly exposed to external factors beyond British Columbia's control.

While the film industry was nowhere near as important to the provincial economy as forestry, mining, and fishing, it had quickly earned a reputation as a growth industry at a time when British Columbia was mired in recession. No longer simply a novelty on the economic landscape, filmmaking had gained credibility as a job-generator, creating not only direct employment for film crews, but indirect employment in all those ancillary industries that serve the film industry, such as hospitality, construction, and transportation.[6] Statistics indicated that the film industry was more than twice as labour-intensive as the forest industry and almost five times more labour-intensive than mining. For example, in 1983, the film industry in British Columbia employed one person for every $36,000 in revenues, while forestry employed one worker for every $84,000 in revenues and mining employed one worker for every $173,000 in revenues (Testar 1985, 74-6).

A 1985 study by Jack Cawdery of Quantalytics Inc. of Vancouver for the Crown British Columbia Development Corporation described studio

facilities as the "weak link" in British Columbia's array of production facilities. Excluding commercial and community television operations, there were three sound stages at Panorama Studios in West Vancouver, two sound stages at the Vancouver and Associated Studios on Richards Street downtown, and one silent stage at the Dominion Bridge site on the Burnaby side of Boundary Road at Grandview Highway. The Panorama Studios, built in 1962, presented two problems. First, it was not clear that the complex was commercially stable. Panorama Estates purchased the 2.8 hectare site in 1982 with the intention of rezoning part of the property for a housing development. But as of June 1985, rezoning had not been approved and the entire property was for sale (Gill 1985). Second, the configuration and limited size of Panorama's three sound stages had already led a number of feature-film productions to choose the Dominion Bridge site. Cawdery (1985, 6) concluded that "the Panorama facilities appear to lack some of the flexibility that the industry is now seeking."

Size was Dominion Bridge's greatest asset; with over 4,600 square metres of floor space and an almost 17 metre ceiling, it was larger than any similar California facility and had attracted $33 million in film production between 1983 and 1985. Cawdery (1985, 6), however, noted that "the facility is in an obvious state of disrepair, and from a technical standpoint has little, if anything, to offer at present." The Dominion Bridge site would require significant and expensive upgrading if it was to continue to serve filmmakers' needs.

The second structural weakness noted by Cawdery (1985, 7) – postproduction capacity – was less pressing, but Vancouver's underdeveloped postproduction sector was allowing potential revenues to escape and could ultimately inhibit expansion of the film industry:[7] "The local industry still has many of the characteristics of a location industry. Producers come to British Columbia from the United States, Eastern Canada, Europe, and Japan, but there are very few indigenous producers and a large share of the postproduction activity still occurs outside British Columbia. Postproduction activity is thus under-represented in the province relative to the production activity taking place." While local producers tended to be the most faithful patrons of postproduction services, a healthy postproduction sector would be an added attraction with which British Columbia could entice non-resident producers.

British Columbia's dependence on foreign location production and its marginal position within the Canadian film industry – of approximately 160

independent Canadian feature films and television programs produced in 1984, only 6 were made in British Columbia (Testar 1985, i) – also compromised the future viability of the west coast film industry. A 1985 *Task Force Report on the Motion Picture Industry in British Columbia*, prepared by Gerald Testar for the BC Film and Video Industry Association, proposed a number of ways to redress the foreign-domestic production imbalance: "The task before the industry, in British Columbia, is to increasingly turn our American employers into our clients and, like any ambitious employee with an entrepreneurial aptitude, to find a variety of ways in which this might take place" (7).

The industrial strategy Testar (1985, 56) proposed was to emphasize the development and production of made-for-television movies that could be sold to the lucrative American market: "The most accessible level of entry into the American marketplace appears to be the low end, feature length drama for television – an area of production in which members of the British Columbia industry have become particularly skilled in creating, for American owned companies. Our own export oriented motion picture projects, under the control of BC companies, should be encouraged to enter this market." This export strategy sought to exploit BC filmmakers' familiarity with American television and their first-hand experience of working on such movies to enable BC film companies to conceive, produce, and claim an equity stake in programming, instead of simply acting as contractors by executing projects initiated by Hollywood.

A key requirement of this strategy, however, was provincial government investment. Testar's report recommended that Victoria adopt a 30 percent tax credit for British Columbians who invested in BC companies involved in film and television development and production, and he recommended a two-pronged BC Film and Television Industry Development Programme. The first element of this program would be a system of financial incentives for script and project development. The second element would be a Film and Television Production Bank, charged with allocating equity investment and loans for BC production. The program was to be funded by new revenues derived from a 7 percent tax on pay-television subscriptions (Testar 1985, 58-9). Testar also proposed a 25 percent BC-content requirement for the Knowledge Network, the provincial government's educational broadcaster, which would create a captive market for BC producers (61).

Promote It and They Will Come

REFORMULATING PROVINCIAL FILM POLICY

The feature film industry in British Columbia had grown so quickly over its first decade that by 1985 there were clear signs it had reached capacity, and that future expansion would require something more than simply publicizing west coast locations and a cheap dollar. In 1985, the BC Film Commission reported that it *turned away* film projects with combined budgets of $50 million because British Columbia had neither enough trained personnel nor sufficient studio facilities to handle the workload (Audley 1986, 10). Two 1986 studies of the industry – by Brad Quenville for the BC Film and Video Industry Association and by Paul Audley for the BC Ministry of Municipal Affairs, Recreation and Culture – supported Testar's (1985) conclusion that some kind of provincial government investment in the industry was necessary to maintain British Columbia's viability as a film location. The province also needed to remain competitive with Alberta, Manitoba, Ontario, and Quebec, each of which had recently established provincial film agencies to stimulate both foreign service production and indigenous filmmaking. The context of film production in British Columbia had changed so dramatically since 1976 that the provincial government had little choice but to adopt a more interventionist stance if the film industry was to restructure and diversify.

While Quenville (1986, 3-4) acknowledged the BC film industry's accomplishments in the introduction to his report – noting, for example, that in 1985 British Columbia was the third-most-popular site of runaway production in North America – he argued that the industry's dependence on foreign location production was perilous, both culturally and industrially. The BC Film Commission had been successful in building an industry, Quenville remarked, but "it has not been a showcase for B.C. culture": "B.C. film personnel have been involved in contributing to the predominance of American pop culture and the province has been camouflaged to play many roles and in the words of the BCFC's film commissioner, Dianne Neufeld, 'particularly the role of Nowheresville, USA.' It will only be indigenous production that will be able to accrue the benefits to B.C. obtained through showcasing B.C.'s culture and scenery to the world" (7-9). Quenville described the industry as "fragilely tied to the exchange rate" and lamented the lack of any ongoing capital commitment on the part of foreign producers (9).

Indigenous film production in British Columbia remained a "cottage industry" that was doubly marginalized. On the one hand, it suffered the

effects of Hollywood's hegemony in the Canadian cinema market. Quenville (1986, 17) argued: "The greatest constipating force inhibiting B.C. film production, as it does across Canada and in many foreign countries, has been the domination of film distribution and exhibition by largely vertically integrated foreign, primarily American, distribution companies." On the other hand, British Columbia suffered from the concentration of the Canadian film and television industries in Toronto and Montreal (26-35).

While federal government policy makers were seeking to address the problem of Hollywood hegemony through the Film Industry Task Force (see Canada 1985) and, subsequently in 1988, the Mulroney government's proposed Film Products Importation Act (see Pendakur 1990; Magder 1993), Quenville argued that provincial government initiative was required to remedy BC filmmakers' marginalization within the Canadian cinema. Quenville noted that if the centralist policies of the federal film institutions – Telefilm Canada, the National Film Board, and the CBC – had largely failed BC producers, federal support nonetheless represented 97.1 percent ($7,155,241) of the direct support the province's indigenous producers received in the fiscal year 1984-5. He pointed out, "Most blatantly insufficient is the current level of provincial support; the province supplying only 1/33 of that supplied by the federal government" (Quenville 1986, 40-1). The BC government offered no film-specific support programs, and therefore offered no remedy to the "centripetal funding flow" (43).[8]

In recommending that the BC government develop a funding policy for indigenous film, Quenville's key insight was to highlight the economic interdependence – known as leveraging – between provincial government funding programs and investment from federal government and private-sector sources. That is, provincial support assisted filmmakers in obtaining public and private investment: "The most dramatic effects of each of these provinces' [Alberta, Quebec, Manitoba, and Ontario] policies has been not only to increase the provincial motion picture production but in so doing, to lever greater funding from federal and private sources" (Quenville 1986, 45-6). As an example, in its first year of operation (1985-6), Film Manitoba estimated that its investment of $356,000 in local film projects had leveraged an additional $609,000 of funding from other sources.

Alberta, Quebec, Manitoba, and Ontario already had film programs in place by the mid-1980s. The Alberta Motion Picture Development Corporation was established in 1982 to administer a $3 million loan fund from the provincial

Department of Economic Development over five years, and as of July 1986, had injected $1.3 million into the Alberta film industry (Quenville 1986, 57-60).

The government of Quebec established La Société générale du cinéma du Québec in 1983, which provided an average of $10 million per year in support of private-sector film production, more than any other province.[9] Quebec's revised Cinema Act (1985) contained six objectives of provincial film policy, among them: the establishment and development of the artistic, industrial, and commercial infrastructure of the film industry; the development of a Quebec cinema, and the spread of cinematic works and culture to all parts of Quebec; the establishment and development of independent and financially autonomous Quebec production companies; and the participation of television enterprises in producing and broadcasting Quebec films. This mandate, Quenville (1986, 68-72) noted, "places high reverence on the cultural significance of indigenous film products."

The government of Manitoba signed a five-year, $21 million Subsidiary Agreement in Communications and Cultural Enterprises under the Regional Economic Development Agreement with Ottawa in 1984, $3.25 million of which was to be committed to film and video investment by Film Manitoba. Film Manitoba was established explicitly as a leveraging vehicle, to provide incentive for private investment in the film industry and to increase Manitoba producers' access to federal sources of funding, especially Telefilm Canada (Quenville 1986, 61-3).

Finally, the Ontario government established the Ontario Film Development Corporation in January 1986 with a budget of $20 million to be spent in equal proportions over three years. The OFDC's mandate was to stimulate employment, investment, and expansion in Ontario's film industry. Offering financial assistance in the forms of equity investment, loans, and guaranteed lines of credit, the OFDC's primary focus was low-budget feature films (budgets under $3 million), but also included documentaries and television programming (Quenville 1986, 63-8).

Based on these provinces' experiences, Quenville advised that the BC government's best option would be to develop a policy of industrial development, rather than trying to straddle the fence between cultural and industrial development, as Ontario had done with the OFDC and the federal government had done with its capital cost allowance program: "As long as there is input by BC creative personnel; directors, actors, designers and particularly scriptwriters, there will be cultural input" (Quenville 1986, 74-5).

This recommendation was the product of pragmatism and a desire for accountability. The BC film industry was operating under both fiscal and market constraints, which meant that local producers were unlikely to ever afford Hollywood-style, mass-market film production (75). Limited government aid was justifiable and necessary: "The state of the BC economy is one that calls for government programs which have strong economic rationale. A development agency whose mandate was based solely [on] industrial development, could be audited to ensure that this provincial investment had sound economic justification. Job creation, revenue growth, and capital expansion could all be measured and quantified" (76).

Quenville recommended that Victoria establish a BC Film Development Corporation under the auspices of the Ministry of Economic Development. The film development agency would be run on "sound business principles" by a chief executive officer and a board of directors, with a jury system to govern project selection. With a proposed budget of between $4 million and $6 million per year (funded either by a box-office levy or a tax on basic cable television service), Quenville (1986, 81-2) argued that its criteria for funding support should be determined by what would best develop British Columbia's indigenous film production industry, such as BC content, producers' expertise, and marketability. The most effective form of assistance, Quenville concluded, would be loan financing, but assistance should vary according to the risk associated with each stage of production (89-90).

The Audley report, which was released in December 1986, signalled a fundamental reformulation of provincial film policy.[10] Audley was commissioned by the provincial Ministry of Municipal Affairs, Recreation and Culture to determine whether Victoria could take steps to substantially increase the share of Canadian production carried out by BC producers. Secondarily, Audley was to recommend ways the BC film industry could increase both the volume of non-resident production and the percentage of film projects' total budgets spent in the province (Audley 1986, 26).

Audley concluded that BC-based producers faced three central limitations in their efforts to expand the indigenous production base. First, few local companies had sufficient levels of capitalization to manage a substantial volume of audiovisual production. Second, producers in British Columbia lacked access to provincial government support: "Since the federal support programs are location-neutral, the question of whether the producers in a province have access to provincial support is now having an important

effect on the level of production activity they can undertake" (Audley 1986, 40-1). Third, BC producers were geographically distant from the head offices of both the private- and public-sector film and television institutions: "One of the difficulties producers based in British Columbia must confront is the fact that most decisions related to the production of English-language Canadian films and television programs are made in Toronto ... For producers without an established reputation the result is extreme difficulty in finding opportunities for production" (41, 32).

Noting that BC government expenditures accounted for a measly 1.3 percent share of total provincial government spending across Canada for the support of film and video production in fiscal 1984-5, Audley (1986, 41) recommended Victoria establish a three-year, $10.5 million funding program to support indigenous filmmaking through investment, loans, loan guarantees, and subsidies. He outlined its goals as follows: "The program would provide assistance to production companies based in the province with an emphasis on the development of production projects, the production of feature films and television programs, and distribution and marketing of BC productions both in Canada and in export markets" (45-6). A wide range of productions would be eligible – theatrical features, documentaries, and animated films, TV movies, pilots, miniseries, and sequels, as well as children's and educational TV programs – provided they were shot primarily in British Columbia and 75 percent of their budgets were spent in the province (48).

Audley (1986, 50-2) argued that such a program would produce significant employment benefits in a labour-intensive industry, and would "promote diversification and expansion in the economy." Besides the increased leverage provincial support would afford producers seeking federal funding, it would also stimulate private investment: "Based on consultations with the industry, the expansion of domestic production is also likely to lead to increased private investment in expanding postproduction facilities in the province." This, in turn, would likely encourage foreign producers to spend a greater share of their budgets in British Columbia. Audley also suggested the provincial government amend the 1985 Small Business Venture Capital Act to allow venture capital corporations to invest in indigenous film and video production companies (52-3). In addition, he recommended that the Knowledge Network become a licensed television broadcaster so that licence agreements with the provincial educational broadcaster would allow BC producers to qualify for Telefilm's Broadcast Program Development Fund (54).

INVESTING IN THE FILM INDUSTRY

Audley's recommendations were largely endorsed by a new Social Credit government, which had won re-election under William Vander Zalm in October 1986. Minister of Tourism, Recreation and Culture Bill Reid unveiled the Film Development Society of British Columbia (BC Film) in September 1987, as the centrepiece of the government's new film strategy. A three-year, $10.5 million film fund, as recommended by Audley, to be financed by BC Lotteries proceeds, BC Film's programs would include: direct loans (at a rate of prime plus 1 percent) for preproduction, promotion, and distribution; equity investment and loans for production; and direct grants for professional development. Preference was to be given to productions based on literary properties that originated in British Columbia and to projects that qualified for eight out of ten points under the Canadian-content definitions used by the capital cost allowance program, though six-point productions would also be eligible.[11] BC Film required applicants to exercise a minimum 50 percent of financial and creative control of eligible projects (Audley 1992, 5-6; B.C. Film 1987; Andrews 1987b).

Conceding that it was not easy to convince his cabinet colleagues to spend $10.5 million on indigenous filmmaking, Reid justified the program in terms of its contributions to British Columbia's economic diversification and its tourism industry. Reid said the establishment of the funding program was an acknowledgment by the Social Credit government of the "key role of service industries" in a restructuring provincial economy emerging from years of recession, noting that BC Film "will translate into jobs and diversification." Moreover, Reid vowed, the images of British Columbia the film industry presented to moviegoers all over the world would be a boost to the tourism industry, following up on the success of Expo '86 in Vancouver (B.C. Film: The promise 1987).[12]

The decision to establish BC Film, Audley (1992, 3) maintained, was taken "in the context of a number of changes in the environment within which the film industry in the province functioned." These changes included: expanded federal government support for audiovisual production with the introduction of the Broadcast Program Development Fund (1983) and the Feature Film Fund (1986); the failure of BC producers to take advantage of this increased federal funding; the underdevelopment of British Columbia's post-production sector; the need for the diversification of a resource-based provincial economy with an expanding population; the availability of a growing

film industry labour force; the volatility of foreign location production; and growing industry assistance from other provincial governments (3-5).[13]

A good example of the importance of leverage is provided by the first film to receive BC Film support in 1988. The $2.35 million feature *The Outside Chance of Maximilian Glick,* by Vancouver producers Stephen Foster and Richard Davis, also received funding from Telefilm Canada, the CBC, the NFB, Rogers Telefund, British Columbia Television, and the Canada-Manitoba Cultural Industries Development Office (Andrews 1988). Similarly, the $2.8 million BC film *Terminal City Ricochet* received $1.2 million from Telefilm, $500,000 from BC Film (including a $90,000 loan), $500,000 from private sources, and deferrals worth $388,000 (Hunter 1988).

While the establishment of BC Film was the Vander Zalm government's principal intervention in the film industry, there were others. Just three days before the 1986 election, Victoria announced it would provide a $5 million loan to private industry for the renovation of the Dominion Bridge industrial site (Film studio 1986). In November 1986, filmmakers Colin Browne and Patricia Gruben of Simon Fraser University's Centre for the Arts established Praxis with $240,000 in funding from the provincial Ministry of Education. The goal of Praxis was to generate independent, low-budget feature films written and produced by Canadians, and it began by offering a six-week program of workshops, seminars, and private script conferences (Andrews 1987a). In 1987, the Vander Zalm government also adopted Audley's recommendation to make film production companies eligible for investment under the Small Business Venture Capital Act (Audley 1993b, 49-50). In 1989, the Cultural Services Branch of the Ministry of Tourism and the Ministry Responsible for Culture established the Film and Video Production Assistance Program, offering between $10,000 and $25,000 to independent productions – in the genres of animation, documentary, drama, and experimental – in which the artist involved had total creative control (56).

Substantial new investment in the BC film industry also came from Hollywood, when television's Stephen J. Cannell Productions purchased the 6 hectare Park and Tilford distillery site in North Vancouver in April 1987, and announced plans to build a $20 million, seven-sound-stage film complex to be called North Shore Studios. The principal tenant would be Cannell Films of Canada, Ltd., but rental space would also be made available on the Hollywood-style film lot. "North Shore Studios will be a significant film magnet for Vancouver," declared Cannell president Michael Dubelko, whose

company had since 1979 produced twelve prime-time American television series, including *The "A" Team* and *Hardcastle and McCormick* (Lewis 1987). The BC government later contributed a $4.3 million loan toward construction (Read 1988).

THE BC FILM INDUSTRY DIVERSIFIES

The BC film industry enjoyed a spectacular average annual growth rate between 1978 and 1989, when direct spending on film and television production in the province cracked the $200 million mark for the first time (Lacey 1989; Luke 1991). The provincial government support provided by BC Film after 1987 had the anticipated effect of spurring local, indigenous production, but Hollywood location activity remained the driving force behind BC film-making. Among the filmmaking regions of Canada, British Columbia, in fact, remained unique in its heavy reliance upon foreign service production (see Audley 1989, 135-6).

In a cost-benefit analysis of BC Film's first five years of operation, Paul Audley (1992, v) concluded that the provincial government funding program "greatly exceeded" its goal of generating $4 for each dollar of support it provided to BC producers.[14] BC Film contributed $16.3 million to sixty-two indigenous film and television projects from 1987 to 1992, principally in the form of equity financing (see Table 4.1). Projects funded by BC Film attracted another $65.4 million from federal government sources in this period. BC Film also contributed $200,000 to non-theatrical production (compared to federal support of $1.1 million) and $500,000 to script and project development (compared to $1.8 million in federal support) (iv-v). Audley was especially pleased with BC Film's success in leveraging investment from national institutions: "At the federal level the availability of BC Film funding not only triggered expanded Telefilm funding, but also increased support from other federal agencies and programs, including the National Film Board (NFB) – although its involvement in BC production remained relatively limited – and the Canadian Broadcasting Corporation (CBC)." CBC expenditures on BC production, for example, increased from $500,000 in 1987-8 to a high of $5.9 million in 1991-2 (52).

Furthermore, Audley's report estimated that 80 percent (by dollar value) of the projects assisted by BC Film would not have been realized without BC Film involvement. The basis for this assertion was that, between the establishment of Telefilm Canada's Broadcast Fund in 1983 and BC Film's creation

Promote It and They Will Come

Table 4.1

Sources of financing: Projects receiving BC Film assistance

Source of financing	1987-8 3 projects		1988-9 21 projects		1989-90 14 projects		1990-1 12 projects		1991-2 12 projects		5-year total 62 projects	
	$	%	$	%	$	%	$	%	$	%	$	%
BC Film	193,453	6.2	4,074,795	15.3	1,952,471	5.9	5,040,662	12.9	5,029,400	11.7	16,290,781	11.2
Telefilm	1,510,526	48.1	10,621,807	39.8	13,166,848	39.7	12,159,215	31.1	13,808,072	32.0	52,266,468	35.3
NFB	469,061	14.9	186,450	0.7	218,000	0.7	380,000	1.0	85,000	0.2	1,338,511	0.9
CBC	505,985	16.1	1,128,093	4.2	405,500	1.2	4,622,817	11.8	5,898,303	13.7	12,560,698	8.6
Other federal	20,000	0.6	0	–	165,219	0.5	15,000	>0.1	40,000	0.1	240,219	0.2
Provincial broadcasters	6,500	0.2	1,778	>0.1	98,000	0.3	185,063	0.5	18,000	>0.1	309,341	0.2
Private broadcasters	11,000	0.4	465,000	1.7	5,820,000	17.5	1,793,995	4.6	3,400,000	7.9	11,489,995	7.9
Pay-TV	0	–	750,000	2.8	0	–	422,930	1.1	0	–	1,172,930	0.8
Specialty services	0	–	0	–	0	–	65,000	0.2	0	–	65,000	>0.1
Canadian distributors	0	–	1,466,613	5.5	3,951,902	11.9	4,341,849	11.1	3,104,000	7.2	12,864,364	8.9
Private (includes deferrals)	422,474	13.5	8,020,335	30.0	3,135,700	9.5	7,113,183	18.2	1,714,170	4.0	20,405,862	14.0
Foreign broadcasters	0	–	0	–	4,267,500	12.7	3,005,750	7.7	80,000	0.2	7,353,250	5.1
Foreign (co-venture/distributor)	0	–	0	–	0	–	0	–	9,990,855	23.1	9,990,855	6.9
Total federal[a]	2,505,572	79.8	11,936,350	44.7	13,955,567	42.1	17,177,032	43.9	19,831,375	45.9	65,405,896	45.0

[a] Includes Telefilm, NFB, other federal, and CBC.
Source: Audley (1992, 18-19). Table reproduced with the permission of British Columbia Film.

in 1987, BC producers attracted just 1.4 percent of Telefilm money, while after 1987, BC producers claimed a 12.8 percent share of Telefilm funding (Audley 1992, v). Audley also estimated that two-thirds of the development projects probably would not have proceeded without BC Film assistance (53).

Audley (1992, viii) also calculated that each $1 million in provincial funds spent by BC Film generated an incremental $17.3 million in production activity, 284.4 jobs, and just under $480,000 in incremental provincial tax revenue. While BC Film had only a limited impact on marketing and distribution – at the time of Audley's study, no British Columbia-based distribution companies qualified for assistance from Telefilm Canada's Distribution Fund (64) – Audley argued that projects assisted by BC Film had a significant impact on British Columbia's postproduction sector. BC projects accounted for 60 percent of postproduction revenues over the five-year period, while other Canadian productions accounted for 16 percent of postproduction revenues (ix).

In his study of a sample of thirty-one projects receiving BC Film assistance, Audley found that more than 80 percent qualified for eight or more Canadian-content points, based on the CAVCO scale. He concluded, "It seems clear that B.C. Film-assisted projects provided substantially expanded opportunities for B.C. residents to carry out key creative functions in film and television production. The result will be the availability in future of a strengthened base of talent in the province capable of taking on an expanded role in production" (Audley 1992, ix).

While Audley's assessment of the impact of BC Film's first five years was largely positive, it was also clear that the agency's principal impact was in television rather than in film. By 1991-2, television programming accounted for 83 percent of the total hours of BC production. Of the three feature films that received assistance in 1991-2, two were produced under the New Views program, "through which B.C. Film provides 100% of funding to stimulate the development of new feature film production talent" (Audley 1992, 22). And while BC Film proved effective in leveraging federal government monies, it was less successful in attracting private-sector investment.

The rapid growth of indigenous production prompted BC Film to conduct a comprehensive program review to deal with the increasing demands on its finite resources. The funding agency actually ran out of money in November 1998, as demand for funds outstripped supply (Edwards 1998b). In 1995, BC Film had restructured its programs to give greater emphasis to leveraging private-sector investment than federal government money. It

adopted a system of grants based on producers' ability to obtain cash commitments from distributors and television broadcasters (BC Film 1995). BC Film announced new guidelines in January 1999, returning to a selective, recoupable financing model for production applications, while maintaining the market-triggered model for development funds.

BC Film has three principal funding programs. The Television and Film Financing Program offers interest-free development advances, equity investment in productions, and equity investment for postproduction work. Film Incentive BC is a tax-credit program for BC film and television producers, with a basic tax credit of 20 percent on eligible BC labour expenditures, and an additional 12.5 percent tax credit available for producers shooting outside of Vancouver. The production services tax credit provides tax relief of 11 percent on BC labour expenditures for Canadian and international producers. BC Film also offers a series of "recoupment umbrellas" to encourage the participation of distribution companies and producers at domestic and international trade shows, film and television markets, and film festivals, as well as assistance to a variety of professional development initiatives (BC Film 2000b).

As important as BC Film has been to the local production community, it has not transformed Vancouver into a centre of indigenous film production to rival Toronto or Montreal. As recently as 1995, British Columbia was responsible for just 7 percent of certified Canadian production budgets, compared to Ontario's 59 percent and Quebec's 30 percent (CFTPA 1997, 1-10), and foreign producers still account for close to two-thirds of spending on film and television production on the west coast.

British Columbia's motion picture industry continues to operate at some remove from Canada's film establishment – whether the "major" Canadian studios like Alliance Atlantis or the public-sector institutions like Telefilm, the NFB, and the CBC – and the provincial governments of Quebec and Ontario, particularly, have remained a step ahead of British Columbia on the film policy front. Besides offering financial assistance to Quebec distribution companies for marketing and distribution, for example, the Quebec government introduced a 150 percent tax shelter for qualifying Quebec productions as early as 1983. Decreased to 100 percent in 1986, the Quebec tax shelter was increased again to 133 percent in 1987 and 166.67 percent in 1988 (Audley 1989, 57-8). Ontario established its two-year, $30.8 million Ontario Film Investment Program in 1989 (it was renewed in 1991 and 1993). OFIP offered Ontario investors cash rebates of up to 20 percent of qualifying costs (60-1).

In its first ten years of operation, BC Film committed almost $41 million to indigenous production, including forty-one feature films (Wong 1997). In spite of its efforts, productions owned and controlled by BC companies account for less than 30 percent of the industry's total spending in the province. However, the introduction of Film Incentive BC in April 1998 has improved BC producers' share of total spending dramatically, to the point that in 1999 and 2000, most of the Canadian production in the province was British Columbia-owned production (Table 4.2). BC Film committed $4.3 million to eighty-four projects in the fiscal year 1999-2000. Three BC feature films – *Here's to Life, Marine Life,* and *On the Nose* – received production money, as did the television series *Da Vinci's Inquest, Cold Squad,* and *Double Exposure,* among others (BC Film 2000a).

If BC Film has done little to correct either the foreign-domestic imbalance in the BC film industry or the concentration of the Canadian film industry in Ontario and Quebec, it has nonetheless solidified BC's indigenous production sector by diversifying the sources of funding available to west coast filmmakers, helped the indigenous sector to grow along with the ever-expanding foreign location production sector, offered a substantial boost to the postproduction industry based in Vancouver, and played a part

Table 4.2

Foreign, Canadian, and BC spending shares in the BC film industry, 1990-2000

Year	Total spending $ millions	Foreign share $ millions	%[c]	Canadian share[a] $ millions	%	BC share[b] $ millions	%
1990	188.5	134.2	71.2	54.3	28.8	32.4	17.2
1991	176.0	103.3	58.7	72.7	41.3	25.1	14.3
1992	211.2	153.9	72.8	57.4	27.2	38.3	18.1
1993	286.0	218.2	76.3	67.8	23.7	39.2	13.7
1994	402.0	303.7	75.5	98.3	24.4	52.5	13.0
1995	432.8	322.5	74.5	110.3	25.5	35.1	8.1
1996	536.9	361.8	67.4	176.1	32.8	43.5	8.1
1997	630.5	424.5	67.0	206.0	33.0	89.0	14.0
1998	808.0	444.8	55.0	363.2	45.0	167.0	20.6
1999	1,069.9	664.1	62.1	405.8	37.9	298.0	27.8
2000	1,180.4	761.0	64.5	419.4	35.5	345.0	29.3

[a] Figures include both Canadian and treaty co-productions.
[b] Productions owned and controlled by BC companies.
[c] All percentages rounded to one decimal point.
Sources: BC Film Commission, Film info – Industry stats, <www.bcfilm.gov.bc.ca>, (15 January 2002); BC Film, News – Press releases, and News – Newsletters, <www.bcfilm.bc.ca>, (15 January 2002); Allen (2001).

Promote It and They Will Come

in the BC film industry's contribution to the diversification of the British Columbia economy. More fairly assessed in qualitative than in quantitative terms, BC Film has been a central factor in the emergence of an indigenous film tradition in British Columbia, having supported such theatrical features as *The Outside Chance of Maximilian Glick, Impolite, Harmony Cats, The Lotus Eaters, Double Happiness, Whale Music, Hard Core Logo, Kissed,* and *Better Than Chocolate.* To cite two examples, BC Film contributed $10,000 to script development and $350,000 to the production of *The Lotus Eaters,* and gave $5,000 for script development and $333,140 to the production of *Harmony Cats* (BC Film 1992, 1993).

A number of these films have distinguished themselves with critics and audiences. *The Lotus Eaters* (Paul Shapiro, 1993) and *Harmony Cats* (Sandy Wilson, 1993) each received eleven Genie Award nominations, including best-film nominations, in 1993, and John Pozer's *The Grocer's Wife* won the Prix Claude Jutra that year for best first feature film. In fact, of the eight nominees for the Jutra prize in 1993, six were BC films, the others being *Impolite* (David Hauka, 1992), *Cadillac Girls* (Nicholas Kendall, 1993), *The Burning Season* (Harvey Crossland, 1993), *Digger* (Rob Turner, 1993), and *The Lotus Eaters.* *Whale Music,* directed by Richard J. Lewis, was chosen to open both the Toronto and Vancouver film festivals in 1994, and was nominated for four Genies, including best picture. Director Mina Shum's debut feature, *Double Happiness,* was a hit on the film-festival circuit and earned $1 million at the box office when it was released commercially in the summer of 1995. Two BC films, Bruce McDonald's *Hard Core Logo* and Lynne Stopkewich's *Kissed,* were nominated for best-picture Genies in 1997. *Kissed* was selected for the Directors' Fortnight at the Cannes film festival in May 1997, and is expected to surpass the box-office earnings of *Double Happiness* to become British Columbia's most commercially successful film yet (Edwards 1997b). *Rupert's Land,* directed by Jonathan Tammuz, was nominated for five Genies in 1998, including nominations for best picture and best director (Edwards 1998c). Bruce Sweeney's third feature film, *Last Wedding,* was chosen as the opening film for the 2001 Toronto International Film Festival. Sweeney's *Live Bait* won the Toronto-City award for best Canadian feature at the 1995 festival (TIFF 2001).

TOWARD A PROVINCIAL CULTURAL POLICY

Paul Audley's cost-benefit analysis of BC Film's first five years was part of a larger review of provincial government cultural industries policy, prompted

by the New Democratic Party's return to power under Mike Harcourt in November 1991. While the Vander Zalm government had rewritten film policy ad hoc, Harcourt's NDP government set out to draft the kind of comprehensive cultural policy position for which it had long been calling from the legislature's opposition benches. Darlene Marzari, the new minister responsible for culture, established the long-term goal of increasing Victoria's arts funding to 1 percent of total provincial expenditures, and vowed to reach a level of 0.5 percent by the end of her government's initial mandate (Dafoe 1992).

The extent to which the NDP government took a different view of cultural practice than its Social Credit predecessors was made manifest when the Harcourt government released the province's first cultural policy statement in May 1995. Its opening sentence asserted: "Governments have a responsibility to protect the cultural heritage and promote the artistic expression of their citizens" (British Columbia 1995a). The statement situated culture as "part of the overall social development framework of the province," describing culture as a social good, an economic good, and "intrinsically valuable and worthy of public support." The provincial government's cultural role was to be "a partner in a sector where artists and arts organizations have the leadership role in artistic creation. The province has a supporting role through funding programs and as an advocate for the arts and culture." Finally, the BC government believed in "a cultural sector which is primarily self-reliant ... The province's overall goal is sustainability: a cultural sector which contributes fully to the province's social and economic objectives, provides stable employment to its practitioners and a stable environment to its stakeholders."

To give these words substance, the Ministry of Small Business, Tourism and Culture introduced a package of initiatives under the title CultureWorks! (British Columbia 1995b). The package included a commitment to create a BC Arts Council during the 1995 legislative session, $4 million in additional funding to arts and culture programs, $50 million in infrastructure projects, $2.5 million to cultural organizations, $850,000 to cultural industries, and $400,000 to marketing initiatives. A message from Premier Harcourt read, in part: "CultureWorks! is an affirmation that the arts have a deep significance for British Columbia as a society, for it is through the arts that we define ourselves."[15]

Historically, British Columbia had had a sorry record in funding the arts;

in the fiscal year 1990-1, for example, Victoria spent $14,984,000 ($6.1 million of this on the film industry alone), which represented just 4.5 percent of the spending by all the Canadian provinces on the cultural industries. Given that British Columbia accounted for close to 12 percent of the country's population and 12.3 percent of Canada's gross domestic product, this was deemed inadequate. As Audley (1993a, 27-30) concluded, it was partly due to the provincial government's general neglect of cultural practices that British Columbia "receives a much lower share of federal cultural spending than would be proportionate to its population." In fiscal 1990-1, British Columbia received just 5.3 percent of federal spending on the cultural industries (although the province received a more respectable 10 percent of Ottawa's film and video spending that year).

Audley was commissioned by the Ministry of Tourism and the Ministry Responsible for Culture to recommend a framework for the development of cultural industries policies for British Columbia, and the first thing he did was to call into question the privileged perception of cultural production as commodity production. Among his first recommendations was that "cultural industries policies for British Columbia should be developed within a conceptual framework which recognizes their primary role, both in British Columbia and in Canada, as instruments of cultural expression and communication, involving a diverse range of content which is important to social, political, economic and cultural development" (Audley 1993a, 11). The key policy issues to be addressed were those "related to the creators of original BC cultural works, the financing of production, access to distribution, domestic and export marketing, the use of the province's purchasing power and publicly owned distribution systems, technology, training and skills development, and the establishing of an ongoing statistical database and research activity" (39).

But while Audley (1993a, 15) foregrounded the cultural goals of policy development, he did not overlook the economic rationale in his policy recommendations: "In considering the priority that should be given to the cultural industries in developing policies for economic growth and diversification, the Province of British Columbia should take into account the fact that both domestic and foreign markets for cultural works are expanding far more quickly than the economy as a whole, and account for a growing share of GDP and employment in Canada." The BC film industry provided him with a ready example; he noted that "the progress that has been made in the

film and video industry provides firm evidence that, with a reasonable commitment of provincial resources, there could be rapid growth in cultural industries production within the province" (16).

A film policy review, which began in August 1992, was to be the first phase in a staged approach to policy development, to be followed by research and policy development for the periodical and book publishing industries, the sound recording and music publishing industries, and the crafts and design industries (Audley 1993a, 35-6).

FILM POLICY REVIEW

With considerable provincial government input – under the leadership of both the right-leaning Socreds and the left-leaning NDP – the BC film industry was restructured between 1985 and 1993 to address the weaknesses that most immediately threatened its future: studio capacity and financial support from the federal and provincial governments. While the financial commitment of the federal government's funding agencies to west coast filmmaking remained a policy concern, the most pressing challenge after 1993 became finding a way to increase private investment in indigenous film production.

In spite of the increasing amounts of foreign spending on filmmaking in the province – more than $300 million annually by 1994 – the fear persisted that without a viable indigenous production sector the BC film industry remained vulnerable to collapse. The global mobility of Hollywood film production was a fact of life by the 1990s (see Gasher 1995; Pendakur 1998), and to British Columbia this meant that a fluctuation in the Canada-US currency-exchange rate, or poor labour relations in the BC film industry, could be enough to send foreign producers packing for more hospitable locations.

Private-sector investment in indigenous production thus became the principal policy target, and Audley's *Policy Recommendations for Future Development of the Film Industry in British Columbia* (1993b, vii-viii) insisted that the initiatives recently undertaken by the Quebec and Ontario governments indicated that "the role of providing an incentive to private investment has now shifted from the federal to the provincial level of government." Victoria would be called upon to become further implicated in the BC film industry. Among Audley's principal recommendations were: the establishment of the BC Production Investment Program, which would offer a rebate to BC investors ranging from 15 to 20 percent (depending on BC- and Canadian-content levels, and how much of the budget was spent in the province);

and a $9 million budget increase over five years to the Knowledge Network "for the purposes of increasing its expenditures to acquire independently-produced B.C. productions" (viii-xi).

What is most striking about this policy document is not its specific recommendations – private-investment incentives had been proposed before, and a provincial tax credit was not introduced until 1997. Rather, it is the manner in which the report depicts Canada's three principal production centres as rival jurisdictions competing to attract both foreign location production and indigenous production spurred by "location-neutral" federal funding vehicles. For example, "Unless British Columbia offers its producers support comparable to that available in Ontario and Quebec, those producers in British Columbia who wish to be involved with genuinely indigenous production will be at a substantial disadvantage, and are unlikely to maintain, much less expand, their market share. An important part of the research we have conducted has involved assessing the existing incentive structure in British Columbia to see to what extent it meets the needs of domestic producers in the province, and how it compares in effectiveness with the incentives available in Ontario and Quebec" (Audley 1993b, 48-9). British Columbia was, in this view, less a branch, or even a junior partner, in a national film industry, than it was a competitor with Ontario and Quebec. The BC Film requirement that eligible productions spend at least 75 percent of their budget in the province inhibited interprovincial co-productions (see Macerola 1997). British Columbia, in fact, enjoyed a closer relationship with Hollywood than with its sister provinces, given British Columbia's record of averaging a 50 percent share of Hollywood production budgets. Interprovincial rivalry would inform BC film policy throughout the 1990s. Toronto was Vancouver's principal rival for the distinction of being North America's third-largest centre of film and television production – i.e., Hollywood North – after the states of California and New York. Montreal was making its own bid for the title by 1996.[16]

But if the competition to attract foreign location production among Canada's three largest cities could be described as generally healthy – after all, 250 jurisdictions around the world were vying for runaway production contracts – the rivalry for federal film funding became increasingly bitter. Even though the BC government had taken steps to address its underfunding of the film industry, the leveraging power of its investments began to fade, and BC producers began accusing the federal cultural institutions of a central

Canadian bias. The Interagency Committee on Film Development Policy (1992, iii), for example, perceived federal cultural expenditures in British Columbia as "considerably disproportionate" to the province's share of the Canadian population. Much more strongly worded was a public notice filed with the Canadian Radio-television and Telecommunications Commission in April 1997, in which the BC Motion Picture Association accused Ottawa and its funding institutions of consistently shortchanging BC filmmakers. The opening sentence of the BCMPA notice reads: "The single undeniable fact of public policy in Canada regarding the indigenous film industry, is that regional inequities in the delivery of federal government funding have caused concentration of such funding to be regionalised in Ontario and Quebec, to the detriment of the British Columbia film community."

The principal target of the BCMPA's hostility was Telefilm Canada, but the association maintained that the CBC's track record in British Columbia "has been equally dismal" (BCMPA 1997, 1). The BCMPA noted that the CBC's contributions to BC film projects, which had ranged from $4.01 to $5.76 million between 1990 and 1995, dropped to $1.06 million for 1995-6 and just $570,000 for the first half of 1996-7. (One month after the BCMPA filed its report, the CBC announced that it was picking up *Da Vinci's Inquest*, a new, hour-long drama series about a Vancouver coroner, for its fall 1998 prime-time schedule [Edwards 1997c]).

Telefilm Canada, though, has been the BC film industry's favourite federal target because it is the country's most powerful funding agency, responsible for some $160 million annually. The BCMPA (1997, 3-4) also noted that Telefilm Canada's contributions to British Columbia producers through its Feature Film Fund had dropped each year, from $3.54 million in fiscal 1992-3 to just $700,000 in 1995-6. BC companies received no money from Telefilm's Feature Film Distribution Fund for four consecutive years, from 1992-3 to 1995-6, and British Columbia received nothing from Telefilm's Commercial Production Fund for five straight years, from 1991-2 to 1995-6.

Not only was British Columbia denied representation on the board of directors of the Canadian Television and Cable Production Fund when it was established in September 1996, but BC companies received just 4 percent ($1.4 million) of the fund's $46.2 million in its first year of operation, and 5.4 percent ($4.3 million) of the $80 million the fund committed in its second year (BCMPA 1997, 1-12). The BCMPA charged: "B.C. companies consistently receive a proportionally lower share of funds from the crown corporations of

Promote It and They Will Come

Canadian Heritage such as Telefilm Canada, which has resulted in B.C. sub-sidizing the development of the cultural industries in Ontario and Quebec for over 20 years" (2). Wayne Sterloff, president and chief executive officer of BC Film from its inception until 1997, commented: "The federal government has implemented policies at Telefilm that prevent a culture being supported in British Columbia" (Rice-Barker 1997).

In its defence, Telefilm made two points. In a letter to Sterloff dated 16 May 1997, Telefilm executive director François Macerola noted, first, that Telefilm's annual commitment to British Columbia between 1990-1 and 1995-6 represented 13 percent of Telefilm's total development and production commitments. If the CBC had not cancelled the British Columbia-based series *Northwood, Odyssey, Mom P.I.,* and *Max Glick,* Macerola maintained, Telefilm's investment would have been 17 percent of its total budget (Macerola 1997). Second, Macerola noted the BC government's own declining commitment to indigenous production. BC Film's annual budget was cut from $5.1 million in fiscal 1993-4 to $3 million in 1997-8 (Rice-Barker 1997). Due to these cuts, BC Film had to suspend its distribution program, through which it bought shares in participating distribution companies. In 1994, for example, BC Film bought a 25 percent interest in TSC Film Distribution, the first distribution company to base itself in Vancouver (Edwards 1996a). Macerola (1997) also noted that BC Film's requirement that 75 percent of an eligible production's budget be spent in British Columbia made interprovincial cooperation difficult.

Both sides made gestures toward resolving the problem of regional fund-ing disparities in the fall of 1997. In September, Telefilm adopted a plan to allocate pockets of funding for western Canadian producers – a measure for which the BC industry had been lobbying – and Telefilm promoted Elizabeth Friesen, an advocate of decentralization, as its new director of operations in Vancouver (Edwards 1997e).[17] In October, the BC government announced plans for a provincial tax credit, to take effect 1 April 1998, bringing the province in line with Manitoba, Ontario, Quebec, New Brunswick, and Nova Scotia, all of which had tax-credit programs to support local film produc-tion. Entitled Film Incentive BC, the plan provides British Columbia-based production companies with a tax credit of up to 20 percent of their labour costs (British Columbia 1997).

Under Film Incentive BC, the provincial government offers a refundable tax credit on a portion of producers' investment in film and television projects.

A "basic incentive" refunds up to 20 percent of eligible labour costs, which are capped at 48 percent of total production costs. In addition, the program offers two "bonus incentives." A training incentive allows producers to claim a refund of up to 3 percent of eligible labour costs for providing training opportunities for workers entering the industry. A regional production incentive allows producers to claim a refund of up to 12.5 percent of labour costs if principal photography occurs outside of the Vancouver area. Producers can access the basic and bonus incentives together, or the bonus incentives alone. To access the basic incentive, a production company must be British Columbia-controlled and have copyright ownership of the project. The regional and training incentives are available to British Columbia-based companies with Canadian ownership. Qualifying projects must incur a minimum of 75 percent of production and postproduction costs in the province, and must meet CAVCO guidelines for Canadian broadcast content, according to the British Columbia Film Web site.

In November 1997, the federal government offered what seemed to be further good news to British Columbia. The Finance Ministry in Ottawa announced a tax credit for foreign producers shooting in Canada, which permits them to claim 11 percent of eligible labour costs, up to a maximum of 5.5 percent of their total budget. The film and video services production tax credit was designed to replace a federal tax shelter called the Production Services Limited Partnership, which expired 31 October 1997 (Edwards 1997f). Instead of simply shoring up Canada's competitive edge in the runaway production sweepstakes, the federal announcement sparked renewed rivalry among its filmmaking provinces. On 17 November 1997, Ontario announced the 11 percent Ontario film and television production services tax credit, in effect doubling the tax credit to foreign producers if they chose to shoot in Ontario (Hoffman 1997b). While the bulk of Ontario's film activity is domestic production, foreign location production remains significant to the Ontario film industry. In 1996, for example, Ontario attracted $252.8 million in direct spending from foreign producers, which represented almost 48 percent of the province's $530 million in total activity (TV, film 1997).

The Ontario announcement, coming so quickly after the federal program was introduced, was a provocative gesture and caught British Columbia by surprise. BC Film chairman Michael Francis told *Playback*: "We've worked for years to have an even playing field in Canada. Now it's uneven again. It's very disappointing and far from the spirit of fair trade among the

Promote It and They Will Come

provinces" (Hoffman 1997b). A Coopers & Lybrand survey released in March 1998 estimated that 65 percent of foreign film and TV producers working in British Columbia would "very likely" relocate to take advantage of production services tax credits, costing British Columbia up to $275 million in direct spending, $100 million in wages, and 5,300 jobs (Edwards 1998a).[18]

Quebec was the first province to respond, matching the Ontario program in its 31 March 1998 budget, in the interest of encouraging "fair competition" between the Canadian provinces (Rice-Barker 1998). British Columbia announced its own 11 percent production services tax credit on 1 June 1998. At a press conference on the set of the television program *The Viper* at the new Paramount Studio Complex in Vancouver, Premier Glen Clark stated: "Not only will this new incentive help keep jobs and the industry thriving in B.C., but it will lead to job creation. By helping keep B.C. competitive with other jurisdictions, the film industry tells us it can grow by 10 percent each year in the next decade, resulting in more than 45,000 new direct and related jobs. This incentive is part of a commitment made in the provincial budget to grow the film and television industry" (British Columbia 1998; Bula 1998).

LABOUR MARKET COMPETITION

This rivalry among the provinces for film industry business was not, however, confined to government; organized labour was also implicated. David G. Murphy (1997) depicts the BC film unions as central collaborators in the project of building a film industry on the west coast. And like the provincial government, the unions found themselves fighting with their counterparts in Toronto to maintain both their independence and their competitive edge. As a national film industry based in Ontario and Quebec emerged in the late 1960s and early 1970s, Murphy writes, "national film industry associations attempted to spread their control of the industry to B.C." (538).

The US-affiliated technicians' (IATSE Locals 891 and 669) and drivers' (Teamsters Local 155) unions, and the BC branch of the Directors Guild of Canada, had the autonomy to negotiate their own collective agreements, as required by BC labour law. Performers and writers, on the other hand, were governed by the national office of the ACTRA Performers Guild in Toronto. When the local ACTRA branch signed a collective agreement with an American television producer in 1989, there was a prolonged dispute between the national and local offices. Ultimately, two rival performers' unions emerged:

ACTRA-BC and the Union of British Columbia Performers. "In the midst of this turmoil," Murphy (1997, 541-2) notes, "two Toronto based technicians' unions, the Association of Canadian Film Craftspeople (ACFC) and the National Association of Broadcast Employees and Technicians (NABET), opened offices, in 1989 and 1994 respectively, to compete with the established Locals 891, 669 and 155." A measure of labour peace was assured in 1996 when ACTRA-BC and the Union of BC Performers merged (Birnie 1996), and the BC and Yukon Council of Film Unions, representing IATSE Locals 891 and 669 and Teamsters Local 155, negotiated a master agreement with the Alliance of Motion Picture and Television Producers, representing the American production community, and the British Columbia branch of the Canadian Film and Television Production Association (Lee 1996; Hiltz 1997).

Manjunath Pendakur (1998) sees the rivalry for film work among Canadian unions as part of a global phenomenon that pits worker against worker in the bid to provide mobile American producers with "more for less." Labour remains organized regionally, while the industry expands globally: "Neither Canadian nor international unions appear to be ready to negotiate with the emerging entertainment industry. They are caught up in the daily demands of survival in which narrow economic interests set the agenda. In the final analysis, workers are pitted against each other: local against local, national versus the provincial, and so on" (237). Pendakur concludes, "In the short run, the strategies pursued by the unions in B.C. appear advantageous to their immediate goals of creating employment in a crisis-ridden economy. Given the changes in the global economy in the last decade and the liberalization regimes at work in many economies around the world, organized labor faces a critical dilemma of choosing between long-term needs and short-term opportunities. B.C. unions have chosen the former, and their leadership is not certain whether this is the right path" (236).

While, as noted above, Canadian film workers are pitted against each other in the interprovincial rivalry to attract audiovisual production, the international dimensions of this contest became evident in the spring and summer of 1999 when film workers in southern California protested increases in runaway production. One thousand actors, directors, and technicians staged a rally in Burbank in April under the banner of the Film and Television Action Committee. California state assemblyman Scott Wildman, describing runaway production as "a real crisis," introduced a bill calling for a 10 percent tax credit on below-the-line labour costs incurred in California

(Barker and Edwards 1999). A second rally along Hollywood Boulevard attracted 2,000 film and television workers in August (Movie, TV 1999).

The Directors Guild of America and the Screen Actors Guild commissioned a study by the Monitor Company as part of a lobbying effort to convince Washington to curtail film work leaving the United States. The Monitor study concluded that US$2.8 billion in direct production expenditures was lost to runaway production in 1998, with 81 percent of that amount spent in Canada. DGA president Jack Shea commented: "It is impossible to look at this study and say that the issue does not pose a grave threat to the future of film and television production in the United States" (DGA 1999). The report concluded that US producers shooting in Canada could realize a 25 percent saving from the combination of exchange rates, lower costs, and government incentives, while working with production crews of comparable quality to those in New York and Los Angeles. Approximately 60 percent of the savings result from below-the-line labour cost differences (Monitor Company 1999).

The International Trade Administration of the US Department of Commerce issued its own report on runaway production in February 2001. While the report noted that runaway production was a serious threat to the United States' positive trade balance in services (5), it did not recommend specific action, and the Department of Commerce subsequently rejected calls for trade action against Canada (Russo 2001). Nevertheless, a bill calling for wage-based tax credits to encourage small and mid-size productions to remain in the United States was introduced in Congress in October 2001 (Garvey 2001a).

CINEMA AS INDUSTRY

The object of policy discourse in British Columbia is less *cinema*, whether as a means of communication, an art form, or a symbol of membership in a sub-national community, than it is *industry*, which has the potential to draw investment capital to the province from both private and public sources, create jobs directly and indirectly, and, ultimately, expand and diversify the provincial economy. Even after 1986, when policy documents began to prioritize the encouragement of indigenous film production, and the issue of "culture" was raised by Quenville (1986), Audley (1986, 1993a), and Premier Mike Harcourt (British Columbia 1995a, 1995b), the principal motivation remained the desire to stabilize an industry deemed vulnerable to Hollywood's increasing mobility and seen to be consistently shortchanged by

federal funding policies. Provincial film policy reflects the view that British Columbia is less a partner contributing to a shared enterprise called national cinema, than it is a rival jurisdiction to Ontario and Quebec in the industry of Canadian audiovisual production. Further, British Columbia is one of hundreds of competitors around the world seeking to attract the capital, employment, and regional industrial development associated with foreign location production.

5

Locating British Columbia As Cinematic Place:
Contending Regimes of Film Production

British Columbia's industrial approach to cinema has an obvious impact upon the kinds of feature films produced in the province. By bringing together both non-resident and indigenous producers, the industry creates an interface between distinct regimes of production – transnational and regional/local – each of which embeds its films in their site of production in particular ways.

The distinction between the way foreign and indigenous producers locate British Columbia in their films, however, should not be drawn too neatly. If Hollywood filmmakers consistently appropriate British Columbia within a continental cinemascape – emphasizing its physical geography, the topographical, climatic, and natural historical features that adjoin the province to Washington, Idaho, Montana, and Alaska – indigenous producers are far more ambivalent in how they situate British Columbia as both a narrative setting and a film production location. Some BC films are indistinguishable from Hollywood productions. Others lay claim to British Columbia as a place of culture, as a source not only of scenery but also of characters, stories, and social particularities.

Feature films are highly constructed spatial and temporal environments whose narrative boundaries, while they may be guided by politics and history, are constrained only by the imaginations of the filmmakers. For this

reason, these spatio-temporal constructs play a signifying role; they grant meanings to place by imagining place in particular ways. Place becomes the setting for a story, a milieu that contributes to the story's tone, atmosphere, and possibly its central themes. Most movies, Robert Fothergill (1977, 347) observes, "do indeed convey, inadvertently or by design, some fragmentary image of a milieu within which their stories are set."

Geographer Edward Relph (1986, 141) notes that identities of place are not given, but result from a complex and dynamic interrelationship between nature and culture: "Places are not abstractions or concepts, but are directly experienced phenomena of the lived-world and hence are full with meanings, with real objects, and with ongoing activities." Specifically, Relph argues that identities of place result from three interrelated components: physical features, activities and functions, and meanings or symbols (61-2). Filmmaking engages all three of Relph's place-defining components. On a symbolic level, films depict the physical features of place, and through their narratives attribute particular meanings to place: wild west, desolate seaport, cosmopolitan urban centre, sleepy village. On a material level, filmmaking is one of the activities and functions of place, employing workers with a range of skills in a labour-intensive industry. It is what people in that place do.

It is common in filmmaking for one place to stand in for another. But what is noteworthy in British Columbia's case is the degree to which the province has built an industry based on its malleability, selling itself to Hollywood as a place that is willing to stand in for anywhere or nowhere. This chapter compares the way the British Columbia feature film industry's two regimes of production depict British Columbia. The implications of these imaginings are then considered in terms of British Columbia's sense of place.

HOT PROPERTY

Because, as noted in Chapter 4, tourism promotion was part of the provincial government's impetus for developing a feature film industry in British Columbia, it is ironic that the province is so well disguised in most films that only those moviegoers who stay until the very end of the credits will know where the films were shot. The BC Film Commission, the institution established by the BC government to promote foreign service production, deliberately markets the fact that its film locations can be disguised as Anywhere, USA.

British Columbia's role as an industrial site of production within the

Locating British Columbia As Cinematic Place

transnational film industry is very much in keeping with the promotional efforts of the BC Film Commission. The BCFC initially promoted the province exclusively as a film location, playing up its natural attributes – the beauty and diversity of its landscapes, the proximity of such diverse locations to Vancouver, British Columbia's proximity to southern California, a shared time zone with Los Angeles – and a favourable currency-exchange rate. As British Columbia's fledgling industry evolved through the 1980s, and Vancouver companies offering both production and postproduction expertise proliferated, the BCFC's mandate came to embrace four main areas of activity: international marketing, location production services, liaison between the film industry and the community, and providing information to the general public, the news media, industry, labour, and government (BCFC 1997).[1]

Operating on an annual budget of approximately $1.5 million,[2] the BCFC competes with about 250 rival jurisdictions to attract a share of what the American Film Marketing Association estimates is $20 billion worth of film, video, and television production by Hollywood annually (Mitchell 1997). These competing jurisdictions include all of the provinces and territories in Canada, American states such as New York, Florida, North Carolina, Texas, and Illinois, and countries such as Australia, Great Britain, Ireland, Luxembourg, the Bahamas, Jamaica, and Poland (see Gasher 1995).[3]

At the time the BCFC was founded in the late 1970s, less than 15 percent of Hollywood production occurred beyond the greater Los Angeles area. British Columbia's relatively early entry into the promotion of location production is responsible for one of its singular advantages: a solid and long-standing reputation among LA producers who were at first nervous about working away from their home base. Recounting that early history, the BCFC's 1997-8 business plan states: "Having little experience in other jurisdictions, [producers] were understandably cautious, bringing entire crews on location and shipping unprocessed film back to Los Angeles. It also meant that when they discovered a community or location they could trust, they became very loyal."[4] The plan claims runaway production accounted for about 40 percent – or $8 billion worth – of the North American film and television production market in 1997 (BCFC 1997, 6-8).

There is little question that the BC Film Commission has been successful in its first twenty-five years of location promotion. Early high-profile films were *First Blood* (1982), the original Rambo film directed by Ted Kotcheff and starring Sylvester Stallone and Brian Dennehy, *Rocky IV* with Stallone and

Talia Shire (1985), the Bill Forsyth film *Housekeeping* (1987), and *Roxanne* with Steve Martin and Daryl Hannah (1987). British Columbia's Hollywood film credits now include: *The Accused, Shoot to Kill, Stakeout, Look Who's Talking, We're No Angels, Jennifer 8, Rumble in the Bronx, Alaska, Happy Gilmore, Jumanji, Freddy Got Fingered, Josie and the Pussycats,* and *Saving Silverman* (see Appendix). The BC film industry maintained an annual growth rate of more than 20 percent from 1986 to 1996, and attracted a record $1.18 billion in direct spending on 192 productions in 2000 (see Table 5.1; BC Film Commission 2001b).

The BC Film Commission sells producers on British Columbia locations in two ways: international marketing and direct contact with producers in the preproduction stage. The BCFC creates awareness of the province and the film services it offers through reportage in both the mainstream media and industry trade publications, by advertising in trade publications, and by maintaining a presence at industry conferences such as the Banff Television Festival, MIPCOM (an international market for film and television programs in Cannes), the Cannes Film Festival, and the annual Film Commission Trade Show in Los Angeles.

Members of the BCFC staff also work directly with producers at three different stages of a project. At a preliminary stage, the BCFC receives and assesses film scripts, breaks them down into component locations, matches

Table 5.1

BC film industry, 1990-2000

Year	Total productions	Feature films	Total spending ($ millions)	Foreign spending ($ millions)	Canadian spending[a] ($ millions)
1990	50	16	188.5	134.2	54.3
1991	53	12	176.0	103.3	72.7
1992	63	16	211.2	153.9	57.4
1993	73	26	286.0	218.2	67.8
1994	85	32	402.0	303.7	98.3
1995	95	35	432.8	322.5	110.3
1996	102	34	536.9	361.8	176.1
1997	106	24	630.5	424.5	206.0
1998	171	28	808.0	444.8	363.2
1999	198	54	1,069.9	664.1	405.8
2000	192	56	1,180.4	761.0	419.4

[a] Figures include both Canadian and treaty co-productions.
Sources: BC Film Commission; *Playback; Canada on Location; Reel West Magazine.*

Locating British Columbia As Cinematic Place

stock photographs from its library to the component locations, and returns the script with proposed BC locations to the producer. At the same time, the producer may be considering any number of jurisdictions in which to mount the project. If the producer remains interested in the province, the BCFC then provides personnel to accompany members of the production team on a scouting trip of potential locations around the province. At this point, the producer may still be considering two or three jurisdictions as candidates. If British Columbia is finally chosen as the location for the film, the BCFC works with the producer throughout the location shoot, providing research assistance, location expertise, and general information (BCFC 1997).

The BC film industry is made up of three types of productions. Television movies-of-the-week are the most sensitive to cost differentials between locations, based as they are on relatively slim profit margins and tight, four-week shooting schedules. Since most of these productions now use unionized crews, they are cheaper to shoot in Canada than in the United States, and Vancouver's stiffest competition for MOWs is Toronto and Calgary. Television series operate on ten-month shooting schedules, and require conducive climatic conditions and diverse locations. Most TV series are shot on the west coast, and therefore Vancouver competes with Los Angeles, San Francisco, and San Diego (Mitchell 1997). With average negative costs of US$51.5 million (as of 1999; see Magder and Burston 2001, 210) and shooting schedules ranging from eight to twelve weeks, major Hollywood feature films tend to be "location-driven," and therefore much more mobile than television shoots. In this sector, British Columbia competes with locations all over the world. Canadian features, on the other hand, are "funding-driven," and British Columbia's ability to attract indigenous features has been handicapped somewhat by its poor track record of attracting federal funding (Mitchell 1997).

The BC Film Commission's success in brokering a partnership between the BC and Hollywood film communities over the past two decades, however, has also revealed a central structural weakness; the BC film industry is overly dependent on Hollywood, rendering it vulnerable to such factors as the Canada-US currency-exchange rate and shifts in labour costs among competing jurisdictions. There is nothing to prevent Hollywood producers from leaving British Columbia as suddenly as they arrived, should any of the elements of British Columbia's competitive position change.[5]

For this reason, the BC Film Commission's 1997-8 business plan called for the promotion of British Columbia as a centre for investment, by

encouraging the major Hollywood studios to establish stable roots in Vancouver and by attracting US and Canadian investment capital to the industry. The next phase, then, encouraged commitment: "The preferred outcome is a permanent facility from one or more of the [major Hollywood] Studios including development, production, postproduction, distribution and marketing operations." The commission set the goal of attracting two major Hollywood studios to invest in British Columbia within five years (BCFC 1997, 9-11).

Some gestures by Hollywood have already been made in this direction. Aaron Spelling Productions, a prolific Hollywood television producer known for such series as *Beverly Hills 90210, Melrose Place, Dynasty,* and *Charlie's Angels,* opened a production and development office in Vancouver in 1992 (Trustcott 1992; BCFC 1992). Walt Disney Studios established an animation studio in Vancouver in December 1996, initially hiring forty-five people to work on the direct-to-video release *Beauty and the Beast: Christmas Belle* (Edwards 1996b). Unfortunately, Walt Disney Animation Canada closed its Vancouver and Toronto studios in 2000 (Vamos and Edwards 2000). Another Hollywood major, Paramount, opened the Paramount Studio Complex in Vancouver in June 1997. With a five-year lease on an empty Molson Brewery distribution centre, the complex houses four sound stages and a production office. Employing 350 full-time staff, the facility is the home of Paramount's *Viper* and *Sentinel* TV series (Edwards 1997d).

Canadian companies have also made investments in Vancouver. Former securities trader Frank Giustra established the publicly traded company Lions Gate Entertainment in 1997 with the purchase of three well-established film companies: the production company Mandalay Television of Los Angeles; the Montreal-based producer and distributor Cinepix Film Properties; and Canada's largest production facility, North Shore Studios, renamed Lions Gate Studios (Gibbon 1997b). Lions Gate Entertainment is involved in the production and distribution of motion pictures, the production of television and animated programming, a video-on-demand service, production management services, and studio operation (Lions Gate Films 2001). Four former executives of Toronto's Alliance Releasing – Tony Cianciotta, Mary Pat Gleeson, Dave Forget, and Maria Muccilli – formed a Vancouver distribution company called Red Sky Entertainment in September 1997 (Monk 1997; Hoffman 1997a). None of the founders remain with the company, which was taken over by Vancouver's Keystone Entertainment in November 2000 (Edwards 2000). Keystone is in the

Locating British Columbia As Cinematic Place

business of feature film production and distribution (Keystone Entertainment 2001). And a new English-language television station in Vancouver, CIVT, began broadcasting in fall 1997, with a promise to draw on the local production community for 95 of the 121 hours of programming the station will produce each year. A key factor in the success of Toronto-based Baton Broadcasting's application to the CRTC for a Vancouver TV licence was its pledge to award to independent producers half of its $72 million in programming over the seven-year term of its licence (Gibbon 1997a; Dafoe 1997).

Studio investment would also alleviate a chronic shortage of studio space in the Lower Mainland. While a number of studio complexes have cropped up in the greater Vancouver area, most are warehouse spaces converted temporarily to audiovisual production use. The preferred sites remain three purpose-built facilities. Lions Gate Studios in North Vancouver has seven sound stages ranging in size from 1,000 to almost 2,000 square metres. Bridge Studios in Burnaby offers six sound stages ranging from about 850 to 1,060 square metres, as well as North America's largest effects stage, measuring 3,750 square metres. The newest facility, Vancouver Film Studios, has thirteen sound stages ranging from 530 to almost 4,300 square metres (Studio facilities 2001). Lions Gate began work on an eighth stage in July 2001, while Vancouver Film Studios began construction on two new studios in August 2001 (Tolusso 2001).[6]

British Columbia's rapid growth as a production centre has created other problems. An estimated 80 percent of all film and television productions in British Columbia are shot in the Lower Mainland, occasionally requiring the BC Film Commission to rule certain overused locations – "hot spots" – out of bounds. Gastown, to cite the best example, attracts the equivalent of 460 shooting days per year. Such concentrated activity tests the patience of area residents and merchants and leads to complaints to the film commission (see Parton 1995).[7]

Also there has been a shortage of crews during peak shooting periods. This is a shortage less of school-trained film technicians and above-the-line personnel than of "vocational" workers – such as hairdressers, carpenters, and electricians – with film-industry experience (Mitchell 1997).

BRITISH COLUMBIA AS CINEMATIC PLACE

An examination of the BC Film Commission's promotional materials reveals the extent to which the location production industry is designed to serve

industrial and economic objectives, and the degree to which cultural consid-erations are excluded (BCFC 2001a).[8] The BCFC promotional literature sells British Columbia as a place in two registers: place as backdrop or setting, and place as industrial site. In casting place as backdrop, the BCFC promotes the province's protean nature. The region, that is, can play any number of narra-tive settings, depending on the needs of the production. Typically, Vancouver is transformed into an American city such as Seattle or San Francisco, and British Columbia becomes part of the US Pacific Northwest. In this way, place becomes a natural resource whose physical geography and architecture can be framed to represent any desired space. Both the social and geograph-ical identity of place are thereby effaced. In casting place as a commercial site, the promotional literature peddles the region's economic, topographical, climatic, architectural, and human resource attributes as advantageous to film and television in a range of ways, from the aesthetic to the cost-effective. This discourse of regional economic and industrial development integrates the BC audiovisual production community into a larger industry based in southern California.

How the BCFC literature empties place of its specificity and constructs British Columbia as nonplace or anyplace merits particular attention. Its locations brochure, *The British Columbia Shooting Gallery* (BCFC 2001a), provides an excellent example of this, particularly in its use of language to emphasize the malleability of British Columbia as a place, and in its framing of the imagery to emphasize variability and adaptability. The subject of the locations brochure is place as backdrop, but it also alludes to place as com-mercial site. The front cover features a dramatic aerial view of a film shoot in downtown Vancouver, a photograph framed by the brochure's title and the claim: "We can give it to you for a song." This tag line refers to the afford-ability of shooting, production, and postproduction in British Columbia, an advantage that is more clearly articulated and more fully elaborated upon inside the brochure and elsewhere in the promotional package.

The brochure's first inside spread situates the backdrops the region offers within a fuller industrial context, promising three kinds of services to the audiovisual production community: locations, "know-how," and assistance throughout film shoots. Subsequently, on pages 4 and 5, the brochure outlines the BCFC's specific roles. Like the photograph on the front cover, the two photographs that accompany this text depict actual film shoots: a set from the 1990 Hollywood feature *Bird on a Wire* on "the world's second largest

special effects stage," and another shoot in front of the provincial legislature in Victoria. The *Bird on a Wire* photo foregrounds the technical capabilities of the province as a production centre, while the Victoria photo emphasizes locations.

The back cover of the brochure reads like a BCFC advertisement. Under the provocative title "Come and get it ..." is an aerial postcard image of Vancouver – the urban core in the foreground, Stanley Park, the Strait of Georgia, and the mountains beyond – with supporting text summarizing what the BCFC offers: "superb locations," "full production facilities," and "step-by-step assistance." The image graphically situates Vancouver as an urban site and service centre close to ocean, forest, and mountains, themselves diverse locations.

The remainder of the brochure is devoted primarily to picturesque images from throughout British Columbia, organized by genre – "The Big City," "Urban Ethnic," "The Wild West" – and emphasizing British Columbia as backdrop. Two points that are crucial to how the BCFC promotional literature constructs place are the brochure's visual depictions of British Columbia as anyplace any time, and the use of language to invest the images with particular meanings.

The first point concerns the photographic images themselves and, specifically, how they are framed to emphasize their malleability as stages on which to set audiovisual productions. Under the generic heading "The Big City," for example, are four urban landscapes. While each is specifically identified by a fine-print caption, the images themselves are composed to assert their lack of specificity, their potential as urban anyplace. The images generically denote urban waterfront, rather than Vancouver waterfront, an urban alleyway, rather than a Vancouver alleyway. The photographs could have been taken in any number of cities. The text that accompanies these photos reinforces the point: "What do New York, Hong Kong, Los Angeles, turn-of-the-century Boston, Detroit, London, and San Francisco all have in common? Answer: We've been stand-ins for all of them, right here in versatile British Columbia." With the exception of the image on the back cover, none of the photos in the brochure is meant to be identifiable as Vancouver or British Columbia. Photos of industrial plants in Vancouver and Campbell River, for example, merely signify "industry." Similarly, mountainscapes, seascapes and rural landscapes are malleable as anywhere settings.

A second striking feature of the photographs is the absence of people,

or, at least, the de-emphasis of the social dimension of these landscapes. If people are not completely absent – as in photos of downtown Vancouver, various industrial sites, a Kerrisdale street scene, Gastown – then they are framed as an insignificant part of the landscape. Some of the photos are more remarkable than others in this regard, as if the photographer *removed* those who would normally occupy these spaces. For example, the lobby of Vancouver's Pan Pacific Hotel is a site accustomed to heavy human traffic, and it is hard to imagine when it would *not* be busy with people. Other photographs quite explicitly present location sites as empty film sets waiting to be peopled by performers. The text that accompanies photographs of the legislative chambers in Victoria and the Orpheum Theatre in Vancouver refers to such indoor locations as "standing sets."

Two notable exceptions to the unpeopled landscapes are photographs of Barkerville's Main Street and of three costumed Native dancers performing at the University of British Columbia. In both cases, the people depicted are themselves performers. Barkerville, for instance, is a kind of theatre, a museumized gold-mining town staffed by actors in late-nineteenth-century costume. The photograph of the Native dancers is worth particular attention as an exception that proves the larger rule of the BCFC promotional material. Of all the images, this is the most explicitly peopled, as the dancers are foregrounded both in the picture and in the text. The photograph, in other words, is of *them,* not the site upon which they are performing. The text, too, draws attention to the "rich and unique culture" of the Haida, Kwakiutl, Kootenay, and Kitsilano people, "Proud people willing to share their heritage with you." This page of the brochure constructs a message that is distinctly contrary to the rest of the literature, in that it is the only part of the larger BCFC discourse that constructs place in social and cultural terms. These people have their own stories to tell, and the international production community is invited, for once, to leave its scripts behind and tell a local story. This, of course, is not what location production is about.

The brochure also uses contrasting imagery to assert malleability, and the text accompanying these images demonstrates the degree to which discourse – that of the brochure, that of the feature film narrative – defines place. The last two inside pages of the brochure, entitled "Fruit Farms" and "Coastlines," are indistinguishable from a tourist brochure. The two images under "Fruit Farms" are pastoral scenes from the Okanagan Valley: a Penticton apple orchard and an Osoyoos vineyard. Nothing in either of the images

Locating British Columbia As Cinematic Place

or in the accompanying text makes reference to audiovisual production. Similarly, the "Coastlines" page features a sweeping aerial photo of ocean waves crashing onto Long Beach on the west coast of Vancouver Island, with well-treed mountains forming the backdrop. Again, there is no visual or textual reference to the film and television industries. The arrival of tourists in these locations would render place as tourist destination. The arrival of film crews would render place as film set.

In striking contrast, in terms of both text and imagery, is the spread entitled "Industrial." Four photographs depict a North Vancouver industrial plant, the Burrard Thermal Plant, the Vancouver docks, and the smoky Campbell River skyline at dusk. While none of these photos is particularly unsightly, their subject matter is a radical departure from the imagery of the preceding examples. More importantly, the text frames these industrial sites as "ugly," "gritty, sooty, back-breaking," and "down and dirty," and assigns their place as "the wrong side of town." The text refers to "script action," emphasizing the sites' potential for particular kinds of movie scenes. The slogan, "Bend me, shape me ...," which runs across the top of the two pages, alludes to the power of filmmakers to manipulate these settings to suit their narrative needs.

Language plays a key role throughout the brochure in constructing British Columbia as shared ground in a service-industry relationship. First- and second-person pronouns (me, you, we, yours, ours) assert an industrial partnership between an unspecified "we" – understood as the BCFC – and "you" – foreign audiovisual producers, primarily Americans. Examples include: "We can give it to you for a song" and "This land is your land ... This land was made for you and me." "We," in other words, are here for "you," and "we" will work in partnership with "you" to exploit the natural and human resources of British Columbia. At the same time, the promotional discourse commodifies place as a resource to be employed in the manufacture of audiovisual products. "We can give it to you for a song" asserts that the BCFC can offer British Columbia locations cheaply to foreign producers. "Bend me, shape me" instructs audiovisual clients to do what they wish with those sites. "Come and get it ..." reads like an advertising slogan for the product – that is, British Columbia.

But language serves another purpose in the brochure; it expresses the BCFC's familiarity with the audiovisual industry, its jargon, and with American popular culture, in order to establish the commission's credibility as a

partner in American popular culture production. This language asserts familiarity in a number of ways: by using film industry vernacular; by making reference to Hollywood films and film genres; and by quoting lyrics and song titles from popular music. The brochure employs theatrical terms like "stand-ins" and "hot property," and makes the claim "We know the biz" to demonstrate its acquaintance with film industry idiom.[9] Jargon is exclusive speech; its use and understanding are confined to those who know the territory to which the language belongs. In this case the territory is film and television production and the BCFC speaks its language.

The use of film titles and genres in the captions and headings expresses in a similar way the BCFC's familiarity with American popular culture and reinforces its claim to insider status. Some examples are "mean streets" (referring to the 1973 Martin Scorsese film), *Clan of the Cave Bear* (Michael Chapman, 1986), *Border Town* (an American television series), *We're No Angels* (Neil Jordan, 1989), "the Orient Express" (which invokes the 1974 Sidney Lumet film *Murder on the Orient Express*), and "The Wild West." Song titles and lyrics are also used in this way: "Don't fence me in ...," "If you go out in the woods today," "Mountain's high ... valley's so deep ...," "Take me home, country roads ..."

On one level, the BC Film Commission's promotional literature effaces the particularity of British Columbia as a distinct social, cultural, historical, and geographical place. On another level, the literature positions British Columbia as an active partner in Hollywood's audiovisual production. The result is that the literature integrates the audiovisual production industry in British Columbia with the broader Hollywood industry. This integration of the industries in the symbolic domain is realized in the material domain, where Hollywood location production largely defines the BC film industry. British Columbia becomes Hollywood North, an integral part of a transnational organization of cultural production.

MADE IN BRITISH COLUMBIA

Most of the foreign service productions shot in British Columbia do, indeed, set their films elsewhere. Usually they are set in American locations. British Columbia has played various settings in Washington state (*First Blood,* 1982; *Housekeeping,* 1987; *Roxanne,* 1987), California (*Jennifer 8,* 1992), New Hampshire (*Jumanji,* 1995), Alaska (*Alaska,* 1996), Massachusetts (*Little Women,* 1994), and Montana (*Legends of the Fall,* 1994). Vancouver has stood in for

Locating British Columbia As Cinematic Place

Detroit (*Bird on a Wire*, 1990), Seattle (*Stakeout*, 1987), New York (*Look Who's Talking*, 1989), and Los Angeles (*Who's Harry Crumb?* 1989). Although in most of these films considerable effort is taken to mask the actual shooting location – changing flags, mailboxes, newspaper boxes, licence plates, police uniforms, signs, and so on – occasionally a film will reveal the artifice. *Rumble in the Bronx* (Stanley Tong, 1996), for example, assigns the New York borough a mountainous backdrop, as if offering a cinematic wink to in-the-know Vancouver moviegoers.

Bird on a Wire (John Badham) is worth a closer look in this regard. Unlike most service productions, the Paramount feature starring Mel Gibson and Goldie Hawn permits the viewer familiar with British Columbia to identify the former BC Penitentiary in New Westminster, the Sinclair Centre, Harbour Centre Tower, the Metropolitan Hotel, and the BC Hydro Building in downtown Vancouver, the Chinatown and Gastown areas of Vancouver, and Market Square and Chinatown in Victoria.[10] Such a representational strategy reflects a supreme confidence on the part of the filmmakers that revealing such architectural and topographical distinctions of southwestern British Columbia will not undermine the spectator's understanding that the narrative is set in the United States.

On the contrary, the film reduces these distinctions to mere urban idiosyncrasies within the larger continental landscape. Hudolin, Pennsylvania, may not have a prison quite like the old BC Penitentiary in New Westminster, but in the film the prison simply marks the release of the David Carradine character, a corrupt drug-enforcement agent and Mel Gibson's nemesis. Any prison would have done the trick. The first-class hotel that serves as Goldie Hawn's base in Detroit may only exist in Vancouver, but it signifies "luxury hotel" rather than "Vancouver hotel" in the film. Similarly, gas stations like that which plays Marvin's Motown Motors in the film can be found in every North American city. *Bird on a Wire*, in effect, continentalizes British Columbia by making the province play the parts of five American states; the story moves from Pennsylvania to New York to New Jersey to Michigan to Wisconsin although the film crew never left British Columbia. The central characters glide past these locales, which are always backdrops to the narrative and never envelop the characters. The scenes in which the locations appear emphasize the generic – prison, hotel, gas station, ranch – rather than the particular.

Cousins (Joel Schumacher, 1989) employs a similar representational

strategy, even if the specific narrative setting is never identified. Ted Danson and Isabella Rossellini are photographed against a number of recognizable Vancouver locations – a suburban Skytrain station, Granville Island Market, the Downtown Eastside, Chinatown, Fantasy Gardens – and yet the movie's backdrop signifies "urban America" rather than "Vancouver." It is as if the filmmakers are acknowledging Vancouver's role in the film while hesitating to grant the city a full-fledged speaking part. Vancouver has no real presence in the film; it is principally a setting. The characters tend not to enter into these locales, or emerge from them, or to be part of them in any way. Vancouver is only superficially evoked, a surface the characters breeze past, as in the scene of Danson and Rossellini escaping for a lovers' tryst to the picturesque Fraser Valley on Danson's motorcycle.

This separation between narrative and environment – between text and context – is made explicit in two scenes of Rossellini awaiting a commuter train on a crowded Skytrain platform. In the first, we see her edge her way to the front of the crowd to stand a step closer to the tracks than anyone else, so that she is on a different plane from her fellow commuters, like someone in the foreground of an old, three-dimensional photograph. In the second scene, she again stands out from the crowd on the platform, this time because her light-coloured clothing distinguishes her from the drab greys, blacks, and navy blues of the background crowd. She seemingly glows in the sunlight as, again, she stands closer to the edge of the platform than the rest, a step beyond the canopy that shades the other, anonymous commuters.

Vancouver, these films suggest, does not yet have sufficient signifying power – sufficient star power, in Hollywood parlance – to play itself. American cities like New York, Miami, Chicago, and San Francisco can lend meaning or atmosphere to a film by their names alone – they are meaningful – because audiences have learned to associate these place names with political and historical events, and with numerous other films, songs, plays, novels, and television programs. The process of constructing such associations with Vancouver has begun – as a site of major sports events (major-league hockey and basketball, an Indy-car race), political meetings (the 1993 Clinton-Yeltsin summit, the 1997 Asia-Pacific Economic Cooperation meeting), cultural gatherings (Expo '86), and, of course, as "Hollywood North" – but Vancouver does not yet evoke significant meaning in the North American imagination.[11]

This is doubly so for rural British Columbia. Films like *Roxanne* (Fred

Locating British Columbia As Cinematic Place

Schepisi, 1987) and *First Blood* (Ted Kotcheff, 1982) were shot in small British Columbia communities deemed so indistinguishable from small-town America that not even their names were changed for the films. Nelson thus becomes Nelson, Washington, in *Roxanne,* and Hope becomes Hope, Washington, in *First Blood.* While a case could be made for the necessity of an American setting in *First Blood* – Stallone plays a renegade Vietnam veteran who becomes the focus for a power struggle between law-enforcement jurisdictions, a common Hollywood theme – *Roxanne,* based on the Cyrano de Bergerac story, could have been set in any small town. However, small-town Washington is a more resonant signifier to American movie audiences – it is more imaginable – than small-town British Columbia, wherever that is.

Occasionally a Hollywood film is *set* in British Columbia. Robert Altman shot and set *That Cold Day in the Park* in Vancouver in 1969, although the story could have been set in any city. *Star 80* (Bob Fosse, 1983) was based on the true story of murdered *Playboy* playmate Dorothy Stratten, who grew up in suburban Vancouver, and some of the film's scenes were shot at locations in her home town, including the Penthouse night club and the Blue Horizon hotel.

More pertinent to this discussion, however, is the Paramount feature *Intersection* (1994), a remake of the 1969 French film *Les choses de la vie* that director Mark Rydell chose to set in the Lower Mainland of British Columbia. The film, which stars Richard Gere, Sharon Stone, and Lolita Davidovich, is so full of explicit Vancouver references that it would seem Rydell went out of his way to trumpet Vancouver as the film's setting. The architect played by Gere has a well-appointed Gastown office that overlooks Burrard Inlet, Canada Place, and the North Shore mountains. Among the Gere character's designs is the University of British Columbia's Museum of Anthropology. When he mails a letter, he uses a Canadian stamp. The journalist played by Davidovich catches a BC Ferry (rather than the SeaBus) from Lonsdale Quay and a Vancouver Taxi to her job at *Vancouver Step* magazine in Gastown. The film also gives us glimpses of the Vancouver city skyline, Granville Island Market, Dewdney General Store, the Squamish Highway, and the Ninety-Niner Restaurant in Britannia Beach (where Gere orders a very un-Canadian drink, bourbon and water, but at least pays with a blue five-dollar bill).

Curiously, though, the setting of *Intersection* remains largely detached from the story; the setting serves merely an aesthetic role, as stunning scenery to complement the stunning Hollywood stars and the high-powered

lives their characters lead. As Georgia Brown (1995) remarked in her *Village Voice* review of the film: "British Columbia's coastal highways, its snow-capped mountains, may as well be an extension of the hero's designer outerwear." *Intersection* is set less in a distinct geographical location than in a social class, as a kind of fictionalized version of *Lifestyles of the Rich and Famous*. Vancouver – or at least the city's prettier side – is visually implicated in the film, but it remains socioculturally detached; this is in no sense a Vancouver story.

British Columbia has also hosted a number of films that might be called "internal runaways," films produced by filmmakers from other parts of Canada. The best-known of these is Atom Egoyan's *The Sweet Hereafter* (1997), a Genie award-winner for best film and a nominee for two Academy Awards (best director and best adapted screenplay). The principal setting for *The Sweet Hereafter* is never identified, but it was shot on location in Merritt and Spences Bridge, British Columbia.

This continentalization of BC film production renders North America and the United States of America consonant in the term "America." Such films are made for US and international film markets, where the signifying power of the place names "Vancouver" and "British Columbia" may be minimal. This transnational regime of film production does not preclude, however, local production that is at least partly *about* British Columbia and British Columbians, and thereby signifies its location of production in particular ways.

MADE BY BRITISH COLUMBIANS

Unlike the BC Film Commission, which as part of its sales pitch proposes a range of scenarios in which British Columbia can accommodate Hollywood filmmaking, British Columbia Film leaves such imagining to the local film community it is mandated to serve. Simply put, BC Film "provides support to film and television initiatives having significant B.C. components that will be of economic and cultural benefit to the Province," according to its Web site.

It would be simply parochial to demand that every BC film map its precise geographic setting. Three of the finest indigenous films to emerge from the province – *The Grocer's Wife* (John Pozer, 1991), *Whale Music* (Richard Lewis, 1994), and *Kissed* (Lynne Stopkewich, 1997) – conceive of place in psychological terms, so that the location of the narrative in time

and space is not especially important. *The Grocer's Wife* was shot in Trail, but its setting, in the words of *Globe and Mail* reviewer Christopher Harris (1993), is "a nameless, dateless, placeless town whose defining feature is a vast and throbbing smelter with a towering stack that vomits forth an eternity of ominous smoke." Nor is the precise setting of *Whale Music* ever identified. The film concerns a reclusive, burned-out pop star who lives in a dilapidated seaside mansion somewhere on the Pacific Coast – it could be Oregon, Washington, or British Columbia. While we don't know exactly where we are in this film, we do know where we are *not:* deep in the urban heart of the music industry. And that is the point of the character's remove. Similarly, we don't know where we are in *Kissed,* but geography isn't pertinent to the story. The film operates on a more confined scale, and Wallis Funeral Home serves nicely as the principal setting of this psychological exploration of necrophilia.

A confusing film with regard to setting, however, is the psychological drama *Deep Sleep* (Patricia Gruben, 1990). The film is about a young woman named Shelly, who is trying to uncover the truth about the shooting death of her father four years earlier. She is the only member of the family who continues to be tormented by the tragedy. The film is set in a city called Vancouver, and we are shown Main Street and the docks area of East Vancouver, but it is not clear where Vancouver is; if anything, the viewer is led to conclude that Vancouver is an American city. During a flashback in which Shelly recalls her father's sexual abuse, she is rewarded for her sexual favours with American dollars. Both Shelly's father and his best friend were captains in the US Navy during the Vietnam War and were based in the Philippines. One of the central themes of the film is power, and American imperialism in the Philippines is linked to the exportation of Filipino children to North America. How the story and its characters are connected to the Canadian city called Vancouver is not clear, unless, as in the foreign service productions, Vancouver has simply been absorbed within "America."

British Columbia also produces outright Hollywood imitations, using American settings and, often, minor Hollywood actors, integrating indigenous production with the continental commercial film industry. *Air Bud* (Charles Martin Smith, 1997), for example, is set in the town of Fernfield, Washington, and recounts the story of a basketball-playing golden retriever named Buddy who helps the Fernfield Timberwolves to the state high school basketball championship. As far-fetched as this may sound, the film was a

hit, winning the Golden Reel Award as the highest-grossing Canadian film of the year in 1997 ($1.6 million at Canadian box offices between October 1996 and October 1997). It proved to be only the first of a continuing series of "Bud" films, which includes *Air Bud: Golden Receiver* (1998) and *Air Bud: World Pup* (2000). Less successful Hollywood imitators have been BC films like *North of Pittsburgh* (Richard Martin, 1992), *Xtro II: The Second Encounter* (Harry Bromley-Davenport, 1991), and *Flinch* (George Erschbamer, 1992).

As opposed to those productions that deny British Columbia a distinct identity, there is another group of indigenous films that explicitly locate British Columbia as a place of history, of politics and of culture, that foreground without timidity BC settings, stories, and characters. These films place British Columbia historically as a former British colony occupying Native lands, in resistance to American expansion. They situate British Columbia geographically by representing the lives of their characters as heavily shaped by cross-border migrations and transcultural interaction, and by representing the province itself as a borderland adjoining western Canada, the northwestern United States, the sub-Arctic region, and the Pacific Rim.

Two historical films that illustrate this point particularly well are based on migrants to the colony who became British Columbia folk legends. *Kootenai Brown* (Allan Kroeker, 1991) recounts the story of John George Brown, a junior officer in the British army who left Ireland in the mid-nineteenth century with the dream of becoming an English gentleman in British Columbia. *The Grey Fox* (Phillip Borsos, 1982) traces the Canadian chapter in the career of Bill Miner, an American outlaw reputed to have been Canada's first train robber in the first decade of the twentieth century.

Kootenai Brown is the tragic story of a man who leads a transient existence in the North American west, meandering throughout what is now western Canada and the northwest United States in his quest to attain social standing as a gentleman after rejecting class-bound Britain, where status was purchased rather than earned. Yet if he envisioned "America" as a meritocracy, he finds it to be a corrupt frontier society populated as much by cheats and thieves as by honest hard-workers. Brown winds up on trial for murder in Montana Territory after knifing his parasitic business partner Eban Campbell, known as McTooth, on the main street of Fort Benton in broad daylight.

The film depicts a ruthless society concerned as much with producing individual wealth as with establishing appropriate social values, where the most significant markers of identity are based on race rather than nationality;

Locating British Columbia As Cinematic Place

citizenship is meaningless here. The white settlers from Europe are by defi-
nition "civilized" men and women, in spite of their behaviour and the differ-
ences among them, and the Native peoples are by definition "savages." Scots,
Irish, Americans, Natives, and Métis work, drink, and play cards together, but
it is a volatile mix. Violent conflict results both from clashes between indi-
viduals – Brown and McTooth, Brown and the card cheat Gilchrist – and
between belief systems – centrally, between Native society and the encroach-
ing white settlers.

Brown's personal struggle to survive, let alone prosper, is punctuated
by bouts of moral uncertainty, even moral cowardice. His path to becoming
a gentleman is strewn with all the vices the new world has to offer – alcohol,
gambling, prostitution, dishonesty, exploitation – and he is rarely able to
resist these lures. He loses his first gold stake in a crooked card game, has
his second bundle stolen during a barroom shoot-out, and he later goes
into the business of trading wolf skins for whiskey with the incorrigible
McTooth.

Brown awkwardly straddles the European settler society of his origins
and the Métis society he adopts through his marriage to the métisse Olivia.
He refers to the Métis as "my people," yet his sense of belonging is ambiva-
lent; he is not forthcoming about why the buffalo are disappearing, he
doesn't tell "his" people about his stint trading watered-down, even poi-
soned, whiskey to Natives, and he refuses to cut his ties to McTooth, who
constantly appeals to Brown as a "gentleman." "We're not savages," McTooth
reminds Brown whenever Brown rejects the ways of white settler society.

Geographically, *Kootenai Brown* evokes the West. The story moves from
Williams Creek in British Columbia to the pre-Confederation North West
Territories, from Assiniboia to Montana Territory. The pertinent territorial
markers in the film are mountains, cold weather, gold, furs, and buffalo
herds; they govern the characters' movements. Whether or not the film is his-
torically accurate, *Kootenai Brown* seeks to capture a sense of what British
Columbia was like during the Cariboo gold rush and relates the experiences
of one mythical figure during that period.

Political boundaries between Canada and the United States are much
more clearly demarcated in *The Grey Fox,* which begins with Bill Miner's
release from San Quentin Prison in 1901. Throughout the film, titles and
dialogue tell us exactly where we are. Part of this can be explained by the
nature of the story itself; Miner is running from law-enforcement officials

on both sides of the border, and legal jurisdiction becomes central to the plot when the American Pinkerton agent Seavey pursues Miner into Canada. Corporal (later Sergeant) Fernie, the local BC Provincial Police officer, clearly resents Seavey's intrusion into his bailiwick, and only cooperates when instructed to do so by his superintendent in New Westminster.

But the borders are also historically relevant by this time. British Columbia is no longer a British colony, but a province in a country called Canada that has begun to forge a sense of nationhood. Similarly, Oregon (1859), Washington (1889), Montana (1889), and Idaho (1890) have formalized their relationship to the United States by achieving statehood. By the time of Miner's release, in other words, the two countries are distinct political and economic entities, and British Columbia is a distinct entity within Canada. The importance of these boundaries to the story is underlined when Miner crosses into Canada after a botched train robbery in Oregon. As Blaine Allan (1993, 73) notes, Miner's border crossing is signified three ways: by the sudden appearance of snow on the ground, by a close-up shot of the boundary marker, and by a superimposed title that reads "British Columbia." Allan writes: "The three signs mark the border for both Bill Miner and the viewer, and ensure that they both understand that the story is moving into someplace different." With newly recruited partner Shorty Dunn, Miner successfully robs a Canadian Pacific Railway train near Mission, and, posing as a mining engineer from Idaho named George Edwards, he hides out in Kamloops until it is safe to continue.

While the film always makes sure we know where we are geographically, we also know where we are historically. Like *Kootenai Brown*, *The Grey Fox* informs us not only of Miner's story, but of its historical context. Miner had been sent to San Quentin for robbing stagecoaches, which, by the time of his release, had been replaced by steam-powered trains. He is inspired to apply his skills to this new technology after watching the Edwin S. Porter film – cinema itself was a new technology – *The Great Train Robbery*.[12] In one of the most striking scenes in the film, it is a train that foils Miner's attempt to rustle a herd of horses. Evoking the Alex Colville painting *Horse and Train*, Miner and Shorty are driving the stolen horses along a railroad track when an unscheduled work train appears. The horses are forced down a steep embankment and those that don't get away have to be destroyed because of their injuries. It is clearly the age of the iron horse.

The railroad in the film also draws attention to Canadian history. The

Locating British Columbia As Cinematic Place

transcontinental CPR was a key element in John A. Macdonald's nation-building program. Miner became a folk hero in British Columbia in large part because he robbed the CPR, an unpopular, monopolistic institution. Shorty makes specific mention of this monopoly – "Damn railroad owns everything, both sides of the tracks" – and in the closing scene of the film, Miner is given a rousing send-off at the Kamloops train station as he leaves for prison.

A very different kind of historical film that nonetheless locates its characters spatially and temporally is *Hard Core Logo* (Bruce McDonald, 1996). The history recounted here is of the western Canadian punk music scene. Based on the book of the same name by Vancouver poet Michael Turner (1993), the film is a mock documentary of the 1995 reunion tour of the fictional Vancouver punk group Hard Core Logo, a band we are told had a large and loyal following during the decade before its break-up in 1991. But although the film's foreground is fiction, the story is set against a non-fiction background; Hard Core Logo plays well-known Vancouver music venues the Smiling Buddha Cabaret and the Commodore Ballroom, and at its kick-off concert in Vancouver, Hard Core Logo appears with actual bands Flash Bastard, Lick the Pole, the Modernettes, Art Bergmann, and D.O.A. This flirtation between fact and fiction extends to two actors in the film who play versions of themselves: the band's booking agent Mulligan, played by Vancouver disc and video jockey Terry David Mulligan, and the filmmaker Bruce McDonald. The band's drummer, Pipefitter, even teases McDonald about two of his previous films, *Roadkill* and *Highway 61*. This narrative strategy reinforces the story's connection to actuality; the film wants to say something about an actual time and place.[13]

The dramatic tension in the film is based on a distinction between what band leader Joe Dick sees as two very different punk scenes: one in which the music is everything, the other in which the music serves commercial ends. These distinctions are personified by Joe Dick, who wants to reunite Hard Core Logo on a permanent basis, and Billy Tallent, the band's lead guitarist, who wants to graduate to punk's upper echelons. Speaking directly to the camera, Joe Dick explains: "There's two different ways to look at it. Billy just wants the models and the limousines, and I'm happy with the hookers and the taxicabs." The film clearly situates the western Canadian punk scene in the music-is-everything category; the Hard Core Logo band members tour from Vancouver to Calgary, Regina, Winnipeg, Saskatoon, and Edmonton,

taking turns at the wheel of their decrepit van, driving all night to the next gig, hoping they sell enough T-shirts to pay their expenses. In this way the film particularizes west coast punk music, distinguishing the subcultural attributes that set it apart from the universal signifier of "punk music," most commonly associated with the United States and Great Britain.

The more personal histories in such films as *My American Cousin* (Sandy Wilson, 1985), its sequel *American Boyfriends* (Sandy Wilson, 1989), and *The Lotus Eaters* (Paul Shapiro, 1993) establish a link between their protagonists' state of being and their place of being in an attempt to deconstruct the way place is imagined. British Columbia is depicted, from the point of view of these characters, as backward, remote, and confining, a place they must graduate from to fulfill themselves. All three films ultimately expose these depictions as based on personal feelings of inadequacy and discontent.

Sandy, the pubescent protagonist of *My American Cousin,* pines to leave her family's ironically titled Paradise Ranch in the Okanagan Valley – where "nothing ever happens," as she notes in her diary – for the more fertile cultural ground of the United States. The catalyst for this escape fantasy is Sandy's California cousin Butch, who arrives unannounced at the ranch late one night in the summer of 1959. Butch embodies Sandy's adolescent perception of "America"; he looks like James Dean with his straight-cut blue jeans and white T-shirt, he drives a cherry-red Cadillac Eldorado convertible with whitewall tires, and he listens to rock 'n' roll on his transistor radio. Unfortunately, Paradise Ranch is out of reach of the American radio stations – "In the States we got rock 'n' roll all day long" – and the hit movie *Rebel without a Cause* hasn't yet made it to the local theatre. Butch's flashy car must endure cattle gates and gravel roads: "Back in the States we don't got roads like this. Everything's paved!" Like Bill Miner in *The Grey Fox,* Butch is clearly someplace different.

Because the story is framed as a personal reminiscence of a more innocent time, *My American Cousin* signifies Sandy's Canada and Butch's America in stereotypical terms. The film establishes a simple dichotomy between lacklustre Canada and the hip United States. Sandy's Canada is a place of conservative values, quaint country music, dirt roads, and chaperoned community dances. Butch's America is characterized by mobile individualism, rock 'n' roll, paved highways, and sexual exploration. America, Sandy imagines, is everything Canada could be when it grows up.

If Sandy's liberation from Paradise Ranch is ultimately denied in *My*

Locating British Columbia As Cinematic Place

American Cousin, she manages at least a temporary escape to California in *American Boyfriends*, set in 1965. Butch is again the catalyst, inviting Sandy, now a somewhat independent first-year student at Simon Fraser University, to his wedding in Portland. Similarly framed as a personal reminiscence, *American Boyfriends* is a more serious film in that it raises the stakes involved in Sandy's American illusion. If in *My American Cousin*, the worst that happens is that Sandy can't go with Butch to California, in *American Boyfriends* Sandy's initial infatuation with California is quickly undermined as "America" reveals a darker side of hostility, violence, and death. At the beginning of the story, Sandy and her school friend Julie perceive the United States as the place of interesting people and significant events: Martin Luther King, Bob Dylan, California surfers, the civil-rights movement, and antiwar protests. The fact that their political science professor is from Berkeley – he's come to teach these young Canadians what *real* politics is all about – punctuates the point. Of course, Sandy and Julie have given little thought to the notion that an antiwar protest requires a war and a civil-rights movement requires systemic prejudice.

Gradually, however, the film probes beneath the theme-park façade. As the young women venture further into America, they lose both their sexual and political innocence. If at Butch's wedding they are initially attracted to the dapper young men in their military uniforms, they soon learn what those uniforms imply. Sandy's friend Lizzie loses her virginity to Butch's best man Daryl, who is due to leave for Vietnam in six days. Similarly, when Sandy and Julie continue on to California in their quest to meet surfers and "radicals," they are struck by the pervasiveness of the war. The surfers they meet in Santa Cruz are macho rednecks who have little regard for antiwar sentiment; one of the surfers recently lost a brother in Vietnam. Sandy and Julie befriend instead two young men the surfers have just bounced from a bar: Spider, a black, fourth-year political science student from UCLA, and Marty, a draft dodger from the Bronx.

The Vietnam War is no longer some remote news event; it assumes an omnipresence that threatens the lives of people Sandy has come to know. Death itself hits home when she learns that Butch has been killed in a car accident. Sandy and Julie bolt back to Canada, which remains a much simpler place, as the final scene suggests; one of the customs agents turns out to be a school friend of Sandy's, and he allows her to sneak Marty across the border.[14]

American Boyfriends doesn't erase the cultural border Sandy drew

between Canadian and American society in *My American Cousin,* it simply redefines that boundary in starker, sociopolitical terms. Far less forgiving than the original film, *American Boyfriends* is a critique less of the United States than of Canadian delusions about "America."

The Lotus Eaters demonstrates that you don't have to be an adolescent to indulge in adolescent fantasy, and it reinforces the point that illusions can have material consequences. It is 1964 and Hal Kingswood is a fogeyish forty-something, the principal of the small elementary school on Dinner Plate Island. His long-held dream of sailing to Mexico – "It's Paradise down there" – is rekindled by the arrival of the free-spirited new teacher Anne-Marie Andrews. Reminiscent of Butch in *My American Cousin,* the Miss Andrews character is an exoticized Other, a young, attractive and bright Québécoise from Montreal who captivates her students, her fellow teachers, and especially Hal.

Shot on Galiano Island, just off the coast of the Lower Mainland, the film depicts Dinner Plate Island as a remote, isolated place resistant to change. When Hal's teenaged daughter Cleo announces that the Beatles are coming, and Hal asks "Here?" Cleo curtly responds: "No, not here. No one ever comes here. Here is nowhere." The most remarkable islanders in the film are never seen, but only spoken about: Hal's father, who left for England after having an affair with Violet Spittle; and Violet herself, who ran off with the man who drained the island's septic tanks. People don't *come* to Dinner Plate Island, they *go*. Miss Andrews is the exception, and she brings the revolutionary excitement of the 1960s with her. Pulling up in a Volkswagen van with the stereo blaring, a guitar over her shoulder and a miniskirt around her waist, she initially scandalizes her principal through the simple act of re-arranging the classroom desks in a circle. Miss Andrews, of course, is not all that the islanders imagine her to be. We eventually learn that Miss Andrews came to the west coast to escape a lifeless relationship in Montreal; she departed on the eve of her wedding. And the reckless affair she initiates with Hal turns out not to be her first ill-considered escapade.

Although Miss Andrews in *The Lotus Eaters* assumes a role comparable to Butch's in *My American Cousin* – as sirenic Other arriving in Paradise (Lotus Land, Paradise Ranch) – there is an important difference in how the films locate their settings. *My American Cousin* situates Paradise Ranch, not in the Okanagan Valley or in British Columbia, but in Canada, and asserts a universalized Canada-US dichotomy. The film offers no sense that Canada

Locating British Columbia As Cinematic Place

has other, more enticing, places to offer; Sandy's American dream remains undiminished when she moves to Vancouver in *American Boyfriends*. *The Lotus Eaters*, on the other hand, particularizes Dinner Plate Island, setting the island community apart from everywhere else; we can imagine life as different elsewhere. Cleo, for instance, imagines a different life in Vancouver, and Hal conjures a utopian Mexico. This means that Dinner Plate Island signifies only Dinner Plate Island, and that we can imagine other island communities, other parts of British Columbia, other parts of Canada, as offering different experiences. This distinction is noteworthy because it begins to paint British Columbia as not merely different from neighbouring Washington and Alaska, but as a heterogeneous, multidimensional space in and of itself. A recurrent theme in British Columbia's indigenous films, for example, is the divide between urban and rural ways of life.

In *Max* (Charles Wilkinson, 1994), former hippies Andy and Jane Blake move to a remote ranch in the Nicola Valley when their son Max is diagnosed as terminally ill with an immune system deficiency believed by doctors to result from environmental toxicity. Andy takes the diagnosis personally, blaming himself for Max's illness because he and Jane bought into the consumer culture of the two-car garage and the home in the suburbs. Both Andy and Jane construct for themselves distinct images of city and country, and it is the contradiction between their views that provides the film's dramatic energy. For Andy, the city is unclean and city-dwellers have been corrupted by their over-reliance on technology – like the doctors who have given up on Max because science tells them the boy's disease is incurable. The country, to Andy, is a more natural and healthy environment, and he eschews all vestiges of urban technology, substituting meditation and faith for science, exercise for medicine, organic for processed food, even a cumbersome handsaw for the chainsaw his Native neighbour recommends. Jane, however, sees the country as menacing in its remoteness – from doctors, hospitals, other people – and the city as secure in its proximity to the professional help Max may need.

A different kind of cultural distinction is portrayed in *Harmony Cats* (Sandy Wilson, 1993). This time it is a gulf between urban high culture and rural popular culture. Graham Brathwaite is a self-centred violinist with the symphony orchestra in Vancouver. When the orchestra goes bankrupt, Graham is forced to find other work and, very reluctantly, joins the country-music band Frank Hay and the Harmony Cats for its annual tour of the

Interior. Like a little boy who knows he will hate spinach before he has tried it, Graham is initially appalled at having to play such pedestrian music. "I'm a world-class musician," he repeatedly protests. Predictably, he learns to respect both the musical talents and musical tastes of his fellow "Cats" by the end of the tour. Graham, in fact, adopts Frank's daughter Debbie as his protégée and it is his validation of her singing and songwriting abilities that gives Debbie the confidence to accept a Nashville recording contract. *Harmony Cats* complicates the cinematic rendering of British Columbia because, like *Max*, it compels its central character to confront and discover a British Columbia he knew very little about. This is a British Columbia of smoky beer halls, shabby motels, male strippers, and line dancing, a working-class culture with its own modes of speech and dress as far removed as one can get from sipping Chardonnay in the lobby of the Orpheum Theatre.

The more fundamental identity markers of race and ethnicity are mapped in *The Traveller* (Bruno Lazaro Pacheco, 1989) and *Double Happiness* (Mina Shum, 1994). The British Columbia depicted in these films is a complex, multi-ethnic and multiracial setting for both inter- and intracultural conflict.

In *The Traveller*, Robert Braun crosses back and forth between British Columbia's Native and non-Native cultures. A non-Native himself, Braun was raised in a Haida community on the northwest coast, married a Haida woman named Helen, and then pursued a career that straddled the two cultures: first as a University of British Columbia anthropologist studying Native culture, then as a dealer in Native masks. Clearly, all his efforts to bridge the two societies have failed. He has left his Native community and separated from his wife; he is accused of stealing the ceremonial masks presented at their wedding. He quit teaching because he found anthropology to be exploitive and he was fed up "selling ideas to students." "So I got into the business of selling them *real* things, *real* masks. It seemed more honest at the time," he explains. As the film unfolds, the Native carvers have come to resent the commercial exploitation of their work. Braun decides to sell his shares in the company he founded when he objects to his business partner's determination to buy cheaper, imitation masks produced by penitentiary inmates.

If the Braun character's naïveté inhibits the story's dramatic impact, *The Traveller* is much more successful in establishing the social proximity of Native and non-Native culture in British Columbia. On the way to Vancouver

Locating British Columbia As Cinematic Place

at the start of the film, Braun's plane flies over the lushly treed islands of the British Columbia coast, the same trees and same waters that bring Native and non-Native society into frequent and fundamental conflict over logging and fishing rights. Some of these islands and waters can be seen from Braun's West End Vancouver hotel room. When he visits the University of British Columbia, he sees some students hanging a banner announcing a Native Rights Student Coalition meeting. And throughout the city he is followed by the haunting call of a raven, a central icon in Haida culture. The British Columbia of *The Traveller* is a place of uneasy coexistence, not unlike the Williams Creek of *Kootenai Brown*.

Double Happiness centres on the Chinese community in present-day Vancouver. The story belongs to Jade Li, who struggles throughout the film to reconcile her personal and career aspirations with the wishes of her strict and custom-bound father Quo. Although Mina Shum, as writer-director, insists the story is her own and she isn't speaking for the larger Chinese community (see Knelman 1995), *Double Happiness* nonetheless addresses the larger issue of intergenerational intracultural conflict as it is played out in its specific Vancouver setting.

Jade's parents and their contemporaries speak Cantonese most of the time – almost half of the film's dialogue is subtitled – eat Chinese food exclusively, shop in Chinatown, and socialize only with other Chinese. They are labourers, shopkeepers, and homemakers who put more ambitious pursuits aside – Quo wanted to be an architect – when they immigrated to Canada. Jade's generation is highly Westernized. They speak Cantonese as a second language, if they speak it at all, listen to Western music, frequent the same Vancouver clubs as non-Chinese, and aspire to professional careers.[15]

Jade, who was born in Hong Kong but came to Vancouver when she was two, wants to be an actress and, in no apparent rush to find a mate, clearly resents being sent on dates with young Chinese men her parents perceive as good marrying material. Jade and her best friend Lisa both have non-Chinese boyfriends. Quo, by contrast, was raised in an affluent Chinese family that lost its wealth and social standing during the Cultural Revolution. He is primarily concerned with restoring and maintaining family honour – "Li family values" – and he has already been disgraced once by his rebellious son Winston, who was subsequently banished and does not appear in the film. Quo wants Jade to set aside her own independent notions, find a suitable Chinese husband and take over her aunt's clothing shop.

Two elements distinguish *Double Happiness* from what Kass Banning (1995, 26) describes as "the common conflict of teen will-to-power against trouble-with-father-knows-best." First, Jade isn't simply rebelling holus-bolus against Quo's paternalism; Jade is in large part wrestling with herself over how to accommodate the aspects of her Chinese identity with which she is comfortable and those elements of her ethnicity she seeks to overcome. The complexity of constructing this new kind of identity for herself resonates in two scenes from her acting career, in which she is either too Chinese or not Chinese enough. During an audition for a bit part as a waitress in a soap opera episode, Jade is asked to deliver her lines with a fabricated Chinese accent. In another audition, this time for a Hong Kong film shooting on location in Vancouver, Jade is chastised in Cantonese by the producer – played by Shum herself – because she can't read the Chinese script: "You can't read Chinese? But you were born in Hong Kong! Are you really Chinese?" Jade's weak, almost inaudible "Yes" sounds more like a question than an answer.

A second distinguishing element of the film is that the conflict isn't simply intergenerational. The Hong Kong producer for whom Jade isn't Chinese enough is, like Jade, a young woman. A more significant character, however, is Ah Hong, a boyhood friend of Quo who is visiting Vancouver; Jade's father is especially concerned about putting up a good-Chinese-family front during Ah Hong's stay. Chia-chi Wu (1998, 10) writes: "In contrast to Li's father, Ah Hong, the 'Chinese Chinese' fresh off the flight from China, is already speaking fluent English and acquired certain western mannerisms. He has learned to speak English in China and obviously adopts a more tolerant attitude toward Jade's individuality. He also has an 'illicit' family that cannot be acknowledged by Li's father's moral values. Implied in this contrast between Ah Hong and the father is a critique of some Asian American families which are more chauvinistically nationalist than people back 'home.'" It is Ah Hong who approves of Jade's decision to move out at the end of the film, undermining the simple, and simplistic, dichotomy between Western liberalism and Asian traditionalism (2).

Taken together, these indigenous films particularize and diversify British Columbia. They render the province a distinct historical, political, social, and cultural entity, but one which nonetheless remains intimately connected to its neighbouring states. If these films erect both material and symbolic boundaries around the province, those boundaries remain permeable and

tenuous; the central social relationships that motivate these narratives transcend national, racial, cultural, and generational frontiers, and at the same time call those borders into question. British Columbia's indigenous cinema is a site of contestation, where filmmakers and audiences can work through the various meanings this place evokes for the people who make their lives there.

PATTERNS OF REPRESENTATION

The way filmmakers represent British Columbia as place can be read in at least three ways. Perhaps the most obvious reading is simply to deny the signifying power of the province's various cinematic guises. Movie settings, after all, are fictionalized spatio-temporal constructs, and the transformation of the film location is part of cinema's artifice. Like a stage or an actor, the location is dressed up to play a particular role, which bears no necessary relationship to the actual location. The problem with this argument is that, while it may hold for individual films, it ignores the larger pattern. That is, foreign films almost always transform British Columbia into an American place, reducing the region to a sociologically empty stage, devoid of the cultural or historical significance that would allow British Columbia to play itself. Such a consistent pattern of denial suggests there are larger, structural forces at play, and points to Hollywood's hegemony in the commercial film industry. It is Hollywood, in other words, that sets the agenda in the business of location production.

Given Hollywood's hegemony, a second reading would situate British Columbia's film industry within a media imperialism thesis. In this view, British Columbia is part of Hollywood's program of Manifest Destiny. In light of Hollywood's long-established dominance of the continental distribution and exhibition sectors, Hollywood has appropriated British Columbia as part of its continentalization – even globalization – of commercial film production. While there is much to be said for this view, it remains unsatisfactory. As discussed in Chapters 3 and 4, the government of British Columbia took the initiative in inviting Hollywood to use its locations, and Victoria was under no illusion that Hollywood would be interested in filming local stories. To this day, in fact, the BC Film Commission promotes the province's ability to play Anywhere, USA, and encourages non-resident producers to "Bend me, shape me ..."

In addition, as noted in Chapters 2 and 4, the province has always

defined cinema in industrial rather than cultural terms, and the film industry replicates any number of other resource-extraction industries in the province by providing the primary natural and human resources for products that are ultimately finished elsewhere. The media imperialism argument also overlooks the view that Hollywood's presence in British Columbia has in some ways *enabled* a local cinema to emerge. The location production industry has encouraged the development of film industry services and personnel, and provides the kind of steady training, employment, and income that a small, indigenous cinema could not provide, but nonetheless benefits from. Rather than moving to Toronto or Los Angeles like many of their predecessors, BC filmmakers today can remain at home, assured that they can find steady work. While Hollywood provides most of the employment, indigenous filmmakers have a pool of skilled labour from which to draw.

What I want to outline in the concluding chapter is a more nuanced reading, one that perceives in the cinematic representation of British Columbia a deconstruction of boundaries, a representational pattern that consistently calls into question cultural, political, and economic borders that have been imposed historically upon the physical geography of North America. In a period of globalization, such a reading sets culture in opposition to nature: the sociohistorical constituents of place such as politics, economics, and culture against the physical, geographic elements of place.

6

Locating the BC Film Industry

The first chapter asserted that the BC feature film industry could not be understood within the conventional national cinema frame, which conceives of films as products of a national culture. Such a prescriptive mode of analysis was rejected in favour of assessing British Columbia's cinema on its own terms. British Columbia's dramatic cinema does not lend itself to ready classification, because of its relatively recent emergence, the predominance of foreign service production, and its limited corpus of indigenous films. Furthermore, because this cinema is created by both non-resident and local producers, with the added complication that local film workers are heavily involved in the production of foreign films, it is in fact defined by a complex interface between transnational and regional/local regimes of film production. As was noted in the preceding chapter, even British Columbia's indigenous films construct distinct notions of place and imagine community in divergent ways.

This chapter posits British Columbia as a particularly suitable candidate for Doreen Massey's proposed reconceptualization of place as "meeting place" or "intersection." Globalization has intensified social relations across space and through time and has thus altered the way we experience and imagine place, the way we define community, and the way we constitute identity. The communications media are heavily implicated in these transformations,

as they bind space and time, and further, as they enable new ways of being and belonging through the formation of new media ecologies. Massey's (1991, 1992, 1995) "global sense of place," which configures place as a locus upon which a constellation of local, regional, national, and international social relations intersect and interweave, is critical to situating the BC film industry.

The transnational flows of people, capital, commodities, information, and images we associate with globalization have a long history in British Columbia, and this is especially true of British Columbia's largest city, Vancouver, where the film industry is based. Rob Wilson and Wimal Dissanayake (1996, 2), in fact, cite Vancouver as one example of the "mingled processing zones and 'global cities' of crosshatched and circular flow" that have resulted from globalization. Reconceptualizing "place" in this way helps us to better understand the relationships between British Columbia as place and both the non-resident and indigenous branches of its dramatic cinema.

Yet the decided imbalance in British Columbia between the transnational and local regimes of film production should not be overlooked. As a way of concluding, then, this chapter considers the extent to which the BC film industry operates on the same terms as the province's traditional resource-extraction industries and underlines the inherent vulnerability this analogy implies.

A GLOBAL SENSE OF PLACE

Doreen Massey (1991) seeks to redefine "place" in light of the complex flows that characterize the global/local interface, which were surveyed briefly in the introductory chapter of this book. Massey conceives of place as an intersection or meeting place "constructed out of a particular constellation of social relations, meeting and weaving together at a particular locus." Her conception embraces both the temporal and the spatial aspects of place: "Instead ... of thinking of places as areas with boundaries around, they can be imagined as articulated moments in networks of social relations and understandings, but where a large proportion of these relations, experiences and understandings are constructed on a far larger scale than what we happen to define for that moment as the place itself, whether that be a street, or a region, or even a construct." Such a formulation entails an "extroverted" sense of place, a sense of place that "integrates in a positive way the global and the local." It is as well a dynamic rather than fixed sense of place, defined as it is by relations

Locating the BC Film Industry

that remain fluid (28-9). Massey (1992, 14) summarizes: "In one sense or another most places have been 'meeting places'; even their 'original inhabitants' usually came from somewhere else. This does not mean that the past is irrelevant to the identity of place. It simply means that there is no internally produced, essential past. The identity of place, just as Hall argues in relation to cultural identity, is always and continuously being produced. Instead of looking back with nostalgia to some identity of place which it is assumed already exists, the past has to be constructed."

Massey's reformulation of place, which moves us away from the notion of place as enclosure to the idea of place as meeting ground or intersection, is a useful way to understand British Columbia as a place, and, more to the point, offers us a new way to locate British Columbia's feature film industry. If British Columbia is not the container for the culture and identity of its people, then the province need not be seen as the container of its film industry. Instead, British Columbia can be thought of as the place where both local and transnational cultural and industrial forces converge and interact.

Massey's "global sense of place" has a particular resonance in the specific case of British Columbia because the province's history has been defined for more than a century by the flows of people, capital, commodities, and images that characterize globalization. British Columbia's population is extremely diverse and more than half of its people today are migrants – from the rest of the world and from the rest of Canada. If British Columbia's earliest immigrants came from Great Britain in the colonial period, they were very quickly joined by Chinese miners and railway workers, Japanese fishers, French Canadian forestry and mill workers, and refugees from Russia and India. British Columbia's place names – Victoria, New Westminster, Lillooet, Ucluelet, Galiano, Juan de Fuca, Quesnel, Maillardville, Sointula, China Ridge – offer some testimony to the origins of its people. Today, one-third of greater Vancouver's population is of Asian descent, with the Chinese alone accounting for almost 20 percent of the city's 1.81 million inhabitants (Kaplan 1998, 52).

British Columbia's political relations have always taken place over great distances. In the colonial period, British Columbia's governors answered to London. Today, relations with Ottawa are a constant source of friction; a four-way spat over the west coast salmon fishery involving Ottawa, Washington, DC, Victoria, and Juneau, Alaska, is only the most recent manifestation of western alienation within Canada (Matas 1999).

As an extractor and processor of natural resources, British Columbia has always been a trading province, shipping raw and semi-processed materials to central Canada, the United States, Europe, and Asia in return for manufactured goods. Today, British Columbia's export markets are more widely distributed than those of any other Canadian province; while its biggest customers are the United States and Japan, in 1995 British Columbia exported commodities to more than 150 countries (BC Stats 1995). Tourism has become since the 1980s one of the province's largest and most important industries, responsible for a record $9.2 billion in 1999 (Tourism BC 2001). Of course, tourism and natural resource industries do not always complement one another, creating considerable tension over British Columbia's economic sense of place (see Belshaw and Mitchell 1996, 330).

Canada is one of the countries most open to cultural imports, and British Columbia is no exception. This is particularly the case in the feature film sector where foreign (primarily Hollywood) films account for between 94 and 98 percent of screen time in Canadian movie theatres.[1] The flow of cultural images has been decidedly one-way in British Columbia, where, until recently, the only Canadian films British Columbians could see were from Ontario and Quebec. Even in television, where local producers have the benefit of screen quotas provided under Canadian-content regulations, dramatic programming produced in British Columbia – e.g., *Cold Squad, Da Vinci's Inquest* – is clearly the exception to the central Canadian rule.

Vancouver suits Massey's formulation of place particularly well. Paul Delany (1994, 1) writes: "The rapid change and growth of this city have always been the product of external forces: Vancouver has been discovered, developed – colonised, some would say – by global migrations and shifts of capital." Vancouver is the destination of choice for migrants to British Columbia – approximately 85 percent of all British Columbia immigrants settle in the greater Vancouver area (BC Stats 1996) – and the city has been the principal financial beneficiary of those recent immigrants who have qualified for entry in the independent economic classes. Vancouver has a distinct, services-oriented economy within the larger provincial economy, providing the crucial link between the resource industries of the BC interior and international export markets (Davis 1993; Shearer 1993-4).

Culturally, Vancouver is very much an intersection for influences from North and South America, Europe, and Asia. If for much of its history Vancouver has tried to deny the significance of the non-European presence in its

Locating the BC Film Industry

midst, in the 1990s its ethnic diversity became a source of celebration. Aboriginal artists like Bill Reid and Roy Vickers, and Asian Canadian artists like Paul Wong, Evelyn Lau, Wayson Choy, and Mina Shum have won mainstream recognition as BC or Vancouver artists.

Contrasting the city with inland centres of political power like Beijing, Paris, Berlin, Vienna, and Moscow, Delany (1994, 19) describes Vancouver as a "city of the edge," like Venice, New York, San Francisco, Hong Kong, and Shanghai, cities that "illustrate the ecological principle that the greatest variety of life-forms will be found at the boundary between different habitats." Of Vancouver itself, Delany writes: "Lacking a major administrative or political function, its reason for being is to be situated where four zones intersect: the Western Canadian hinterland, the US and Mexican West Coast, the North Coast up to Alaska, and the Pacific Rim."

While the global flows lend Vancouver its social, economic, and cultural vibrancy, they also make it a difficult city to "place," at least in conventional terms. Delany (1994, 6) notes that Vancouver has recently produced three best-selling authors – Douglas Coupland, William Gibson, and Nick Bantock – who write "location-independent" literature. Controversies surrounding Asian immigration (see Mitchell 1996; Abu-Laban 1997) and the Eurocentric design of the Library Square complex (see Haden 1995) testify to the contested nature of Vancouver's sense of place.

The British Columbia feature film industry, based as it is in Vancouver, is subject to these same flows. While its promoters seek to set the west coast's film industry against a picturesque backdrop of seaside and mountains – with a derivative "Hollywood North" sign overlooking Vancouver from the North Shore mountains (see MacIntyre 1996) – we are better served in our understanding of this cinema by situating it where British Columbia's particular flows of people, capital, commodities, and images merge and intersect. In this sense, the film industry in British Columbia is very much a cinema of its time and place.

BEING AND BELONGING

This study has rejected the national cinema frame as a way of understanding the emergence since the late 1970s of a feature film industry in British Columbia. I have instead taken to heart Tom O'Regan's argument (1996) that particular cinemas must be considered on their own terms. I also extend O'Regan's observation by insisting that place, too, needs to be considered in

terms of its own particularities, not simply as a precisely bounded enclosure but, following Doreen Massey (1991, 1992, 1995), as a meeting ground whose identity is constructed as a complex weave of regional, national, and transnational social, political, and economic relations. This book therefore portrays the feature film industry in British Columbia as the product of several influences: the distinct history of filmmaking on the west coast, a distinct political-economic relationship to the commercial film industry in the United States and the dramatic cinema based in central Canada, a particular perception of cinema by the provincial government in Victoria, and the diverse imaginings of British Columbia's place in the world by the filmmakers working there.

Three of the central qualities that characterize the BC feature film industry today have defined BC cinema for most of this century. First, foreign producers have been visiting British Columbia to shoot films since the turn of the century, attracted by the province's natural beauty and the variety of its landscapes. Second, the provincial government has assumed a central role as promoter, patron, and producer in BC cinema since at least 1908. And third, Victoria's active engagement in BC film production has granted the province a principal role in defining the medium. Historically, that is, the BC government has perceived cinema as a medium to attract immigrants, capital investment, and tourists; encourage tourism by British Columbians within their own province; advertise its industrial products around the world; and promote public education about health, safety, and conservation. Victoria's interest in *feature* filmmaking in the 1970s was not a conceptual departure from this history, but a recognition that cinema could become a capital- and labour-intensive industry in its own right.

The opportunity for British Columbia to become a major film production centre in the 1970s arose as Hollywood began to externalize production and as the emergent Canadian film industry concentrated its production and distribution activities in central Canada. The breakdown of the studio system in Hollywood following the 1948 Paramount Decision, the arrival of television as a rival entertainment medium, and the trend to suburbanization compelled a restructuring of the commercial film industry in the United States. Externalized production and location shooting were part of the Hollywood studios' strategy to reduce both the risks and the costs associated with filmmaking, and British Columbia was one of the places where cost savings could be realized. Such runaway production became the principal

activity of filmmakers on the west coast, even though Canada's own dramatic cinema had been launched with the establishment of the Canadian Film Development Corporation in the late 1960s. The Canadian cinema remained centred in Ontario and Quebec, near Canada's television industries and financial institutions. Vancouver's relative proximity to Los Angeles proved to be a structural advantage when Hollywood began to externalize production – particularly as of the 1970s when the exchange rate favoured Canadian locations – but Vancouver's distance from Toronto and Montreal was a clear disadvantage to Vancouver filmmakers' participation in Canada's indigenous cinema.

The economic opportunity that foreign location production represented was well suited to Victoria's industrial perception of cinema and its long-term objective of expanding and diversifying the province's recession-prone, resource-based economy. When Victoria began to encourage filmmaking in the province through the promotional efforts of the BC Film Commission, it was strictly an economic development initiative designed to attract foreign capital and create local jobs. Even when the provincial government began to provide filmmakers with financial assistance in producing indigenous films, the industrial perception of cinema prevailed.

If Victoria's interest in promoting cinema as a medium of regional industrial development set British Columbia apart from the cultural preoccupations of the Ontario and Quebec governments, federal film policy encouraged competition rather than collaboration among Canada's principal filmmaking provinces. Ottawa's "location-independent" funding policies favoured Toronto and Montreal filmmakers who were in close proximity to the head offices of Canada's television networks, film distributors, financial institutions, and the funding agencies themselves. Ontario, Quebec, and British Columbia have more recently extended their rivalry to foreign location production. The film policy sphere not only sets British Columbia apart as a distinct film industry within Canada, but as a competitor to Ontario and Quebec both intra- and internationally.

The cinematic depiction of British Columbia as place is complicated by the interplay between distinct transnational and regional/local regimes of film production. While foreign producers consistently continentalize British Columbia, rendering North America and the United States consonant in the signifier "America," indigenous films tend to particularize and diversify British Columbia. They render the province as a distinct historical, political,

social, and cultural entity, even if its boundaries remain permeable and tenuous; the central social relationships that motivate these films transcend national, racial, cultural, and generational frontiers, and at the same time call these borders into question. British Columbia's indigenous cinema is a site of contestation over meanings of place, echoing struggles over the region's sense of place in the political, economic, and social realms as the province comes to terms with its roles in Canada, North America, and the Pacific Rim.

Yet if the BC film industry is distinguished by its particular relationship to place, by the way the feature cinema produced on the west coast *belongs* to British Columbia, it is also distinguished by the vulnerability inherent in this relationship. That is, the industry remains overly dependent on a highly mobile and highly competitive sector of the industry: foreign location production.

The film industry is, technically, part of a service sector that has become increasingly important to the British Columbia economy in the postwar period, and that has largely replaced the resource sector as the province's primary generator of jobs and output.[2] But the film industry more closely resembles the economic model of resource extraction. It is an industry devoted primarily to the execution of film projects conceived, financed, and completed elsewhere, films that are subsequently imported back into British Columbia for commercial consumption. British Columbia supplies both natural and human resources – i.e., scenery and predominantly below-the-line labour – to footloose Hollywood film companies, while the important creative elements of story and character remain rooted elsewhere, usually in Los Angeles.

While the spending patterns of foreign film companies in recent years may suggest otherwise, British Columbia's feature film industry depends on the provision of those elements of film production for which Hollywood producers can shop all over the world. If media globalization is the best way to understand the emergence over the past twenty-five years of a feature film industry in British Columbia, it also underscores the fundamentally tenuous relationship between this cinema and this place.

It may be tempting to see this study as parochial, as speaking only to the particular circumstances of feature film production in Vancouver and British Columbia. That would be unfortunate. While the case of British Columbia is unique in many respects, it is nonetheless part of a growing and widespread phenomenon in which film industries around the world – and outside

Locating the BC Film Industry

Quebec and Ontario within Canada – are founded largely on their ability to attract foreign service production.

When the research for this book began in earnest in 1995, British Columbia's dependence on foreign service production was unique among Canada's principal filmmaking provinces. But since the mid-1990s, runaway production has become increasingly central to the established film industries of Ontario and Quebec, as well as the nascent industries in provinces like Alberta and Nova Scotia. Today, the film industries of those provinces are part of this larger process of redefining the relationship between cinema and place. This means that filmmakers across Canada are implicated in a new, transnational circuit of film production in which the distinctions between the global and the local are harder to pinpoint. It also means that the object of study for film scholars demands considerable rethinking of all aspects of cinema, from production to distribution to reception, from film history to political economy to textual analysis. I hope this book has served as a step in that direction. I hope, too, that it has given the notion of globalization some clarity and force, by describing a concrete instance of globalization at work.

Appendix: Partial List of BC Feature Film Credits, 1976–2000

Dates are according to the Internet Movie Database, <http://us.imdb.com>, (25 April 2002).

US FILMS

The Accused (1988)
Ace Ventura II (1995)
Air Up There (1994)
Alaska (1996)
Alive (1993)
Along Came a Spider (2001)
American Dragons (1997)
Bad Moon (1996)
Bear Island (1979)
Bird on a Wire (1990)
Bones (2001)
Cheaters (2002)
Clan of the Cave Bear (1986)
Cousins (1989)
Deep Rising (1998)
Double Jeopardy (1999)
First Blood (1982)
Flipper (1996)
Freddy Got Fingered (2001)
Free Willy II (1995)
Get Carter (2000)
Happy Gilmore (1996)
Hitman (1991)
Housekeeping (1987)
Intersection (1994)
Jennifer 8 (1992)
Josie and the Pussycats (2001)
Jumanji (1995)
K2 (1991)

Lake Placid (1999)
Leaving Normal (1992)
Legends of the Fall (1994)
Look Who's Talking (1989)
Look Who's Talking Now (1993)
Look Who's Talking Too (1990)
Mission to Mars (2000)
Mr. Magoo (1997)
No Fear (1996)
Prophecy (1979)
Rocky IV (1985)
Romeo Must Die (2000)
Roxanne (1987)
Saving Silverman (2001)
Seven Years in Tibet (1997)
Shoot to Kill (1988)
Snow Falling on Cedars (1999)
Stakeout (1987)
Stakeout II (1993)
Star 80 (1983)
Stay Tuned (1992)
This Boy's Life (1993)
Unforgettable (1996)
We're No Angels (1989)
Who's Harry Crumb? (1989)
White Fang II (1994)

CANADIAN FILMS

Air Bud (1997)
Air Bud: Golden Receiver (1998)

Air Bud: World Pup (2000)
American Boyfriends (1989)
Better Than Chocolate (1999)
The Burning Season (1993)
By Design (1982)
Chaindance (1990)
The Changeling (1980)
Deadly Ambition (1995)
Deep Sleep (1990)
Digger (1993)
Dirty (1998)
Double Happiness (1994)
Drive, She Said (1997)
The Final Cut (1995)
The Grey Fox (1982)
The Grocer's Wife (1991)
Hard Core Logo (1996)
Harmony Cats (1993)
Home Movie (1992)
Horsey (1997)
Impolite (1992)
Kingsgate (1989)
Kissed (1997)
Kitchen Party (1997)

Kootenai Brown (1991)
Last Wedding (2001)
Live Bait (1995)
The Lotus Eaters (1993)
Lunch with Charles (2001)
Mask of Death (1996)
Max (1994)
Mile Zero (2001)
Mindstorm (2001)
Mob Story (1990)
My American Cousin (1985)
My Kind of Town (1984)
North of Pittsburgh (1992)
The Pianist (1991)
Quest for Fire (1981)
Rupert's Land (1998)
Saving Grace (1998)
Skip Tracer (1977)
The Sweet Hereafter (1997)
Terminal City Ricochet (1990)
Urban Safari (1996)
Walls (1986)
Whale Music (1994)
White Lies (1998)

Notes

CHAPTER 1: CINEMA IN THE AGE OF GLOBALIZATION

1 Quebec's French-language cinema has long presented a challenge to the category of Canadian national cinema. Does Canada have two national cinemas, or one national cinema that speaks two languages? How do we classify English-language films made in Quebec, or French-language films produced outside Quebec?

2 The souvenir program states: "Chacune de ces oeuvres témoigne d'un regard personnel sur le monde et sur la vie, mais traduit aussi un rapport particulier à un territoire, puisque les grandes régions du Canada ont créé des cinématographies aux personnalités bien différentes. Entre l'océan Pacifique et l'Atlantique, ces cinématographies se sont épanouies à leur rythme propre, façonées par des géographies, des modes de vie, des traditions et des cultures distinctes." [Each of these works adopts a personal view of the world and life in general, but reflects as well a unique rapport with the land, because the regions of Canada have produced filmmakers with very different visions. Between the Pacific and Atlantic oceans, these filmmakers have adopted their own styles, shaped by regional geographies, ways of life, traditions, and distinct cultures] (Les cinémas 1993, my translation).

3 These cinemas offer particular approaches to their topics and develop very different styles, to the point that it would have been more logical to title this retrospective and this work, "The Cinemas of Quebec and Canada." However, this title had to be abandoned because of the political-economic problems resulting from the interminable and complex Canadian constitutional debate (my translation).

4 Martin McLoone (1994, 151) notes that "Hollywood cinema ... has insinuated its way into the consciousness of Ireland, Britain and Europe so completely that its images are now part of common currency." Of Ireland specifically, McLoone writes: "In a situation where Hollywood has dominated the screens of Ireland unchallenged by indigenous filmmaking, the only cinematic images of Ireland with which the Irish were familiar were the representations that flowed out of the Hollywood industry (and at crucial points when it was productive, the British industry as well). In other words, 'cinematic Ireland' was entirely a foreign construction."

5 The phenomenon of globalization, of course, should not be totalized, as its effects are not evenly felt: "Air travel might enable businessmen to buzz across the oceans, but the concurrent decline in shipping has only increased the isolation of many communities" (Massey 1991, 25). We need to consider, in other words, who enjoys mobility under globalization and who doesn't, who initiates such flows and who doesn't, "for different social groups, and different individuals, are placed in very distinct ways in relation to these flows and interconnections."

CHAPTER 2: CINEMA AS A MEDIUM OF REGIONAL INDUSTRIAL DEVELOPMENT

1 George Quimby, curator of exhibits in the department of anthropology at Chicago's Field Museum, came across a faded and scratched print of Curtis's film in the late 1940s. Quimby was interested in restoring the film and conducted some preliminary research. In 1962, he met Bill Holm, a scholar of Kwakiutl culture, who had heard about the film and became interested in Quimby's restoration project. It was not until 1973, however, that Curtis's film, retitled *In the Land of the War Canoes*, was finally restored and edited. Quimby and Holm also added a soundtrack to the film (Holm and Quimby 1980, 13-17). To determine the availability of films cited in this chapter, see Browne (1979) and Duffy (1986).

2 For a more extensive list of feature-length films made in British Columbia, see Walsh (1976), MacIntyre (1996), and the Appendix (pp. 145-6).

3 In a letter to Attorney-General A.M. Manson on 14 December 1923, J. Edward Bird of the law firm Bird, Macdonald, Bird and Collins stated: "There is no encouragement at the present time for anybody to undertake business of this nature in British Columbia. If the parties had a right to exhibit their motion pictures anywhere within the Province by paying a reasonable fee therefor [sic] there would be an encouragement given for development of a local business which would tend to advertise British Columbia not only to the residents of the Province themselves but it would encourage production of films that would find their way all over the world" (BCARS, GR 1323, file M-283, microfilm B2211).

4 A reel of 35 mm film had a running time of between eight and twelve minutes.

5 A 27 September 1927 letter to Attorney-General Manson, from his secretary, makes reference to a plebiscite by the city of Victoria regarding "a by-law designed to assist the establishment of a moving picture industry in this city" (BCARS, GR 429, box 20, file 4).

6 Ping Yang Lai, consul for China, wrote to BC Attorney-General Gordon Sloan on 27 March 1935, requesting that *Secrets of Chinatown* be banned: "I am wholly convinced and declare unequivocally that the whole tone throughout the said picture is derogatory to the self-respect of China." Sloan responded in a letter dated 2 April 1935, upholding the censor's approval of the film: "I see nothing in it derogatory to the Chinese race in general, – no more than the picture of Chicago gangsters could be taken as typical of American life" (BCARS, GR 1323, file M-178, microfilm B2327).

7 One theatre manager who was happy to screen Picture Service films was George E. Clark of the Allan Theatre. In an undated letter to Dr. A.R. Baker, director of the BC Patriotic and Educational Picture Service, Clark wrote: "The subjects we have played have rounded out our program nicely, and have proven to be very enjoyable subjects." Two films Clark singled out for praise were *Stanley Park* and *The Land of Wonder Review*. However, Frank Campbell, a partner in the British American Film Co., complained that provincial government film production hurt his business. Writing to Attorney-General J.W. de B. Farris on 11 December 1920, Campbell requested "at least a portion of the Government work" (BCARS, GR 1323, file M-283, microfilm B2211).

8 As early as 1961, David R. Monk, director of the BC Forest Service's Public Information and Education Division, discussed the methods used by the Forest Service to "educate" the forest industry. Monk perceived his department's function as "not so much to educate in its classical context but rather to assist the Forest Service in the administrative execution of its policy aims, through the securing of compliance" by the forest industry. In a speech delivered 12 May 1961 to a Forest Service silviculture meeting, Monk stated:

> In order to attain departmental goals it is ultimately essential that the various publics comply with the needs of our policies; that they change their attitudes to comply; that they change their behaviour to comply ... Thus this Service's policy of persuasion has always been directed towards the justification of the means by the virtue of the ends because it is in the area of means that there is less solidarity of opinion and thus less resistance. In other words, we direct our efforts towards the development of a broad, socially based acceptance of the sustained-yield program in order to create such a climate of opinion amongst the largest segment of the community – the disassociated – that the direct-interest group are [sic] forced to comply due to the pressures of social mores" (BCARS, GR 1295, box 4, file 32).

CHAPTER 3: THE TERMS OF INCLUSION

1 The term "independent" is a slippery one in the film industry. It is used here to refer to producers who operate either on a contract basis with, or completely outside of, Hollywood's major studios.

2 "A constant inflow of new residents, buying inexpensive bungalows and seeking work, maintained a surplus of settled laborers and kept wages low, from a fifth to a third below the prevailing rates in San Francisco, and in some cases half the wage levels of New York. As the studios moved into feature production and built more elaborate and authentic sets, they needed skilled craftworkers – carpenters,

electricians, dressmakers and many other specialists – and lower costs became an increasingly important factor in locating production in Los Angeles" (Sklar 1978, 68).

3 There was another group of production companies, nicknamed Poverty Row. Studios such as Monogram, Republic, Grand National, and Producers' Releasing Company served smaller theatres with low-budget movies and had little financial impact on the industry (Balio 1990, 4-5).

4 Above-the-line personnel are those associated with a film's principal creative elements, such as the writer, director, and lead performers. Below-the-line personnel include crew members, equipment suppliers, drivers, and caterers (see Moshansky 1996).

5 However, the major Hollywood studios retained their primacy in spite of the restructuring the Paramount Decision required: "In 1954, the Big Five and the Little Three plus two minor companies collected most of the domestic film rentals, as did ten companies (not all the same ones) 20 years later. Overseas, the majors fared just as well. Despite trade restrictions and stiffer competition from foreign producers, US film companies continued to dominate foreign screens; they distributed the lion's share of the gross. Before the war, about a third of their revenue came from abroad; during the fifties, the proportion rose to one-half" (Balio 1990, 6). This, Tino Balio believes, is because the major studios maintained their distribution capacity: "By allowing the defendants to retain their distribution arms, the court, wittingly or not, gave them the means to retain control of the market. The reason, simply stated, is that decreasing demand for motion picture entertainment during the fifties foreclosed the distribution market to newcomers ... Without new competition, the film rentals collected by the majors represented a market share of 90 percent in 1972, the same share they collected during the halcyon days of the thirties and forties" (ibid.).

6 Viacom is the world's third-largest media company after AOL Time Warner and Disney. Its five principal areas of operation are broadcasting, publishing, video and music, theme parks and entertainment. Its other holdings include Blockbuster Video, MTV, Showtime, Aaron Spelling Productions, Republic Pictures, and movie theatres in eleven countries (Viacom 2001). Viacom acquired Paramount Communications Inc. in 1994, and with it, complete ownership of Famous Players Canada Ltd. Investment Canada extracted $400 million from Viacom in 1996 in exchange for the federal government's approval of the transfer of ownership of Paramount's Canadian assets (Enchin 1996). In September 1999, Viacom reached an agreement to acquire the US radio and television broadcast network CBS in a deal worth US$37.3 billion.

7 Loews Cineplex Entertainment filed a Chapter 11 bankruptcy recovery plan in the United States in November 2001. The plan would give Onex Corp. and Oaktree Capital Management control of the theatre chain and allow the company to avoid bankruptcy (St. Onge 2001).

8 In July 1998, Alliance Communications and Atlantis Communications merged to created Alliance Atlantis Communications, the twelfth-largest production and broadcasting company in the world. Michael MacMillan of Atlantis took over as chairman and chief executive officer of the new company, while Alliance chairman and co-founder Robert Lantos announced his decision to return to producing films. Lantos signed an exclusive three-year production contract with Alliance Atlantis (Shecter 1998; MacDonald 1998).

9 If, during the 1950s, the Quebec film industry produced at most two features per year, and if in 1962 *Seul ou avec d'autres* was the only feature film made, eight features were produced in 1964 and thirteen in 1965. An industry began to develop: for the better (an increase in production) and for the worse (a predominance of economics over creativity) (my translation).

10 At the same time as the CFDC and the tax shelter were making investment capital available to independent producers, the pressure intensified on the NFB and the CBC to externalize production. The private sector had been complaining since at least the late 1940s that the NFB was retarding the development of a Canadian film industry (Evans 1991, 9-10). Specific bones of contention were the NFB's occasional forays into feature film production after 1963 and its exclusive right to produce sponsored films for federal government departments, mandated by the Film Act (Evans 1991, 95; Canada 1977,

170). The Federal Cultural Policy Review Committee (known as the Applebaum-Hébert committee) recommended in its 1982 report that the NFB be transformed into a research and training centre and delegate the bulk of its filmmaking to independent producers (Canada 1982, 256-65). This recommendation was echoed by the 1984 Film and Video Policy (Canada 1984) and the 1996 Mandate Review Committee, which noted the inappropriate concentration of 81 percent of the entire NFB staff at its Côte-de-Liesse production facility in Montreal (Canada 1996, 163-4, 171).

The Applebaum-Hébert committee similarly recommended in its 1982 report that the CBC relinquish all of its production activities – with the exception of its news programming – to independent producers (Canada 1982, 292-4). The Caplan-Sauvageau report in 1986 endorsed the CBC's strategy of increasing its proportion of independent production (outside of sports and information programming) to 50 percent by 1988, noting that the federal Department of Communications had created the Broadcast Program Development Fund in 1983 "partly as a consequence of the unsatisfactory relationship between the CBC and the independent sector" (Canada 1986, 277-8, 315). Yet as recently as 1996, the Mandate Review Committee again recommended that a majority of CBC programming outside of news, current affairs, and sports "should be produced by the independent production community" (Canada 1996, 102).

11 Challenge for Change was a different approach to decentralizing NFB filmmaking. Its purpose was to provoke social change through the use of video and film by allowing communities throughout Canada to make their own films, with guidance from NFB producers (see Hénault 1991; Burnett 1991). From the program's inception in 1967 through to 1979, eighty-three Challenge for Change films were made (Evans 1991, 176). John Grierson, the NFB's original commissioner, was critical of Challenge for Change as a program of decentralization. When Grierson heard talk of making films "not *about* people but *with* them," he argued: "But not yet is there a real decentralizing of production. The cinéastes may make their films *with* the people and *in* the villages, but they are soon *off* and away *from* the people and the villages to their normal metropolitan milieu" (Grierson 1977, 133-4).

12 One of the best-known NFB films made in Vancouver was *Whistling Smith*, directed by Marrin Canell and Michael Scott, which was nominated for an Academy Award in 1975.

13 This citation is reproduced with the permission of the National Film Board of Canada archives. © National Film Board of Canada. All Rights Reserved.

14 Between 1960 and 1970 they created the foundations of a politically engaged cinema and forged a path for future generations (my translation).

CHAPTER 4: PROMOTE IT AND THEY WILL COME

1 Until 2001, the provincial ministry responsible for the film industry was the Ministry of Small Business, Tourism and Culture. With the election of Gordon Campbell's Liberals in May 2001, the responsibility for film shifted to the Ministry of Competition, Science and Enterprise.

2 In an interview, Dave Barrett (1998) said he could not recall any details of his government's efforts to establish a film policy, insisting that the resource industries occupied most of his government's attention.

3 While the Social Credit party was in opposition in 1973, Dan Campbell of W.A.C. Bennett's office commissioned a set of fifteen "Liberty Papers," which were written by Delbert Doll, president of the Comox constituency. The last of these papers was entitled "Private Enterprise and the Arts," and it outlined the benefit to the arts community of a private-enterprise system of governance. The paper concludes: "The private enterprise system does not deny the existence of values other than those formed by the market process. It simply leaves to the individual the responsibility of determining his own esthetic values and reducing them to dollar terms in his willingness to buy a painting, attend a symphony, purchase a record or a book. The private enterprise system has provided the artist with the media means of propagating his set of values, the materials to create art, and the wealthy public to purchase it and thereby provide the artist with creative and monetary satisfaction" (Simon Fraser University Archives, MG 1/1, box 12, file 6).

4 The Canadian film magazine *Take One* recently selected *The Grey Fox* as one of its top twenty Canadian films of all time (Top 20 1998).

5 The city of Victoria jumped on the bandwagon in December 1983 when the Greater Victoria Chamber of Commerce established a film commission and distributed 5,000 copies of a directory of Vancouver Island film resources to producers in Los Angeles, New York, and Toronto (Canadian Press 1983).

6 The list of support services for film and television production includes: accommodations, accounting services, aircraft rentals, antiques and period pieces, boat and yacht charters, bookstores, catering, communications, computer services, consultants (e.g., marine and mountain), costume design, costume rental, courier and delivery services, customs brokers, first aid, general rentals, guarantors, insurance, lawyers and legal services, location scouting, medical services, office services, performers' supplies, pilots, plants, properties, publicity, restaurants, scenic supplies, security services, snow control, theatre equipment, translators, travel consultants, vehicle rentals and leases, and veterinarians (see Quenville 1986, 47-8). Manjunath Pendakur (1998, 224) notes: "It is estimated that more than 1,500 retail and wholesale businesses in the Greater Vancouver area receive some portion of their annual revenue from film/TV production activity."

7 Postproduction is the final assembly of the sound and picture elements of a film, which are recorded during the production stage. Music, narration, sound effects, additional dialogue, special visual effects, graphics, titles, and credits are added during this process, and the total package is edited so that each of these elements works to the filmmakers' satisfaction (see BCMPA 1992, 6).

8 Quenville (1986) cited three provincial programs that supported film production. The first was the Ministry of Economic Development, which offered two forms of support: direct funding of feasibility studies and management improvement, $15,000 of which was committed to three film projects in 1984-5; and indirect support through the BC Development Corporation, which had spent $300,000 on a feasibility study of the Dominion Bridge industrial site, and which had put up a $5 million loan for its renovation. The second was the Knowledge Network, which produced between twenty and thirty hours of original programming per week. Given that its $4 million annual budget was insufficient to finance significant amounts of local production, its principal contribution was to provide independent producers with access to its facilities and technical crews. The third support program was the Ministry of International Trade and Investment, which had four instruments to assist BC companies to develop international markets, but, Quenville concluded, "they would seem to be of little particular benefit to the film industry as a whole" (37-40). Defending Telefilm Canada's funding record, executive director Peter Pearson argued that British Columbia's 3 percent share of Telefilm money over the previous four years was a reflection of the state of its indigenous film industry, which was restricted to "below the neck" production of films conceived outside of the province. BC director Jack Darcus claimed that the BC government "had done nothing for the arts for 30 years" (in Godfrey 1986).

9 La Société générale du cinéma du Québec was combined with La Société de développement des industries de la culture et des communications (SODICC) to form La Société générale des industries culturelles (SOGIC) in 1988 (Audley 1989, 56).

10 It could even be argued that the choice by the Ministry of Municipal Affairs, Recreation and Culture to commission Paul Audley to conduct the study itself signalled a philosophical shift in film policy. Audley was best known at the time for his landmark textbook *Canada's Cultural Industries* (1983), which foregrounded the cultural dimension of the publishing, recording, radio, television, and film industries in Canada. In the book's introduction, Audley noted that his study was "predicated on the view that cultural goals ought to be primary and that what is required is an approach to the cultural industries that effectively integrates a concern for the achieving of well-defined cultural goals with an understanding of the structure and operation of the industries themselves" (xxviii). Until 1986, of course, the BC government had emphasized economic goals in its approach to film policy, to the total exclusion of cultural goals.

11 The Canadian Audio-Visual Certification Office (CAVCO) determines Canadian-content eligibility on the basis of a points system for key creative positions on a film. The director and screenwriter positions are worth two points each, while single points are awarded to art director, director of photography, picture editor, music composer, highest-paid actor or actress, and second-highest-paid actor or actress (CFTPA 1994).

12 Given that most of the productions shot in British Columbia are not set in the province, the BC Film Commission demands a credit that identifies the film location. "We always get a credit," insists Grace McCarthy (1997). The promotional logic here is that moviegoers will be intrigued enough by the scenery in a film to sit through the credits and want to visit the place where the film was shot. A concrete example of how this works is provided by *Roxanne*. The Columbia Pictures feature starring Steve Martin and Daryl Hannah was shot in Nelson in 1986 – Nelson, British Columbia, played Nelson, Washington, in the film – and injected $650,000 into a region with an unemployment rate of 25 percent. On its release in the summer of 1987, the film further contributed to the Nelson economy by attracting tourists, who became known as "Roxanne people," from Washington, Oregon, California, Iowa, Montana, and Illinois (Young 1987; Canadian Press 1987). The Hope and District Chamber of Commerce publishes a self-guided walking tour to locations used in the fall 1981 shooting of *First Blood,* describing itself as the "big screen birthplace" of the Sylvester Stallone character John Rambo. Stop one on the tour notes: "Sheriff Teasle drops Rambo off at Water Avenue, near Gardner Chev-Olds" (Tour local 1997).

13 As recently as March 1986, Premier Bennett had insisted the Bridge Studios renovation would be exclusively a private-sector initiative. Promoting the BC film industry during a business trip to California, Bennett maintained: "This will be done without subsidized film-making. I don't think our taxpayers want to pay for their movies twice, once at the box office and once on their taxes" (Palmer 1986). In the same vein, Socred MLA John Reynolds responded to opposition calls for greater government involvement in the film industry with this statement to the legislature on 9 May 1986: "Throughout the development of the film industry our government has helped as a partner, as it does for all private sector industries. We believe that government should play a role in supporting the film industry, but government should neither control nor dictate to it. Because of the nature of the industry, it is best left to the private sector, where it can draw from the greatest number of creative and innovative people" (British Columbia 1986a, 8133).

14 BC Film's mandate was renewed in January 1990, when the agency was granted $15 million over three years (BC Film gets 1990). BC Film funding became an ongoing expenditure of the provincial budget in fiscal 1992-3, when its $5 million annual grant was incorporated into the estimates of the Ministry for Tourism and the Ministry Responsible for Culture (Audley 1993b, iv).

15 The Ministry of Small Business, Tourism and Culture commissioned a BC Advisory Committee on the Status of the Artist in 1993, recognizing that: "To choose to be an artist in British Columbia in the 1990s is almost inevitably to live on the economic margins" (British Columbia 1994, 4). Among the committee's recommendations was that the provincial government introduce "film investment incentives" on a sliding scale. That is, the higher the percentage of BC above-the-line personnel working on a project, the greater the incentive (11).

16 As recently as 1992, not one Hollywood feature film was shot in Quebec, but foreign spending in the province reached $192 million in 1998. Two Montreal-area studio projects were announced in 1999 to encourage foreign location production. The $25.5 million Ciné Cité Montréal in St-Hubert was designed to house five indoor studios totalling 5,700 square metres, while the $24 million Mel's Cité du Cinéma promised 6,100 square metres of indoor studio space (Lamey 1999; Kelly 1999).

17 A former production officer at BC Film, Friesen (2001) admitted in an interview with the author to having been critical of Telefilm's commitment to regional funding allocation. She explained that in 1999 and 2000, Telefilm set funding targets of 35 percent for the Prairie provinces and British Columbia, but future commitments to decentralization remain dependent upon policies established at head

office in Toronto. In July 2001, Friesen was appointed acting director of Canadian operations for Telefilm, working from the Vancouver office (Telefilm Canada 2001).

18 A front-page article in the *Globe and Mail* (Saunders 1998) detailed the intense competition among Canadian provinces to attract film and television production: "Over the past 18 months, provincial governments have clambered to outdo one another in the generosity of the tax credits and subsidies they offer production companies, both Canadian and foreign, for shooting within their borders."

CHAPTER 5: LOCATING BRITISH COLUMBIA AS CINEMATIC PLACE

1 Postproduction activity is a gauge of film industry stability. Vancouver-based companies have performed postproduction work on such TV series as *Poltergeist, Outer Limits, Millennium, The X-Files,* and *Highlander* (Edwards 1997a).

2 This figure includes $500,000 for British Columbia's regional film offices (Allen 2001).

3 Even within state and provincial jurisdictions, smaller regional film offices have sprouted up. The Florida Film Commissioners Association, for example, has twenty-five member commissions. Ontario has film commissions in Toronto, the Durham and Niagara regions, and the town of Huntsville. Besides Vancouver, British Columbia has film offices in Campbell River, Chilliwack, Kamloops, Kelowna, Mission, Nelson, Prince George, Salmon Arm, Surrey, Terrace, Victoria, and Williams Lake.

4 Peter Mitchell (1997), former director of the BC Film Commission, estimates that between 60 and 70 percent of the Hollywood producers working in British Columbia are repeat customers.

5 It is important to understand that the currency-exchange rate is a managed economic variable. Because it plays a key role in all sectors of the Canadian economy – more than 80 percent of Canada's trade is with the United States – the federal government manages the rate through the acquisition and sale of international currency reserves and through the formulation of monetary policy to serve exchange-rate objectives. While the BC film industry is sensitive to exchange-rate fluctuations, so is British Columbia's forestry industry, which is highly dependent on export sales. In a study of British Columbia as a low-cost location for American audiovisual production, however, Catherine Walshe (1997, 46) concluded that even with the Canadian and American currencies at par, Vancouver's costs of production would remain less than 95 percent of comparable costs in Los Angeles.

More specifically, the exchange rate results from international transactions that create a supply of, and a demand for, Canadian dollars in the foreign-exchange market. Transactions that create a supply of Canadian dollars include the importation of goods and services, travel by Canadians abroad, Canadian foreign investment, foreign borrowing in Canada, and interest and dividend payments to foreign investors. Transactions that create a demand for Canadian dollars include the export of goods and services, foreign visits to Canada, income from foreign investments and foreign investment in Canada (Dobson 1980). The exchange rate has a broad economic impact: "When a country's currency appreciates, its export industries find it harder to compete in world markets. At the same time, industries that face import competition find it difficult to compete in domestic markets. When a country's currency depreciates, in contrast, export and import-competing industries boom, but industries that rely on imported energy or imported raw materials suffer" (Vogt, Cameron, and Dolan 1993, 661).

6 The Vancouver accounting firm Ellis Foster published a study of British Columbia's studio space in July 1998. It concluded that "a critical shortage of studio space" in the Lower Mainland meant that British Columbia was losing productions. The full-service studio facilities tend to be monopolized by major Hollywood television series producers like MGM, Paramount, and Fox (Clarance 1998, 1-6).

7 There are structural reasons for the industry's concentration in Vancouver. First, that is where the ancillary services required by film shoots are located, including hotels, equipment rentals, and film processing labs. But second, labour agreements require higher wages for shoots outside of the "grid," which is the Vancouver shooting zone bounded by Sunset Marina in West Vancouver to the north, the US border to the south, 168th Avenue in Surrey to the east, and the waterfront to the west (Hiltz 1997).

8 The promotional package I received from the BC Film Commission in April 2001 contained:

- the 2001 *Reel West Digest,* a 432-page directory of services for audiovisual production in western Canada
- a 30-page locations brochure entitled *The British Columbia Shooting Gallery*
- the 2001 edition of the *BC Film Commission Production and Budget Guide,* a detailed outline of cost breakdowns for film-related services, as well as government regulations, a sunrise/sunset chart, a temperature/precipitation chart, and a metric conversion guide
- a copy of the Spring 2001 edition of *Playback International* magazine
- a press release summarizing "quick facts" about the BC film and television industry
- a bulletin from the Income Taxation Branch of the BC government, explaining its production services tax credit
- a series of five full-colour brochures picturing shooting locations in the Lower Mainland, Okanagan, Kootenay-Columbia, Cariboo-Chilcotin, and North Coast-Peace River districts of the province
- a 2001 *Vacation Planner* and road map from Tourism British Columbia.

9 Frequent use of this idiom can be found in the Hollywood trade publication *Variety.* In *Variety,* a studio head is a "prexy," executives who leave for another company "ankle," a film reporting strong box-office returns is described as "socko," and television networks are "webs."

10 Ken MacIntyre (1996) has published a thorough guide to Hollywood North, which lists all the films shot in British Columbia and describes their locations. This section makes extensive use of MacIntyre's work.

11 I want to credit Maurice Charland for bringing this point to my attention.

12 Gerald Mast (1986, 37) describes *The Great Train Robbery* as "almost a little textbook on 'How to Rob a Train' – first you tie up the telegraph operator so he can't send a warning, then you climb aboard the train when it stops for water, then you unhook the locomotive from the passenger cars so the passengers can't escape, and so forth. Many of the earliest moral fears about the movies arose from their ability to teach audiences how to perform daring crimes in precise and clear detail."

13 A published diary by screenwriter Noel S. Baker (1997) provides a fascinating study of the evolution of this low-budget Canadian feature. From the early stages of preparing the script, Baker describes the processes of casting actors, scouting locations, lining up funding, and finally, shooting the film.

14 These highly autobiographical stories also speak to Sandy Wilson's own questions about life as a filmmaker on the two sides of the international fence. Acknowledging that she often wonders whether Los Angeles might afford her greater career opportunities, Wilson told an interviewer: "I guess I'm still crazy enough to think we can make movies here. It's very tough but this is where my community is, this is where I draw my strength from. And I think we are always just on the brink of fulfilling the promise in the Canadian film industry" (in Mitchell 1991, 75).

15 Chia-chi Wu (1998, 2) argues that *Double Happiness* adopts a very Western, even Orientalist, view of the Li family, beginning with Jade's opening monologue, in which she asserts "her own otherness from her family while highlighting her family's 'otherness' from the white family." Wu points out: "As an 'ethnic' film, while talking to us and eliciting our identification, Jade's direct address is used to introduce her point-of-view at her own family, as someone from 'their' culture and a cultural informant who can talk in 'our' language. As Jade says, 'I want to tell you about my family,' her perspective is mobilized to stand in for the camera's gaze at the ethnic culture" (5).

CHAPTER 6: LOCATING THE BC FILM INDUSTRY

1 While statistics relating to the share of screen time occupied by Canadian films in commercial theatres are commonly cited in scholarly articles and the popular media, Quebec is the only jurisdiction

in Canada to keep such data. National figures are derived from Statistics Canada data that report distributors' earnings from foreign and domestic films. These data do not take into account differences between provinces or between urban, suburban, and rural theatres. Statistics Canada (2000) reports that for the fiscal year that ended March 1998, foreign movies shown in Canadian theatres and drive-ins accounted for 98 percent of distributors' revenue.

2 As of 1991, the service industries accounted for 75 percent of the provincial work force, compared to the resource industries' 6 percent (Howlett and Brownsey 1996, 18, 348). As early as 1961, the service industries accounted for 60 percent of the province's gross domestic product, and approximately 70 percent by 1991 (Belshaw and Mitchell 1996, 331).

References

INTERVIEWS AND PERSONAL COMMUNICATION

Allen, Lindsay. 2001. [Manager, Cultural Industries, Cultural Services Branch, BC Ministry of Small Business, Tourism and Culture.] Conversation with author, 23 April.

Barrett, Dave. 1998. Telephone interview with author, 8 March.

Friesen, Elizabeth. 2001. Interview with author, 26 April.

Hiltz, Tim. 1997. Interview with author, 3 June.

McCarthy, Grace. 1997. Interview with author, 12 June.

Mitchell, Peter. 1997. Interview with author, 4 June.

OTHER SOURCES

Abu-Laban, Yasmeen. 1997. Ethnic politics in a globalizing metropolis: The case of Vancouver. In *The politics of the city: A Canadian perspective*, ed. Timothy L. Thomas, 77-95. Toronto: ITP Nelson.

Affron, Charles, and Mirella Joan Affron. 1995. *Sets in motion: Art direction and film narrative.* New Brunswick, NJ: Rutgers University Press.

Agent-General for British Columbia. 1909. Annual report. *British Columbia Sessional Papers*, G41-4.

–. 1910. Annual report. *British Columbia Sessional Papers*, H33-5.

Allan, Blaine. 1993. Canada's sweethearts, or our American cousins. *Canadian Journal of Film Studies* 2 (2-3):67-80.

Anderson, Benedict. 1989. *Imagined communities: Reflections on the origin and spread of nationalism.* London: Verso.

Andrews, Marke. 1987a. Praxis strives to change the fortunes of Canada's film culture. *Vancouver Sun,* 31 January, G2.

–. 1987b. Lights, camera, action: B.C.'s film fund is off and running. *Vancouver Sun,* 1 December, B6.

–. 1988. They won against all the odds. *Vancouver Sun,* 16 January, D1.

Associated Press. 1971. Bennett wooing U.S. film-makers. *Vancouver Province,* 10 May, 27.

Audley, Paul. 1983. *Canada's cultural industries: Broadcasting, publishing, records and film.* Ottawa: Canadian Institute for Economic Policy.

–. 1986. *The development of the film industry in British Columbia: Review and recommendations.* Toronto: Paul Audley and Associates.

–. 1989. *The development of regional film and television production in Canada.* Toronto: Paul Audley and Associates.

–. 1992. *A cost-benefit analysis of B.C. Film: 1987-88 to 1991-92.* Toronto: Paul Audley and Associates.

–. 1993a. *A framework for the development of cultural industries policies for British Columbia.* Toronto: Paul Audley and Associates.

–. 1993b. *Policy recommendations for the future development of the film industry in British Columbia.* Toronto: Paul Audley and Associates.

Baker, Noel S. 1997. *Hard core roadshow: A screenwriter's diary.* Toronto: Anansi.

Balio, Tino. 1985. Retrenchment, reappraisal, and reorganization, 1948-. In *The American film industry,* ed. Tino Balio, 401-47. Madison: University of Wisconsin Press.

–, ed. 1990. *Hollywood in the age of television.* Boston: Unwin Hyman.

Banning, Kass. 1995. You taste Canasian: Negotiating *Double Happiness. Border/Lines* 36 (April):24-6.

Barker, Leo-Rice, and Ian Edwards. 1999. Runaway U.S. production. *Playback,* 3 May, 1, 10-11.

Bastien, Jean-Pierre, and Piers Handling. 1980. Allan King. In *Self Portrait: Essays on the Canadian and Quebec cinemas*, ed. Pierre Véronneau and Piers Handling, 207-8. Ottawa: Canadian Film Institute.

BC Bureau. *See* British Columbia Bureau of Provincial Information.

BC Committee for CBC Reform. 1976. B.C. committee of one hundred damns CBC: Corporation a Toronto-controlled mess. *Vancouver Sun,* 11 March, 6.

BC Development. *See* British Columbia Department of Industrial Development, Trade and Commerce.

BC Film. *See* British Columbia Film.

B.C. Film: The promise is fulfilled. 1987. *Reel West Magazine,* October-November, 17-18.

BC Film gets $15 million. 1990. *Vancouver Sun,* 16 January, B6.

BC Lands. *See* British Columbia Department of Lands.

B.C. really getting into the picture. 1978. *Vancouver Sun,* 31 August, C9.

BC Recreation. *See* British Columbia Department of Recreation and Conservation.

BC Small Business. *See* British Columbia Ministry of Tourism and Small Business Development.

BC Stats. 1995. *International commodity exports*. Victoria: Ministry of Government Services.

–. 1996. *Immigration*. Victoria: Ministry of Government Services.

BC Statutes. See British Columbia Statutes.

BC Tourism. *See* British Columbia Ministry of Tourism.

BC Trade. *See* British Columbia Department of Trade and Industry.

BC Travel. *See* British Columbia Department of Travel Industry.

BC Travel Bureau. *See* British Columbia Government Travel Bureau.

BCARS (British Columbia Archives and Records Service). GR 429, box 20, file 4. Attorney-General, Correspondence and News, 1914-1931.

–. GR 1295, box 4, file 32. Forest Service, Public Information and Education Division.

–. GR 1323, file M-178, microfilm B2326-7. Attorney-General, Correspondence, 1925-1937.

–. GR 1323, file M-283, microfilm B2210-11. Attorney-General, Correspondence, 1919-1924.

–. GR 1672, boxes 6242 and 6245. Motion Picture Industry.

BCFC (BC Film Commission). 1992. Spelling opens. *Focal Point* (Fall): 1.

–. 1997. *British Columbia Film Commission: Business plan 1997/98.*

–. 2001a. Promotional literature for location filming in British Columbia. 25 April. [Available from BC Film Commission, 350-375 Water Street, Vancouver, BC, V6B 5C6.]

–. 2001b. Quick facts about the BC Film Commission. 17 July. <www.bcfilm.gov.bc.ca>, (13 May 2002).

BCLF. *See* British Columbia Department of Lands and Forests.

BCLFW. *See* British Columbia Department of Lands, Forests and Water Resources.

BCMPA (British Columbia Motion Picture Association). 1992. Post production in British Columbia: An examination of the post production sector of British Columbia's motion picture industry. Internal report, March.

–. 1997. Comments from the British Columbia Motion Picture Association on a proposal to direct programming contributions by broadcasting distribution undertakings to the Canada Television and Cable Production Fund. Internal report, 21 April.

Belshaw, John Douglas, and David J. Mitchell. 1996. The economy since the great war. In *The Pacific province: A history of British Columbia,* ed. Hugh J.M. Johnston, 313-42. Vancouver: Douglas and McIntyre.

Berton, Pierre. 1975. *Hollywood's Canada: The Americanization of our national image*. Toronto: McClelland and Stewart.

Big nine to form producers group, looking for increased commercial clout. 1981. *Cinema Canada* 2:10.

Birnie, Peter. 1996. Union merger good news for B.C. film business. *Vancouver Sun,* 15 March, C1.

Bitzer, G.W. 1973. *Billy Bitzer: His story.* Toronto: Doubleday Canada.

Blowen, Michael. 1985. Say goodbye to Hollywood. *Winnipeg Free Press,* 13 July, 17.
Bordwell, David, and Kristin Thompson. 1986. *Film art: An introduction.* New York: Alfred A. Knopf.
British Columbia. 1924. *Journals of the Legislative Assembly,* 11 November, 15.
–. 1937. *Report of the Royal Commission on Projectionists and Kinematographs.* Victoria: Provincial Secretary's Office.
–. 1949. *Journals of the Legislative Assembly,* 18 February, 18.
–. 1970. *Debates,* 16 March, 626.
–. 1979. *Debates,* 26 July, 1036-7.
–. 1981. *Debates,* 9 March, 4407.
–. 1986a. *Debates,* 9 May, 8133-4.
–. 1986b. *Debates,* 2 June, 8480-1.
–. 1994. *In spirit and in law: Report of the B.C. Advisory Committee on the Status of the Artist.* Victoria: Ministry of Small Business, Tourism and Culture.
–. 1995a. *A cultural policy for British Columbia.* Victoria: Ministry of Small Business, Tourism and Culture.
–. 1995b. *CultureWorks! Investing in arts and culture.* Victoria: Ministry of Small Business, Tourism and Culture.
–. 1997. Film industry gets major boost with film production incentive. Press release, 10 October. <www.tbc.gov.bc.ca>, (11 October 1997).
–. 1998. Premier announces production services tax credit aimed at foreign producers. Press release, 1 June. <www.tbc.gov.bc.ca>, (2 June 1998).
British Columbia Bureau of Provincial Information. 1911. Annual report of the Bureau of Provincial Information. *British Columbia Sessional Papers,* M33-5.
British Columbia Department of Industrial Development, Trade and Commerce. 1970. Report of the Department of Industrial Development, Trade and Commerce. *British Columbia Sessional Papers,* Y21-9.
British Columbia Department of Lands. 1921. Report of the Forest Branch of the Department of Lands. *British Columbia Sessional Papers,* n.p.
–. 1925. Report of the Forest Branch of the Department of Lands. *British Columbia Sessional Papers,* E40-1.
–. 1926. Report of the Forest Branch of the Department of Lands. *British Columbia Sessional Papers,* AA37-8.
British Columbia Department of Lands and Forests. 1954. Report of the Forest Service of the Department of Lands and Forests. *British Columbia Sessional Papers,* 109-10.
–. 1957. Report of the Forest Service of the Department of Lands and Forests. *British Columbia Sessional Papers,* 47-8.
–. 1958. Report of the Forest Service of the Department of Lands and Forests. *British Columbia Sessional Papers,* 40-2.
–. 1959. Report of the Forest Service of the Department of Lands and Forests. *British Columbia Sessional Papers,* 33-4.
–. 1960. Report of the Forest Service of the Department of Lands and Forests. *British Columbia Sessional Papers,* 35-6.
British Columbia Department of Lands, Forests and Water Resources. 1970. Report of the Forest Service of the Department of Lands, Forests and Water Resources. *British Columbia Sessional Papers,* 27-8.
–. 1972. Report of the Forest Service of the Department of Lands, Forests and Water Resources. *British Columbia Sessional Papers,* AA39-40.
–. 1974. Report of the Forest Service of the Department of Lands, Forests and Water Resources. *British Columbia Sessional Papers,* S41-2.

British Columbia Department of Recreation and Conservation. 1958. Report of the Department of Recreation and Conservation. *British Columbia Sessional Papers*, II34-43.

–. 1959. Report of the Department of Recreation and Conservation. *British Columbia Sessional Papers*, Q45-56.

–. 1960. Report of the Department of Recreation and Conservation. *British Columbia Sessional Papers*, Y41-55.

–. 1962. Report of the Department of Recreation and Conservation. *British Columbia Sessional Papers*, V45-65.

–. 1966. Report of the Department of Recreation and Conservation. *British Columbia Sessional Papers*, Y47-66.

–. 1967. Report of the Department of Recreation and Conservation. *British Columbia Sessional Papers*, T53-75.

British Columbia Department of Trade and Industry. 1939. Report of the Department of Trade and Industry. *British Columbia Sessional Papers*, FF13-23.

–. 1941. Report of the Department of Trade and Industry. *British Columbia Sessional Papers*, Q24-32.

–. 1942. Report of the Department of Trade and Industry. *British Columbia Sessional Papers*, M24.

–. 1950. Report of the Department of Trade and Industry. *British Columbia Sessional Papers*, DD57-9.

British Columbia Department of Travel Industry. 1968. Report of the Department of Travel Industry. *British Columbia Sessional Papers*, Q9-43.

–. 1969. Report of the Department of Travel Industry. *British Columbia Sessional Papers*, P49-57.

–. 1970. Report of the Department of Travel Industry. *British Columbia Sessional Papers*, H60-1.

–. 1975. Report of the Department of Travel Industry. *British Columbia Sessional Papers*, H50-2.

British Columbia Film. 1992. *Annual report, 1991-92*. Vancouver: BC Film.

–. 1993. *Annual report, 1992-93*. Vancouver: BC Film.

–. 1995. B.C. Film Fund announces new alignments in film finance. Press release, 28 August.

–. 2000a. *Annual report, 1999-2000*. Vancouver: BC Film.

–. 2000b. Programs. <www.bcfilm.bc.ca>, (26 April 2000).

British Columbia Government Travel Bureau. 1942. *Why British Columbia was the chosen locale for "Commandos Strike at Dawn."* Victoria: British Columbia Government Travel Bureau.

British Columbia Ministry of Tourism. 1981. Tourism British Columbia annual report. *British Columbia Sessional Papers*, 1-4.

British Columbia Ministry of Tourism and Small Business Development. 1980. Annual report of Tourism British Columbia. *British Columbia Sessional Papers*, 1-6.

British Columbia Statutes. 1920. *Moving Pictures Act*, c. 95.

–. 1967. *Centennial Cultural Fund*, c. 7.

–. 1972. *British Columbia Cultural Fund*, c. 10.

Brown, Georgia. 1995. Intersection, Village Voice, 2/1/94. *Film Review Annual*. Englewood, NJ: Film Review Publishers.

Browne, Colin. 1979. *Motion picture production in British Columbia: 1898-1940. A brief historical background and catalogue*. Victoria: British Columbia Provincial Museum.

–. 1989. The phantom ride. *Vanguard* 18 (2):26-31.

–. 1992. Il était une fois Hollywood North: Colombie britannique: 1929-1986. In *Les cinémas du Canada: Québec, Ontario, Prairies, côte Ouest, Atlantique*, ed. Sylvain Garel and André Pâquet, 173-87. Paris: Centre Georges Pompidou.

Bula, Frances. 1998. B.C. copies Ontario film tax-credit program. *Vancouver Sun*, 2 June, D1-2.

Burnett, Ron. 1991. Video/film: From communication to community. In *Video the changing world*, ed. Nancy Thede and Alain Ambrosi, 54-60. Montreal: Black Rose Books.

Caddell, Ian. 1998a. Coffee mates. *Reel West Magazine*, January-February, 8-9.

–. 1998b. Telefilm plans to improve relations with west. *Reel West Magazine*, January-February, 9.

Canada. 1931. *Investigation into an alleged combine in the motion picture industry in Canada: Report of the commissioner.* Ottawa: F.A. Acland.

—. 1951. *Report of the Royal Commission on National Development in the Arts, Letters and Sciences, 1949-1951.* Ottawa: Edmond Cloutier.

—. 1957. *Report of the Royal Commission on Broadcasting.* Ottawa: Edmond Cloutier.

—. 1977. *The film industry in Canada.* Department of the Secretary of State. Ottawa: Minister of Supply and Services Canada.

—. 1982. *Report of the Federal Cultural Policy Review Committee.* Ottawa: Minister of Supply and Services Canada.

—. 1984. *The national film and video policy.* Department of Communications. Ottawa: Minister of Supply and Services Canada.

—. 1985. *Canadian cinema: A solid base. Report of the Film Industry Task Force.* Ottawa: Minister of Supply and Services Canada.

—. 1986. *Report of the Task Force on Broadcasting Policy.* Ottawa: Minister of Supply and Services Canada.

—. 1996. *Making our voices heard. Mandate Review Committee: CBC, NFB, Telefilm.* Ottawa: Minister of Supply and Services Canada.

Canadian culture? 1995. *Vancouver Sun,* 18 March, A1.

Canadian Press. 1979. Barkerville comes alive with hope of movie gold. *Victoria Colonist,* 3 May, 36.

—. 1983. Victoria selling itself as movie, TV location. *Globe and Mail,* 24 December, E4.

—. 1987. Movie put Nelson on map. *Vancouver Sun,* 20 August, A1.

Careless, J.M.S. 1980. Submarines, princes and Hollywood commandos, or at sea in B.C. *B.C. Studies* 45 (Spring):3-16.

Cawdery, Jack. 1985. *The film and video industry in British Columbia: Industry structure and market survey.* Vancouver: Quantalytics Inc.

CBC (Canadian Broadcasting Corporation). 1960. *Annual report 1959-60.* Toronto: CBC.

—. 1961. *Annual report 1960-61.* Toronto: CBC.

—. 1965. *Annual report 1964-65.* Toronto: CBC.

CCTA (Canadian Cable Television Association). 1995. *1994-95 annual report.* Toronto: CCTA.

CFDC (Canadian Film Development Corporation). 1969. *Annual report, 1968-69.* Toronto: CFDC.

—. 1972. *Annual report, 1971-72.* Toronto: CFDC.

—. 1973. *Annual report, 1972-73.* Toronto: CFDC.

—. 1978. *Annual report, 1977-78.* Toronto: CFDC.

—. 1979. *Annual report, 1978-79.* Toronto: CFDC.

—. 1980. *Annual report, 1979-80.* Toronto: CFDC.

—. 1981. *Annual report, 1980-81.* Toronto: CFDC.

—. 1982. *Annual report, 1981-82.* Toronto: CFDC.

—. 1983. *Annual report, 1982-83.* Toronto: CFDC.

CFTPA (Canadian Film and Television Production Association). 1997. *The Canadian film and television production industry: A 1997 profile.* Toronto: CFTPA.

—. 1994. Canadian Content. *The guide.* Toronto: CFTPA.

Christopherson, S., and M. Storper. 1986. The city as studio; the world as back lot: The impact of vertical disintegration on the location of the motion picture industry. *Environment and Planning D: Society and Space* 4:305-20.

Clandfield, David. 1987. *Canadian film.* Toronto: Oxford University Press.

—. 1992. De Nobody Waved Goodbye à Videodrome. Ontario: 1963-1984. In *Les cinémas du Canada: Québec, Ontario, Prairies, côte Ouest, Atlantique,* ed. Sylvain Garel and André Pâquet, 133-41. Paris: Centre Georges Pompidou.

Clarance, Neal. 1998. *The British Columbia film industry: Opportunities for film and video production and investment in British Columbia,* April. Vancouver: Ellis Foster, Chartered Accountants.

Cook, Pamela. 1985. *The cinema book: A complete guide to understanding the movies*. New York: Pantheon Books.

Cox, Kirwan. 1980. Hollywood's empire in Canada. In *Self-portrait: Essays on the Canadian and Quebec cinemas*, ed. Pierre Véronneau and Piers Handling, 11-41. Ottawa: Canadian Film Institute.

Craig, Susanne. 2001. Loew's Cineplex prepares cash-crunch financing. *Globe and Mail*, 12 January, B1.

Crofts, Stephen. 1993. Reconceptualizing national cinema/s. *Quarterly Review of Film and Video* 14 (3):49-67.

Dafoe, Chris. 1992. Activist combats "sense of desperation." *Globe and Mail*, 25 January, C3.

–. 1997. Baton shakes up Lotusland. *Globe and Mail*, 5 February, A12.

Davis, H. Craig. 1993. Is the metropolitan Vancouver economy uncoupling from the rest of the province? *B.C. Studies* 98 (Summer):3-19.

Dean, Malcolm. 1981. *Censored! Only in Canada: The history of film censorship – the scandal off the screen*. Toronto: Virgo Press.

Delany, Paul. 1994. Introduction: Vancouver as a postmodern city. In *Vancouver: Representing the postmodern city*, ed. Paul Delany, 1-24. Vancouver: Arsenal Pulp Press.

DGA (Directors Guild of America). 1999. DGA/SAG commissioned study shows total economic impact of U.S. economic runaway production reached $10.3 billion in 1998. Press release, 25 June. News – Press Releases – Archives. <www.dga.org>, (25 April 2002).

Dick, Ronald. 1986. Regionalization of a federal cultural institution: The experience of the National Film Board of Canada 1965-1979. In *Flashback: People and institutions in Canadian film history*, ed. Gene Walz, 107-93. Montreal: Mediatexte Publications.

Dobson, Wendy. 1980. *The exchange rate as a policy instrument*. Toronto: C.D. Howe Institute.

Dorland, Michael. 1998. *So close to the state/s: The emergence of Canadian feature film policy*. Toronto: University of Toronto Press.

Douglas, Dave. 1996. Exile on Hastings and Main Street: The Vancouver films of Larry Kent. *Canadian Journal of Film Studies* 5 (2):85-99.

Drache, Daniel. 1995. Celebrating Innis: The man, the legacy, and our future. In *Staples, markets, and cultural change: Selected essays*, ed. Daniel Drache, xiii-lix. Montreal: McGill-Queen's University Press.

Duffy, Dennis. 1986. *Camera west: British Columbia on film 1941-1965*. Victoria: Provincial Archives of British Columbia.

Duffy, Dennis, and David Mattison. 1989. A.D. Kean: Canada's cowboy movie-maker. *Beaver*, February-March, 28-41.

Dwyer, Michael. 1995. Ireland. In *Variety international film guide 1996*, ed. Peter Cowie, 220-4. London: Hamlyn.

Edwards, Ian. 1996a. B.C. Film freezes distrib funding. *Playback*, 1 January, 1, 32.

–. 1996b. Disney office splash. *Playback*, 16 December, 10.

–. 1997a. Vancouver can do it all. *Playback*, 13 January, 29, 37, 40.

–. 1997b. Kissed by success. *Playback*, 5 May, 23.

–. 1997c. CBC picks Van.'s Da Vinci's Inquest, *Playback*, 19 May, 10.

–. 1997d. Paramount opens studio. *Playback*, 14 July, 3, 17.

–. 1997e. Friesen heads B.C. Telefilm. *Playback*, 22 September, 5.

–. 1997f. Tax credit 5.5%. *Playback*, 3 November, 1, 13.

–. 1998a. Foreign credit crucial, says B.C. study. *Playback*, 23 March, 12.

–. 1998b. BC Film fund closes early. *Playback*, 19 October, 67.

–. 1998c. Rupert lands Genie nomination. *Playback*, 14 December, 27.

–. 2000. Keystone Entertainment finalizes Red Sky deal. *Playback*, 19 December, 8.

Elias, Justine. 1996. The city that can sub for all of America. *New York Times*, 17 November, H36.

Enchin, Harvey. 1996. Ruling creates major player. *Globe and Mail*, 20 July, C1, C3.

Evans, Gary. 1991. *In the national interest: A chronicle of the National Film Board of Canada from 1949 to 1989.* Toronto: University of Toronto Press.

Famous Players. 2001. About Famous Players. 31 July. <www.famousplayers.com>, (25 April 2002).

Farrer, David. 1975. Canadian film industry is facing a crisis. *Vancouver Province,* 3 April, 27.

Featherstone, Mike. 1996. Localism, globalism, and cultural identity. In *Global/local: Cultural production and the transnational imaginary,* ed. Rob Wilson and Wimal Dissanayake, 46-77. Durham, NC: Duke University Press.

Film and Television Action Committee. 2001. Countervailing tariffs – Petition drive. 30 July. <www.ftac.net>, (25 April 2002).

Film studio start slated for winter. 1986. *Vancouver Sun,* 20 October, A9.

Foote, Jennifer. 1984. Movie exodus gains momentum. *Winnipeg Free Press,* 29 December, 23.

Fothergill, Robert. 1977. A place like home. In *The Canadian film reader,* ed. Seth Feldman and Joyce Nelson, 347-63. Toronto: Peter Martin Associates.

Garel, Sylvain. 1992. Un cinéma dans tous ses états. In *Les cinémas du Canada: Québec, Ontario, Prairies, côte Ouest, Atlantique,* ed. Sylvain Garel and André Pâquet, 7-11. Paris: Centre Georges Pompidou.

Garel, Sylvain, and André Pâquet, eds. 1992. *Les cinémas du Canada: Québec, Ontario, Prairies, côte Ouest, Atlantique.* Paris: Centre Georges Pompidou.

Garvey, Megan. 2001a. House bill aims to retain films. *Los Angeles Times,* 17 October.

–. 2001b. Petition on "runaway" productions filed. *Los Angeles Times,* 5 December.

Gasher, Mike. 1995. The audiovisual locations industry in Canada: Considering British Columbia as Hollywood North. *Canadian Journal of Communication* 20:231-54.

–. 1997. From sacred cows to white elephants: Cultural policy under siege. Special issue *Canadian cultures and globalization,* ed. Joy Cohnstaedt and Yves Frenette. *Canadian Issues* 19:13-29.

Giannetti, Louis D. 1993. *Understanding movies.* Englewood Cliffs, NJ: Prentice Hall.

Gibbon, Ann. 1997a. Baton wins Vancouver TV licence. *Globe and Mail,* 1 February, B1, B5.

–. 1997b. Giustra trades mining for movies. *Globe and Mail,* 29 September, B9.

Gill, Ian. 1985. Wanna buy a movie studio? *Vancouver Sun,* 6 June, B8.

Godfrey, Stephen. 1986. B.C. bust. *Globe and Mail,* 4 October, E1-2.

Grierson, John. 1977. Memo to Michelle about decentralizing the means of production. In *The Canadian film reader,* ed. Seth Feldman and Joyce Nelson, 132-6. Toronto: Peter Martin Associates.

Guback, Thomas H. 1969. *The international film industry: Western Europe and America since 1945.* Bloomington: Indiana University Press.

–. 1985. Hollywood's international market. In *The American film industry,* ed. Tino Balio, 463-86. Madison: University of Wisconsin Press.

Haden, Bruce. 1995. Toga party. *Canadian Architecture* 40 (8):32-3.

Hall, Stuart. 1995. New cultures for old. In *A place in the world? Cultures and globalization,* ed. Doreen Massey and Pat Jess, 175-211. New York: Oxford University Press.

Harcourt, Peter. 1981. *Jean Pierre Lefebvre.* Ottawa: Canadian Film Institute.

Harris, Christopher. 1993. Where there's smoke there's irony. *Globe and Mail,* 5 March, A11.

Hénault, Dorothy. 1991. The "Challenge for Change/Société nouvelle" experience. In *Video the changing world,* ed. Nancy Thede and Alain Ambrosi, 48-53. Montreal: Black Rose Books.

Higson, Andrew. 1989. The concept of national cinema. *Screen* 30 (4):36-46.

Hill, John. 1994a. Introduction. In *Border crossing: Film in Ireland, Britain and Europe,* ed. John Hill, Martin McLoone, and Paul Hainsworth, 1-7. Belfast: Queen's University of Belfast.

–. 1994b. The future of European cinema: The economics and culture of pan-European strategies. In *Border crossing: Film in Ireland, Britain and Europe,* ed. John Hill, Martin McLoone, and Paul Hainsworth, 53-80. Belfast: Queen's University of Belfast.

Hoffman, Andy. 1997a. Distrib industry in flux. *Playback,* 20 October, 1, 16.

–. 1997b. Ont. debuts service credit. *Playback,* 1 December, 1, 8.

Hollywood leaves home. 1984. *Economist,* March, 27-8.

Holm, Bill, and George Irving Quimby. 1980. *Edward S. Curtis in the land of the war canoes: A pioneer cinematographer in the Pacific Northwest.* Vancouver: Douglas and McIntyre.

Howlett, Michael, and Keith Brownsey. 1996. From timber to tourism: The political economy of British Columbia. In *Politics, policy and government in British Columbia,* ed. R.K. Carty, 18-31. Vancouver: UBC Press.

Hunter, Ian. 1988. Training reels. *Equity,* September, 35-36, 55, 62-66.

Interagency Committee on Film Development Policy. 1992. *Towards a federal-provincial strategy: The report of the committee's working group on federal-provincial relations,* 21 September. Vancouver: Interagency Committee on Film Development Policy.

International Trade Administration. 2001. US Department of Commerce. *The migration of U.S. film and television production.* February. <www.ita.doc.gov/PRFrameset.html>, (25 April 2002).

Jean, Marcel. 1991. *Le cinéma québécois.* Montreal: Boréal.

Jess, Pat, and Doreen Massey. 1995. The contestation of place. In *A place in the world? Cultures and globalization,* ed. Doreen Massey and Pat Jess, 133-74. New York: Oxford University Press.

Jones, D.B. 1981. *Movies and memoranda: An interpretative history of the National Film Board of Canada.* Ottawa: Canadian Film Institute.

Kaplan, Robert D. 1998. Travels into America's future: Southern California and the Pacific Northwest. *Atlantic Monthly,* August, 37-61.

Kelly, Brendan. 1999. City reels in film studio. *Montreal Gazette,* 14 April, A9.

Keystone Entertainment. 2001. Corporate – Company overview. <www.keypics.com>, (25 April 2002).

King, Russell. 1995. Migrations, globalization and place. In *A place in the world? Cultures and globalization,* ed. Doreen Massey and Pat Jess, 5-33. New York: Oxford University Press.

Knelman, Martin. 1978. *This is where we came in: The career and character of Canadian film.* Toronto: McClelland and Stewart.

–. 1987. *Home movies: Tales from the Canadian film world.* Toronto: Key Porter Books.

–. 1995. Happiness – come hell or high water. *Financial Post* (Toronto), 22 July, 18-19.

Kupecek, Linda. 1993. Biz on the range. *Hollywood Reporter: Alberta Special Issue,* 6 July, S3-4, S14.

Lacey, Liam. 1989. Is there a big chill descending on B.C. film industry? *Globe and Mail,* 14 December, C15.

Lamey, Mary. 1999. New role for air base. *Montreal Gazette,* 30 March, D1.

LCE *See* Loews Cineplex Entertainment.

Lee, Jenny. 1996. New labor pact will put B.C. back in film spotlight, producer predicts. *Vancouver Sun,* 8 May, D1-2.

Les cinémas du Canada. 1993. *Les cinémas du Canada: Programme-souvenir,* 5. Montreal: Telefilm Canada.

Lever, Yves. 1988. *Histoire générale du cinéma au Québec.* Montreal: Boréal.

Lewis, Brian. 1987. Studio set to go. *Vancouver Province,* 2 April, 31.

Lions Gate Films. 2001. Corporate info. <www.lionsgatefilms.com>, (25 April 2002).

Locherty, Lorraine. 1979. Hatley Castle goes Hollywood. *Victoria Times,* 16 January, 15.

Loews Cineplex Entertainment. 2001. Corporate info – Corporate history. 31 July. <www.enjoy theshow.com>, (25 April 2002).

Luke, Paul. 1991. Banking on the movies. *Vancouver Province,* 13 October, A54.

McCarthy, Shawn. 1997. Cineplex deal may hinge on sale of unit. *Globe and Mail,* 3 October, B1, B20.

MacDonald, Gayle. 1998. Entertainment rivals join forces. *Globe and Mail,* 21 July, A1, A4.

Macerola, François. 1997. Letter to Wayne Sterloff, president and chief executive officer, British Columbia Film, 16 May. Author's personal files.

MacIntyre, Ken. 1996. *Reel Vancouver: An insider's guide.* Vancouver: Whitecap Books.

McLoone, Martin. 1994. National cinema and cultural identity: Ireland and Europe. In *Border crossing: Film in Ireland, Britain and Europe,* ed. John Hill, Martin McLoone, and Paul Hainsworth, 146-73. Belfast: Queen's University of Belfast.

Magder, Ted. 1993. *Canada's Hollywood: The Canadian state and feature films.* Toronto: University of Toronto Press.

–. 1996. Film and video production. In *The cultural industries in Canada: Problems, policies and prospects,* ed. Michael Dorland, 145-77. Toronto: James Lorimer and Company.

Magder, Ted, and Jonathan Burston. 2001. Whose Hollywood? Changing forms and relations inside the North American entertainment economy. In *Continental order? Integrating North America for cybercapitalism,* ed. Vincent Mosco and Dan Schiller, 207-34. Lanham, MD: Rowman and Littlefield.

Massey, Doreen. 1991. A global sense of place. *Marxism Today,* June, 24-9.

–. 1992. A place called home? *New Formations* 17:3-15.

–. 1995. The conceptualization of place. In *A place in the world? Cultures and globalization,* ed. Doreen Massey and Pat Jess, 48-87. New York: Oxford University Press.

Massey, Doreen, and Pat Jess. 1995. Places and cultures in an uneven world. In *A place in the world? Cultures and globalization,* ed. Doreen Massey and Pat Jess, 215-39. New York: Oxford University Press.

Mast, Gerald. 1986. *A short history of the movies.* 4th ed. New York: Macmillan.

Matas, Robert. 1999. Alaskan haul angers idled BC fishermen. *Globe and Mail,* 28 July, A1, A3.

Mattison, David. 1986a. The British Columbia Government Travel Bureau and motion picture production, 1937-1947. In *Flashback: People and institutions in Canadian film history,* ed. Gene Walz, 79-104. Montreal: Mediatexte Publications.

–. 1986b. The projected image: Provincial government travel films, 1920-1984. Unpublished manuscript.

Miller, Mary Jane. 1987. *Turn up the contrast: CBC television drama since 1952.* Vancouver: UBC Press and CBC Enterprises.

Miller, Toby. 1993. *The well-tempered self: Citizenship, culture, and the postmodern subject.* Baltimore: Johns Hopkins University Press.

–. 1996. The crime of Monsieur Lang: GATT, the screen and the new international division of cultural labour. In *Film policy: International, national and regional perspectives,* ed. Albert Moran, 72-84. London: Routledge.

Mitchell, Don. 1991. A film-maker who wonders why she's still in Canada: Sandy Wilson. *B.C. Business* 19 (11):73-5.

Mitchell, Katharyne. 1996. In whose interest? Transnational capital and the production of multiculturalism in Canada. In *Global/local: Cultural production and the transnational imaginary,* ed. Rob Wilson and Wimal Dissanayake, 219-51. Durham, NC: Duke University Press.

Monitor Company. 1999. U.S. runaway film and television production study report. June. <www.dga.org/new/pr_runaway.pdf>, (25 April 2002).

Monk, Katherine. 1997. Reeling in the bucks. *Vancouver Sun,* 24 October, E1.

Moran, Albert. 1996. Terms for a reader: Film, Hollywood, national cinema, cultural identity and film policy. In *Film policy: International, national and regional perspectives,* ed. Albert Moran, 1-19. London: Routledge.

Morley, David, and Kevin Robins. 1995. *Spaces of identity: Global media, electronic landscapes and cultural boundaries.* London: Routledge.

Morris, Peter. 1978. *Embattled shadows: A history of Canadian cinema, 1895-1939.* Montreal: McGill-Queen's University Press.

–. 1994. In our own eyes: The canonizing of Canadian film. *Canadian Journal of Film Studies* 3 (1):27-44.

Moshansky, Tim. 1996. *A to Z guide to film production terms*. Vancouver: First Wave Publishing.

Movie, TV workers rally against job flight. 1999. *Los Angeles Times On-Line*, 16 August. <www.latimes.com>, (25 April 2002).

Mulgrew, Ian. 1982. "Hollywood North" $60 million scene. *Globe and Mail*, 9 November, 1-2.

Murphy, David G. 1997. The entrepreneurial role of organized labour in the British Columbia motion picture industry. *Relations Industrielles/Industrial Relations* 52 (3):531-53.

Musser, Charles. 1991. *Before the nickelodeon: Edwin S. Porter and the Edison manufacturing company*. Berkeley: University of California Press.

NAC (National Archives of Canada). MG 31, D210, vol. 3, file 3.14. Peter Jones, Correspondence (personal), 1972-73.

–. MG 31, D210, vol. 3, file 3.18. Peter Jones, Correspondence (personal), 1974-75.

–. MG 31, D210, vol. 4, file 1. Peter Jones, Correspondence (personal), 1976-80.

–. MG 31, D210, vol. 4, file 7. Peter Jones, Correspondence (personal), 1982.

–. MG 31, D210, vol. 7, files 3 and 5. Peter Jones, Regional Production (general), 1967-80.

–. MG 31, D210, vol. 7, file 6. Peter Jones, Regional Profile, 1976.

Negroponte, Nicholas. 1995. *Being digital*. New York: Alfred A. Knopf.

NFB (National Film Board of Canada). 1977. *Annual report, 1976-77*. Montreal: NFB.

Nietschmann, Bernard. 1993. Authentic, state, and virtual geography in film. *Wide Angle* 15 (4):5-12.

Olijnyk, Zena. 2000. Build them and they'll sit empty. *National Post*, 9 September, D1.

O'Regan, Tom. 1996. *Australian national cinema*. London: Routledge.

Palmer, Vaughan. 1986. Here's the slate for B.C.'s film future. *Vancouver Sun*, 7 March, B4.

Parton, Nicole. 1995. Movie-biz glamor wears thin in Hollywood North. *Vancouver Sun*, 5 June, A1, A3.

Pasquill, Frank T., and Joan Horsman. 1973. *Wooden pennies: A report on cultural funding patterns in Canada*. Toronto: Programme in Arts Administration, York University.

Pendakur, Manjunath. 1990. *Canadian dreams and American control: The political economy of the Canadian film industry*. Toronto: Garamond Press.

–. 1998. Hollywood North: Film and TV production in Canada. In *Global productions: Labor in the making of the "information society,"* ed. Gerald Sussman and John A. Lent, 213-38. Creskill, NJ: Hampton Press.

Quenville, Brad. 1986. *The need for and the creation of a B.C. film development corporation*. Vancouver: BC Film and Video Industry Association.

Raboy, Marc. 1990. *Missed opportunities: The story of Canada's broadcasting policy*. Montreal: McGill-Queen's University Press.

Read, Nicholas. 1988. New North Shore studio will be Canada's largest. *Vancouver Sun*, 30 July, H15.

Reimer, Derek. 1986. Foreword. In Dennis J. Duffy, *Camera west: British Columbia on film, 1941-1965*. Victoria: Provincial Archives of British Columbia.

Relph, Edward. 1986. *Place and placelessness*. London: Pion.

Rice-Barker, Leo. 1996. Victor victorious. *Playback*, 6 May, 1, 5, 14.

–. 1997. Telefilm, B.C. Film debate funding drop. *Playback*, 13 January, 6, 12.

–. 1998. Que. f/x credit. *Playback*, 6 April, 1, 9.

Robins, Kevin. 1997. What in the world's going on? In *Production of culture/cultures of production*, ed. Paul Du Gay, 11-47. London: Sage.

Rockett, Kevin. 1994. Culture, industry and Irish cinema. In *Border crossing: Film in Ireland, Britain and Europe*, ed. John Hill, Martin McLoone, and Paul Hainsworth, 126-39. Belfast: Queen's University of Belfast.

Rose, Gillian. 1995. Place and identity: A sense of place. In *A place in the world? Cultures and globalization*, ed. Doreen Massey and Pat Jess, 87-118. New York: Oxford University Press.

Russo, Robert. 2001. U.S. report blames Canada for Hollywood woes but rejects trade action. *Vancouver Sun*, 18 February, B9.

References

St. Onge, Jeff. 2001. Loews files Chapter 11 recovery plan. *Los Angeles Times,* 13 November.

Saunders, Doug. 1998. Lights! Cameras! Tax breaks! *Globe and Mail,* 14 August, A1, A4.

Schatz, Thomas. 1983. *Old Hollywood/new Hollywood: Ritual, art, and industry.* Ann Arbor: UMI Research Press.

Shearer, Ronald A. 1993-4. The economy. *B.C. Studies* 100 (Winter):121-39.

Shecter, Barbara. 1998. Alliance, Atlantis forge $750M giant. *Financial Post* (Toronto), 21 July, 1-2.

Shepherd, John R. 1979. A challenge to change: The regionalization of the National Film Board of Canada. *Journal of the University Film Association* 31 (3):13-17.

Shepherd, Leslie. 1980. Film makers flocking to B.C. leave money and free publicity. *Victoria Times,* 16 July, 21.

Shields, Roy. 1973. Canadians ponder biggest crap game in world. *Vancouver Province,* 31 January, 11.

Shohat, Ella, and Robert Stam. 1996. *Unthinking Eurocentrism: Multiculturalism and the media.* London: Routledge.

Simon Fraser University Archives. MG 1/1, box 12, file 6. W.A.C. Bennett Papers, Personal Papers 1915-1979 (Legislature, Information 1973).

Sklar, Robert. 1978. *Movie-made America: A cultural history of American movies.* London: Chappell and Company.

Smythe, Dallas W. 1982. *Dependency road: Communications, capitalism, consciousness, and Canada.* Norwood, NJ: Ablex Publishing.

Stanley, Robert H. 1978. *The celluloid empire: A history of the American movie industry.* New York: Hastings House.

Statistics Canada. 2000. Film and video distribution 1997-98. *Daily,* 3 February.

Storper, Michael. 1989. The transition to flexible specialisation in the US film industry: external economies, the division of labour, and the crossing of industrial divides. *Cambridge Journal of Economics* 13:273-305.

Studer, David. 1971. A star is born west of Rockies. *Victoria Daily Colonist,* 2 February, 29.

Studio facilities across Canada. 2001. *Playback,* 23 July, 32-4.

Stukator, Angela. 1993. Critical categories and the (il)logic of identity. *Canadian Journal of Film Studies* 2 (2-3):117-28.

Telefilm Canada. 2001. Elizabeth Friesen appointed Acting Director – Canadian Operations. Press release, 3 July.

Testa, Bart. 1992. Du structurel au néo-narratif: Le cinéma expérimental. In *Les cinémas du Canada: Québec, Ontario, Prairies, côte Ouest, Atlantique,* ed. Sylvain Garel and André Pâquet, 235-41. Paris: Centre Georges Pompidou.

–. 1994. In Grierson's shadow. *Literary Review of Canada,* November, 9-11.

Testar, Gerald. 1985. *Clearing hurdles: A task force report on the motion picture industry in British Columbia.* Vancouver: British Columbia Film and Video Industry Association.

Thomas, Bob. 1971. B.C. woos filmland. *Victoria Daily Colonist,* 11 May, 21.

TIFF (Toronto International Film Festival). 2001. World premiere of *Last Wedding* to open festival. Press release, 19 July. Media centre – news releases. <www.e.bell.ca/filmfest/2001>, (25 April 2002).

Tolusso, Susan. 2001. Buoyant B.C. pushes ahead. *Playback,* 23 July, 27, 31.

Top 20: The best Canadian films of all time. 1998. *Take One,* Spring, 18-24.

Tour local filming locations. 1997. *Hope and area: Daytripper's paradise.* Hope: Hope and District Chamber of Commerce.

Tourism British Columbia. 2001. The value of tourism. February. Media – Facts and stats. <www.hellobc.com>, (25 April 2002).

Trustcott, Brian. 1992. TV mogul sets up shop in Kits. *Vancouver Courier,* 26 July, 1, 13.

Turner, Graeme. 1990. *Film as social practice.* London: Routledge.

Turner, Michael. 1993. *Hard core logo*. Vancouver: Arsenal Pulp Press.

TV, film production at record high. 1997. *Montreal Gazette*, 16 January, C9.

U.K. filming in B.C. 1965. *Vancouver Province*, 4 October, 10.

UPI (United Press International). 1976. Motion picture business "national disgrace." *Victoria Daily Colonist*, 30 January, 21.

Vamos, Peter, and Ian Edwards. 2000. Disney closing may affect tax credits. *Playback*, 21 February, 1.

Van Dijk, Teun. 1997. The study of discourse. In *Discourse as structure and process*, ed. Teun Van Dijk, 1-34. London: Sage.

Viacom. 2001. About Viacom – Viacom corporate fact sheet. 31 July. <www.viacom.com>, (25 April 2002).

Vogt, Roy, Beverly J. Cameron, and Edwin G. Dolan. 1993. *Economics: Understanding the Canadian economy*. 4th edition. Toronto: Holt, Rinehart and Winston of Canada.

Walsh, Michael. 1972. Special movie tax favored to support Canadian films. *Vancouver Province*, 25 May, 43.

–. 1974. Canadian content quota sought for theatres. *Vancouver Province*, 11 February, 11.

–. 1975. B.C. film industry faces extinction. *Vancouver Province*, 23 June, 9.

–. 1976. Vancouver films. In *The Vancouver book*, ed. Chuck Davis, Marilyn Sacks, and Daniel Wood, 408-11. North Vancouver: J.J. Douglas.

–. 1980a. Two films shot in B.C. lead in race for Canadian awards. *Vancouver Province*, 8 February, B8.

–. 1980b. Year-end rush is on in B.C. film-making. *Vancouver Province*, 13 November, D3.

Walshe, Catherine. 1997. British Columbia: A low cost location for American feature film and television production. Honours thesis, University of British Columbia.

Warren, Ina. 1980. Canadian movie industry boomed as never before in 1979. *Calgary Herald*, 4 January, D9.

Wasko, Janet. 1995. *Hollywood in the information age: Beyond the silver screen*. Austin: University of Texas Press.

Wasserman, Jack. 1976. Untitled column, *Vancouver Sun*, 21 August, 31.

Wedman, Les. 1971. Who's taking Bennett's bait? *Vancouver Sun*, 22 April, 41.

–. 1974. Don't count on Victoria to foster a film industry. *Vancouver Sun*, 30 November, 43.

–. 1977. The hard sell: B.C. woos movie-makers. *Vancouver Sun*, 13 December, C3.

–. 1978. B.C.'s new film coordinator fighting early dismissal. *Vancouver Sun*, 22 April, B3.

–. 1980. Grey Fox to ride again. *Vancouver Sun*, 6 April, F1.

Wertenstein, Wanda. 1995. Poland. In *Variety international film guide 1996*, ed. Peter Cowie, 274-9. London: Hamlyn.

Wilson, Rob. 1996. Goodbye paradise: Global/localism in the American Pacific. In *Global/local: Cultural production and the transnational imaginary*, ed. Rob Wilson and Wimal Dissanayake, 312-36. Durham, NC: Duke University Press.

Wilson, Rob, and Wimal Dissanayake. 1996. Introduction: Tracking the global/local. In *Global/local: Cultural production and the transnational imaginary*, ed. Rob Wilson and Wimal Dissanayake, 1-18. Durham, NC: Duke University Press.

Wong, Anita. 1997. British Columbia Film: A decade of commitment (promotional supplement). *Playback*, 22 September, 45-9.

Wu, Chia-chi. 1998. Double Happiness: The doubling of nationality and sexuality. Unpublished manuscript.

Yaffe, Samantha. 2001. Production still booming. *Playback*, 1 March, 1.

Young, Pamela. 1987. A nose for the tragic heart of comedy. *Maclean's*, 29 June, 48.

Index